LOCH RAVEN

BALTIMORE COUNTY, MARYLAND

39° 27'N 76° 34'W

Printed in China by Everbest Printing Co.,
Through Four Colour Print Group, Louisville, Kentucky

ISBN 978-0-9841144-0-5

LOCH RAVEN

BALTIMORE COUNTY, MARYLAND

DAVID SIMPSON PHOTOGRAPHY

Design: Carolyn McGeorge & Andy Ellis / E&O 2

Over the last twenty-some years, I've driven down Jarrettsville Pike from my home in Monkton, Maryland, south towards Towson and/or Baltimore, more days than I haven't. And the highlight of that near-daily trek is where Jarrettsville Pike merges into Dulaney Valley Road at the bridge crossing Loch Raven Reservoir. You'd think after countless crossings, I might have grown blasé about the view this bridge affords me of the 2,400-acre reservoir below. Nothing could be further from the truth. After all, you are presently holding what I deem to be a personal, photographic love letter to a man-made, and nature-enhanced, body of water.

As a film director who primarily shoots TV commercials, I have used the reservoir as a location in several projects. But this is also where I've photographed my children over the years, taken my dogs for long walks and taught my son, Christian, how to ride a bike.

So, it's really no wonder that a few years ago when I decided I needed a hobby, I was drawn to the reservoir. Plus, I was looking to exercise, too. Everything fell into place when I found myself in a local sporting goods shop where I discovered the "Native 12," a cool name for an equally cool Kayak. And given it was season's end and on sale, I could easily justify the purchase. Paddling is exercise, after all. I'd be in a place I loved. And I could take pictures – something I've always enjoyed. Here was my new hobby/exercise program. Hence the idea for this book was born. One big problem, however. Did you know it's nearly impossible to take photographs and paddle a kayak at the same time? Me neither?

While shooting photos, one gets lost in the process – waiting for the cloud's reflection in the water to move just slightly, repeatedly second guessing the aperture and f-stop, quickly clicking off a dozen shots in a row. These are the sorts of things that take one's attention away from paddling and results in running aground, running into trees, nearly running into other boaters. I was out of control, and I was a risk to myself and others.

While leafing through an L.L. Bean catalogue, I came across a small battery-powered, trolling motor rig designed for a canoe. I figured canoes and kayaks are kind of cousins (maybe not kissing cousins, but…), and in no time at all I quickly became known as that nut-job on the reservoir with the motorized kayak. I got teased quite a bit from others on the water, "Just get a boat, chowderhead," "How's they bitin', mister?" and "What in world do you think you're doing?" I made up a story, claiming I was working on a photo book. Early in the process, I thought, if these photos are good enough, maybe there is a book here.

I guess what I was doing was trolling/fishing for photographs. So, what started as an attempt to gain a little relaxation and exercise, developed into a project with a great deal of satisfaction, and virtually zero exercise.

It's my pleasure to introduce you to the most beautiful, peaceful places on earth I know.

Please stay away,

David Simpson
Spring, 2009

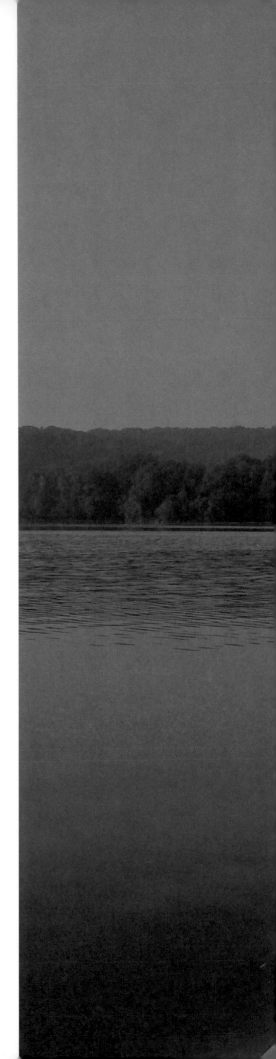

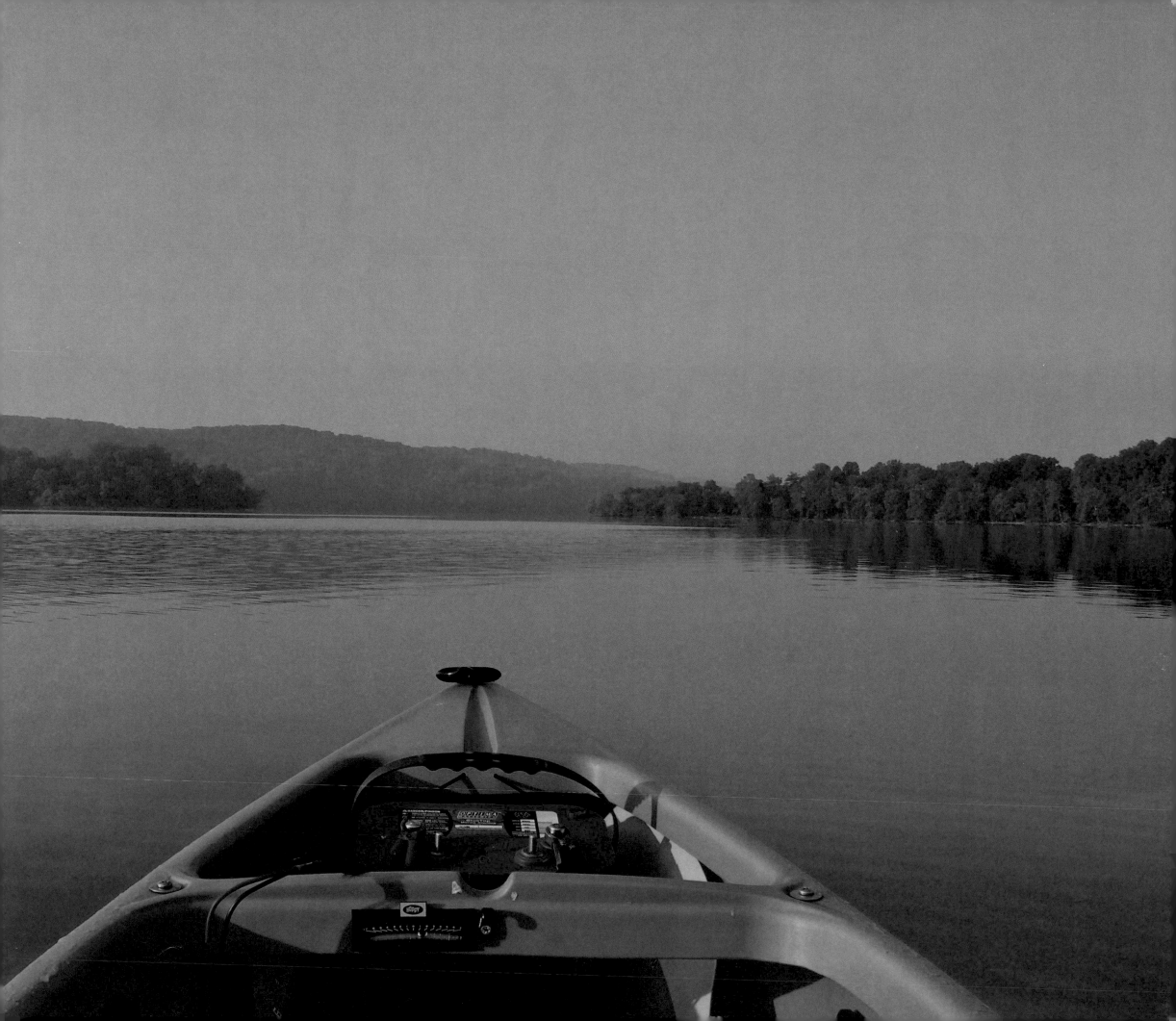

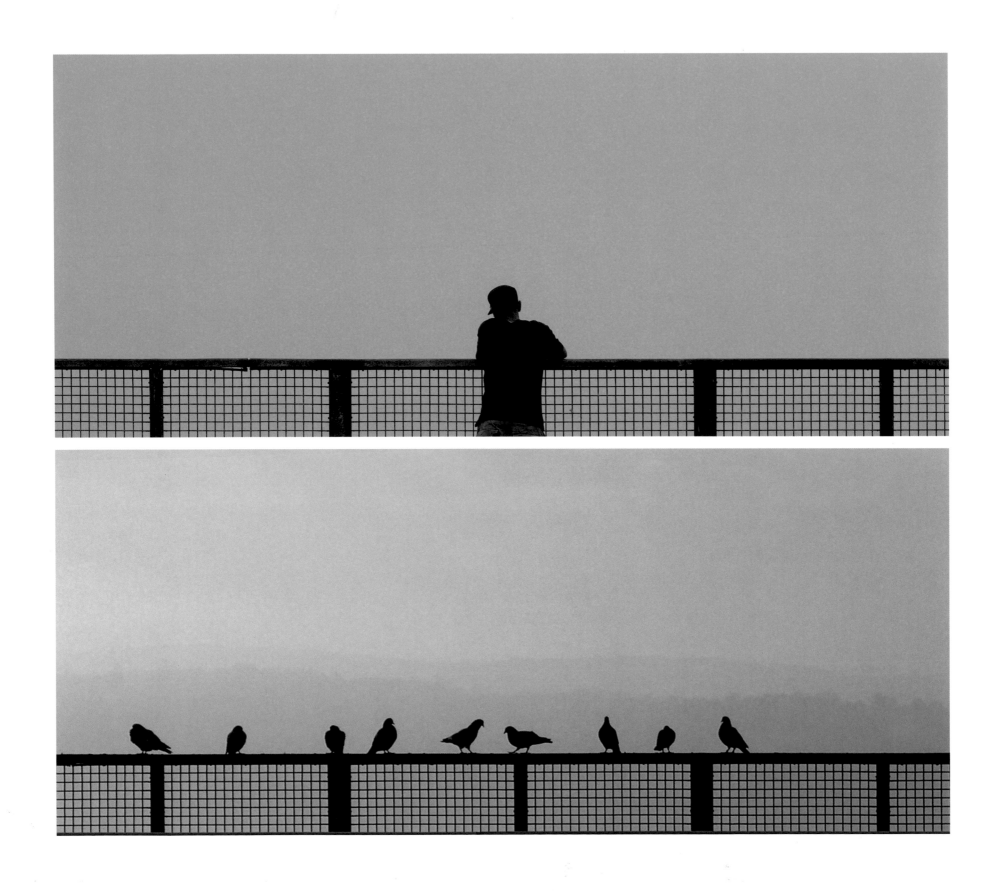

Warren Road Bridge, *shot early morning on my way to my day job.* >

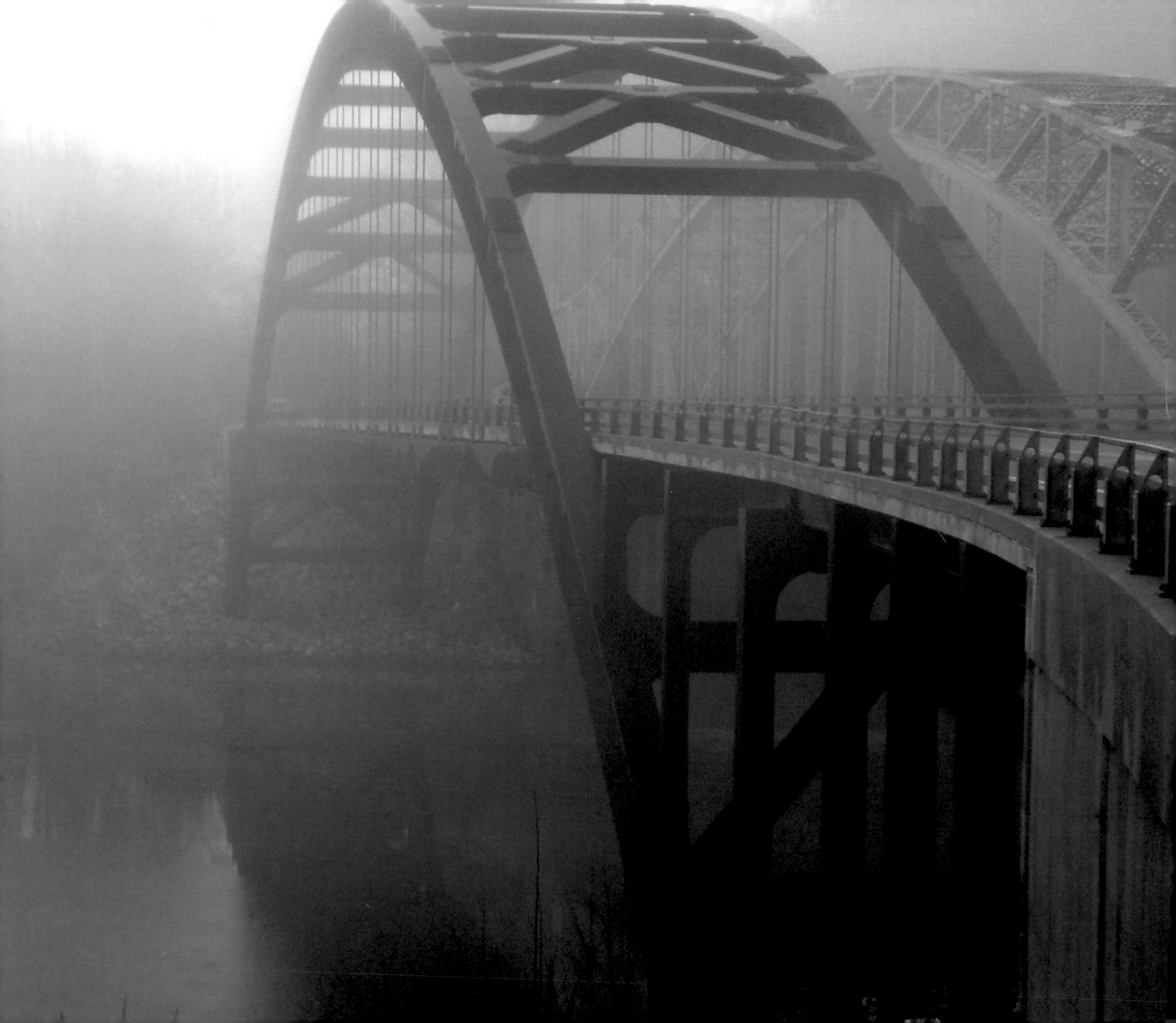

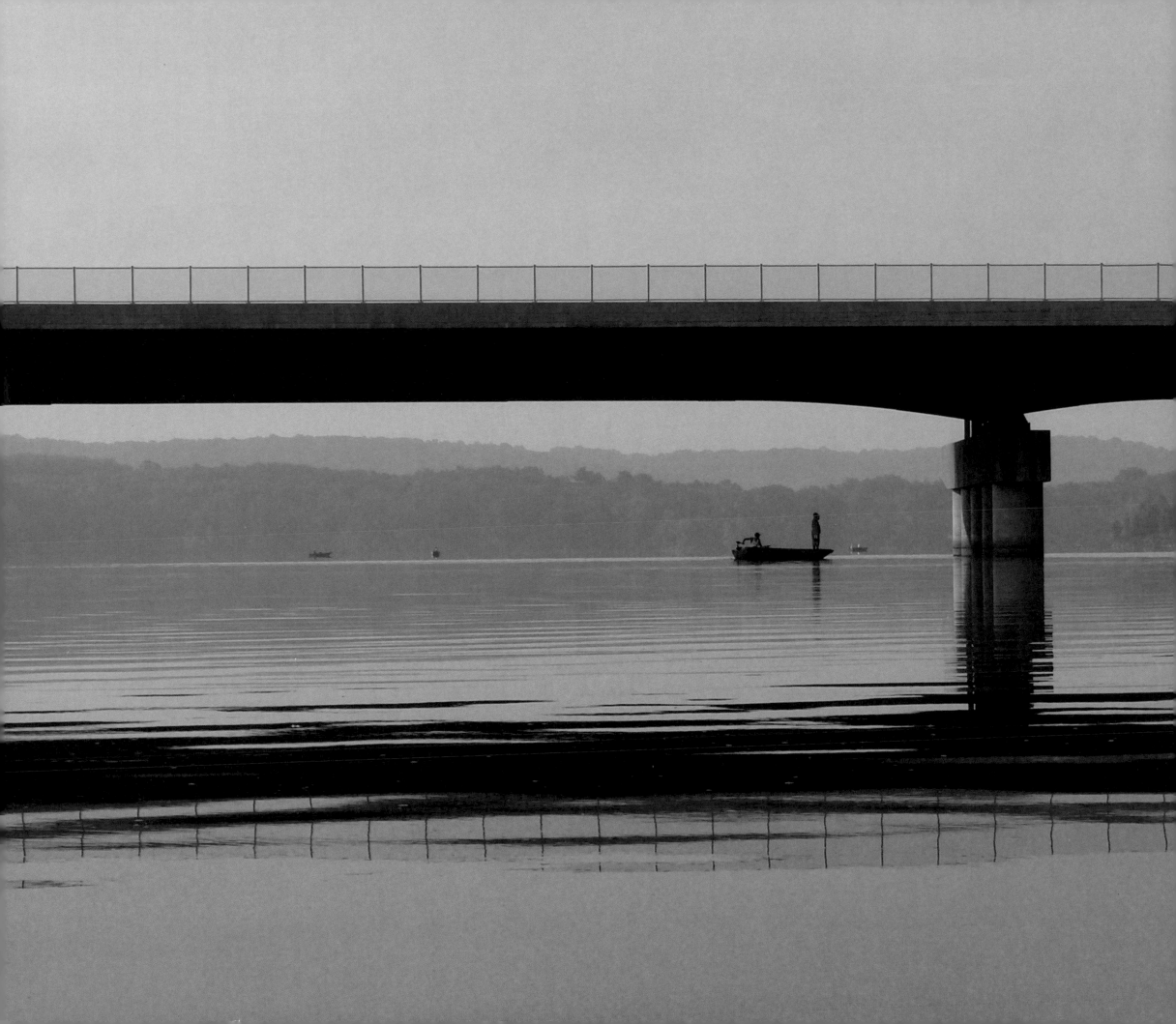

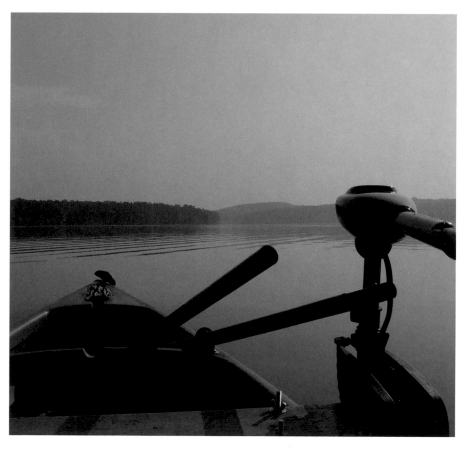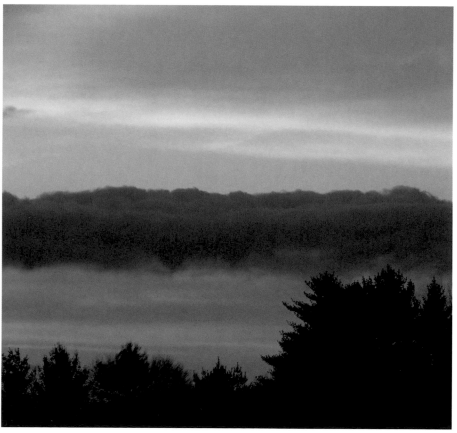

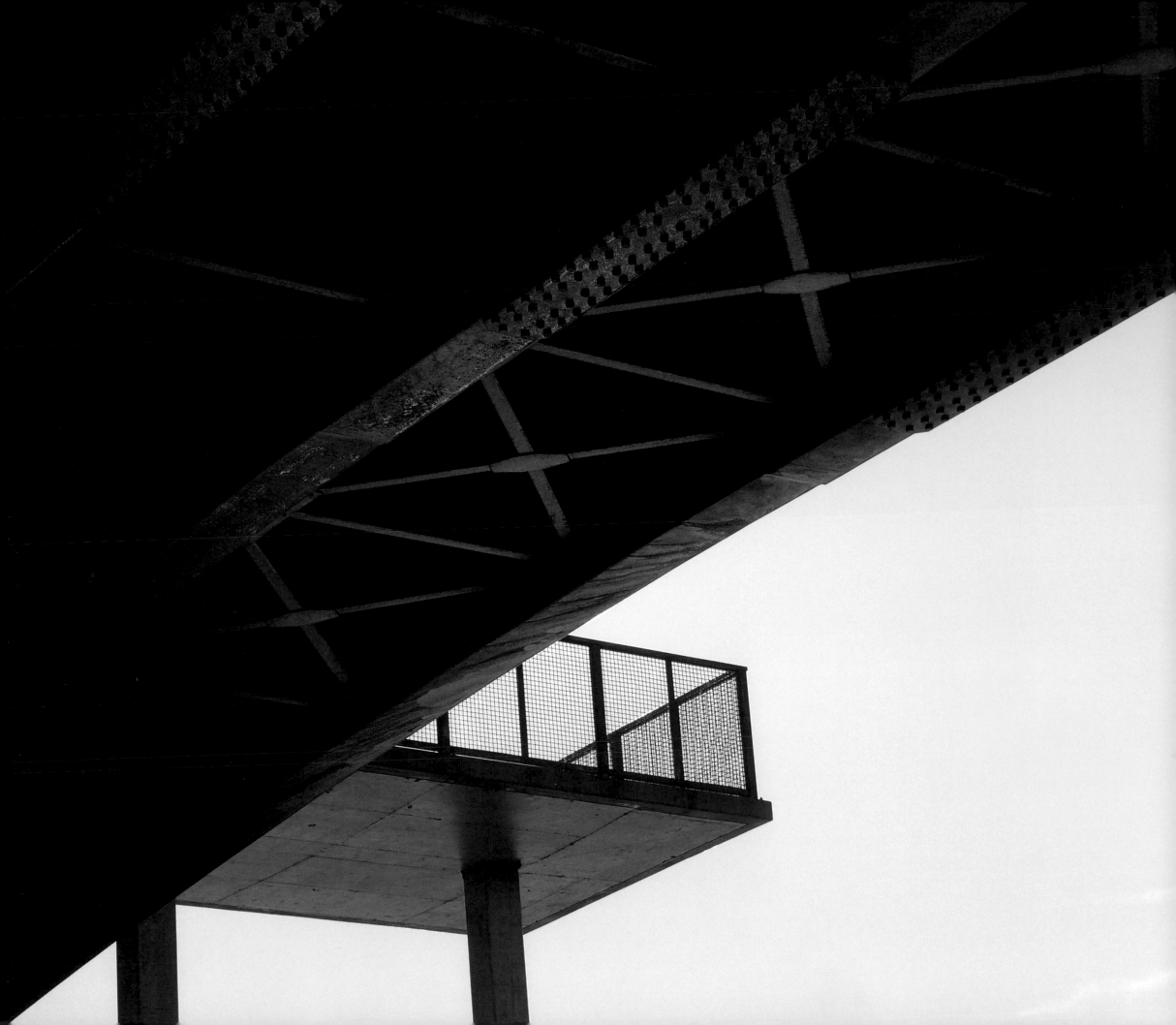

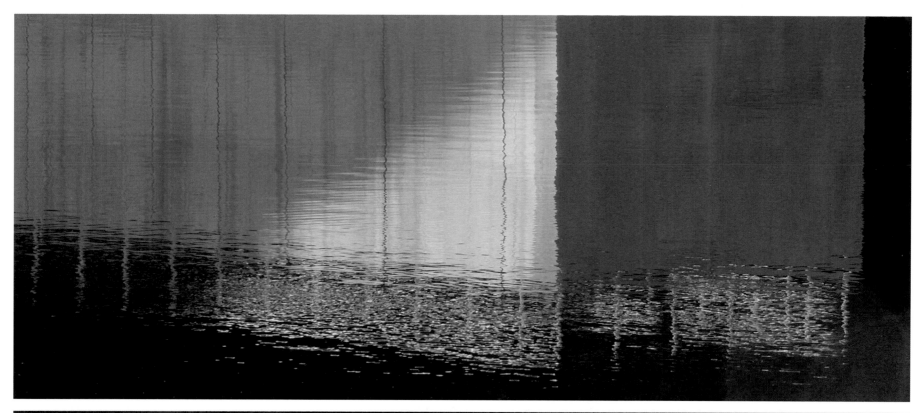

< The underbelly of Dulaney Valley Road Bridge.

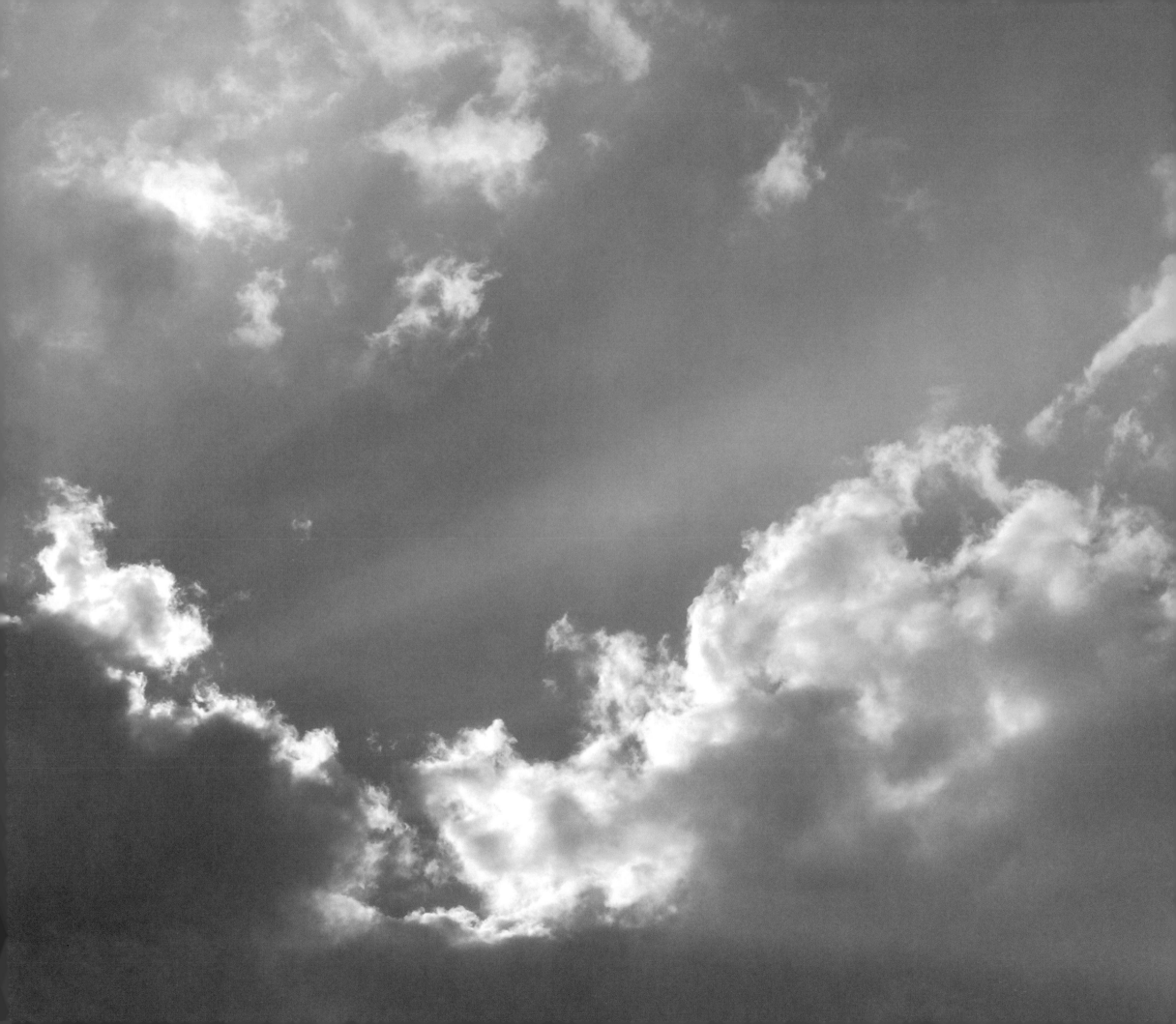

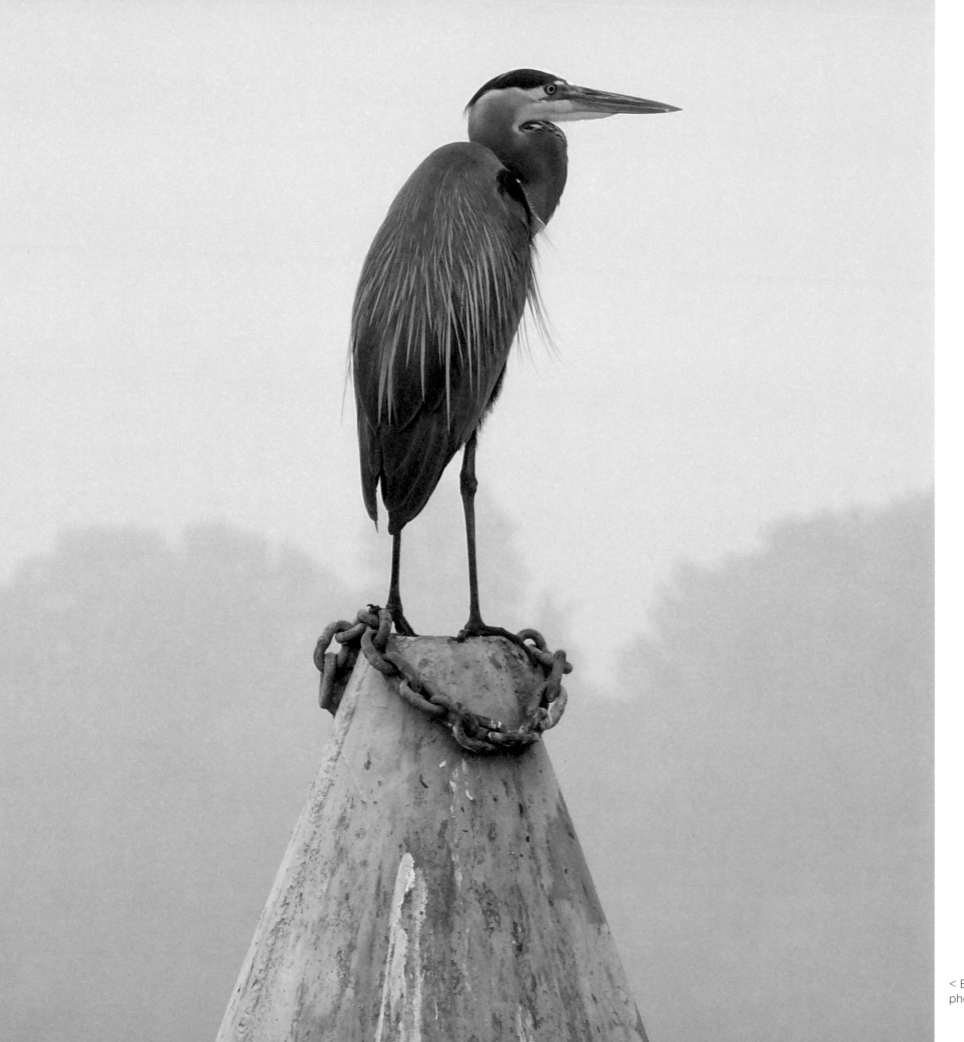

< Blue Heron (perhaps my favorite photograph in this book).

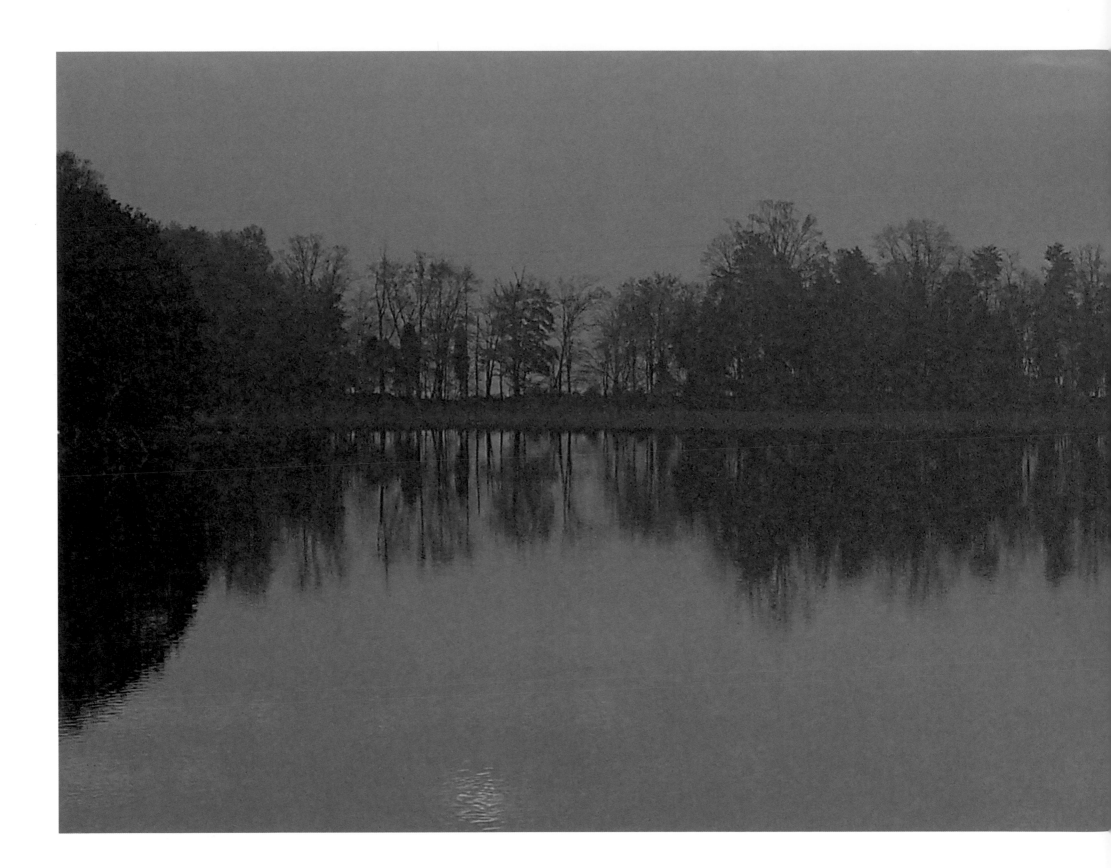

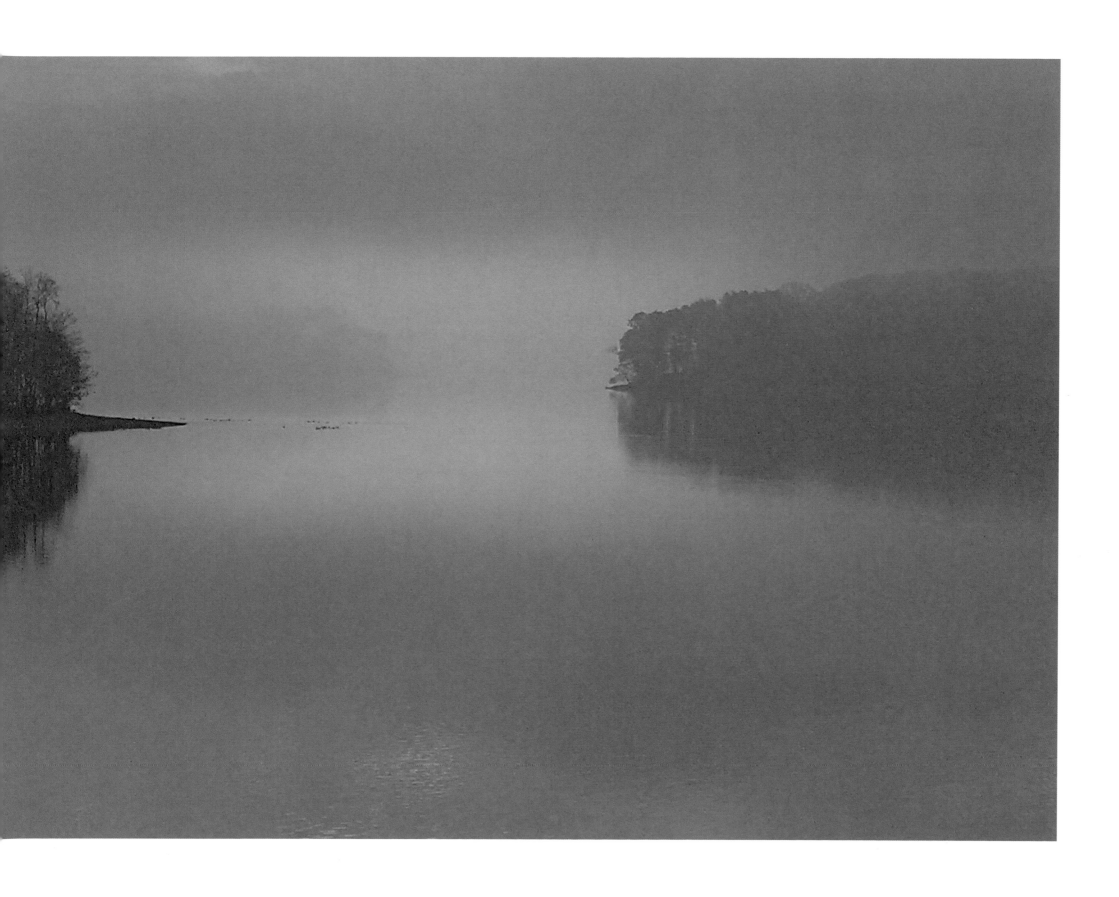

I saw this scene on my way to the office and asked myself,
"Am I a filmmaker or a photographer?" I stopped the car.

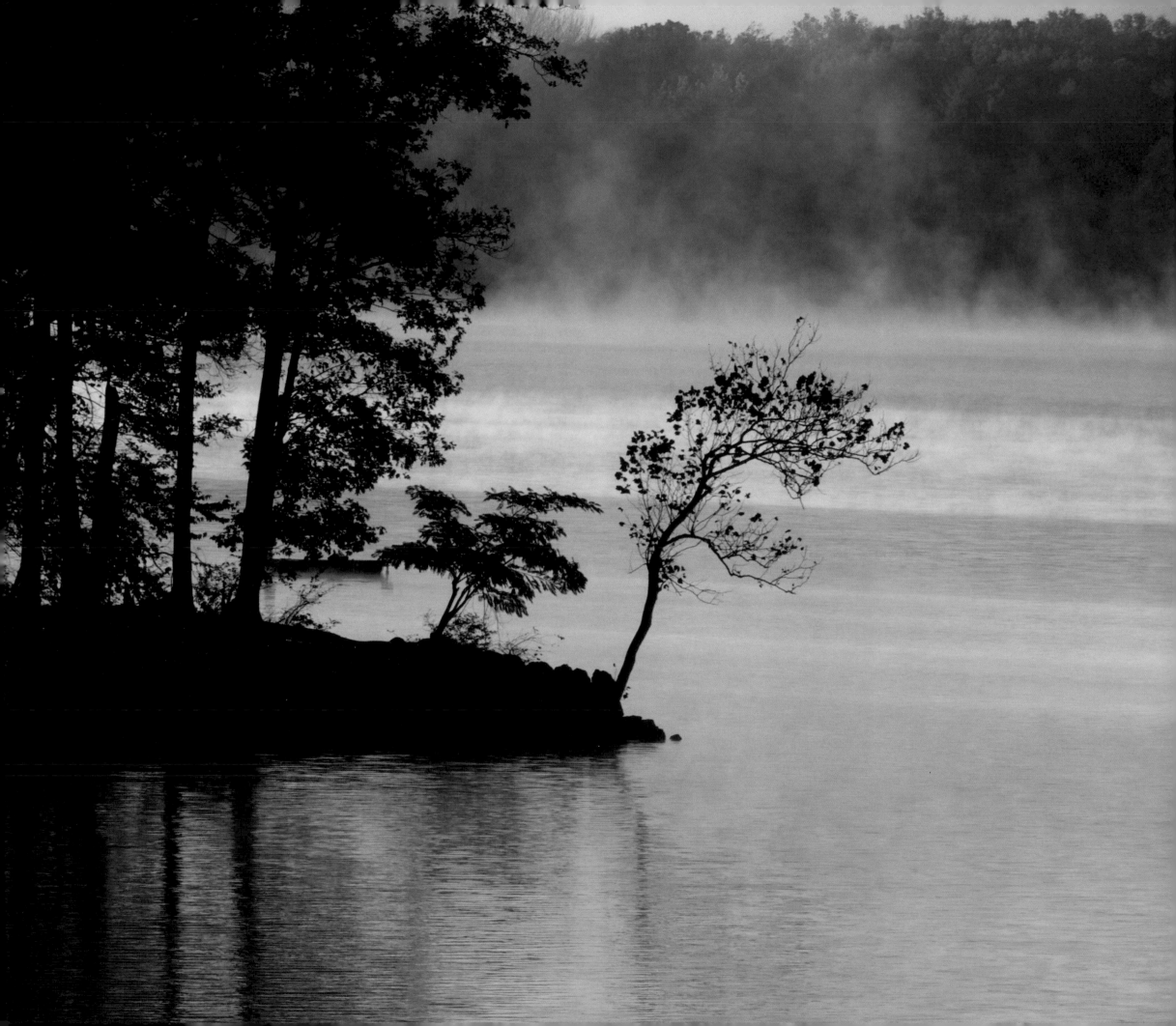

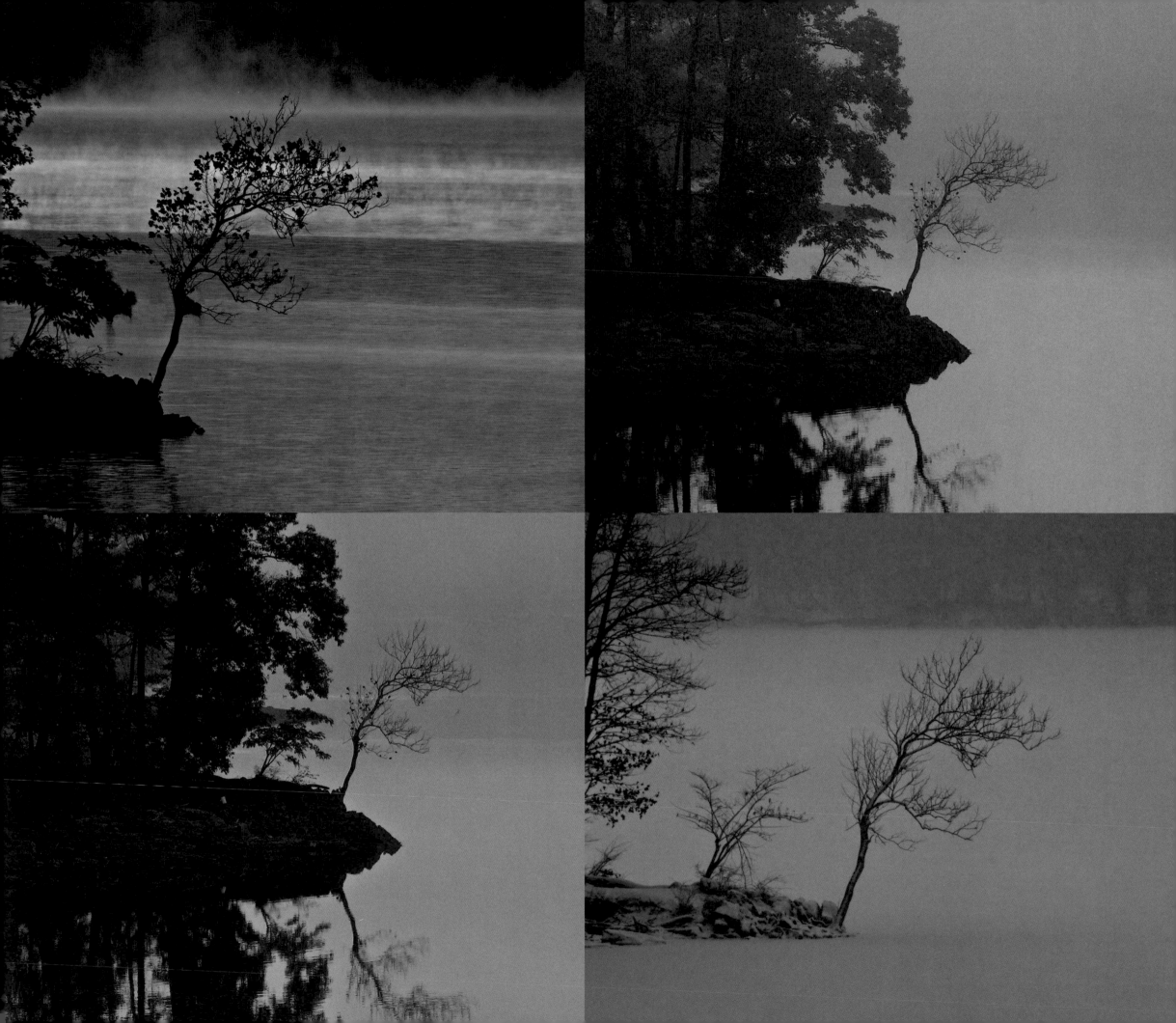

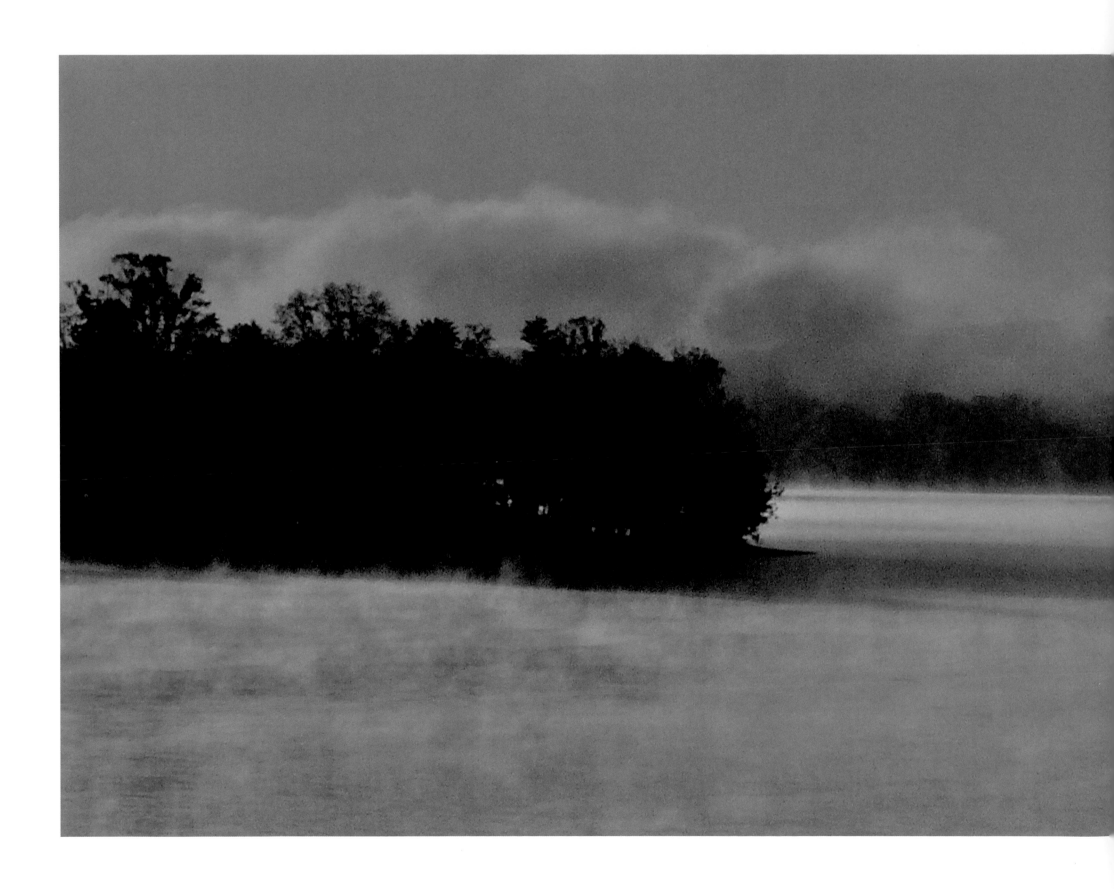

This photograph could have been taken 50 years ago.
But 50 years ago I was probably busy doing something less interesting.

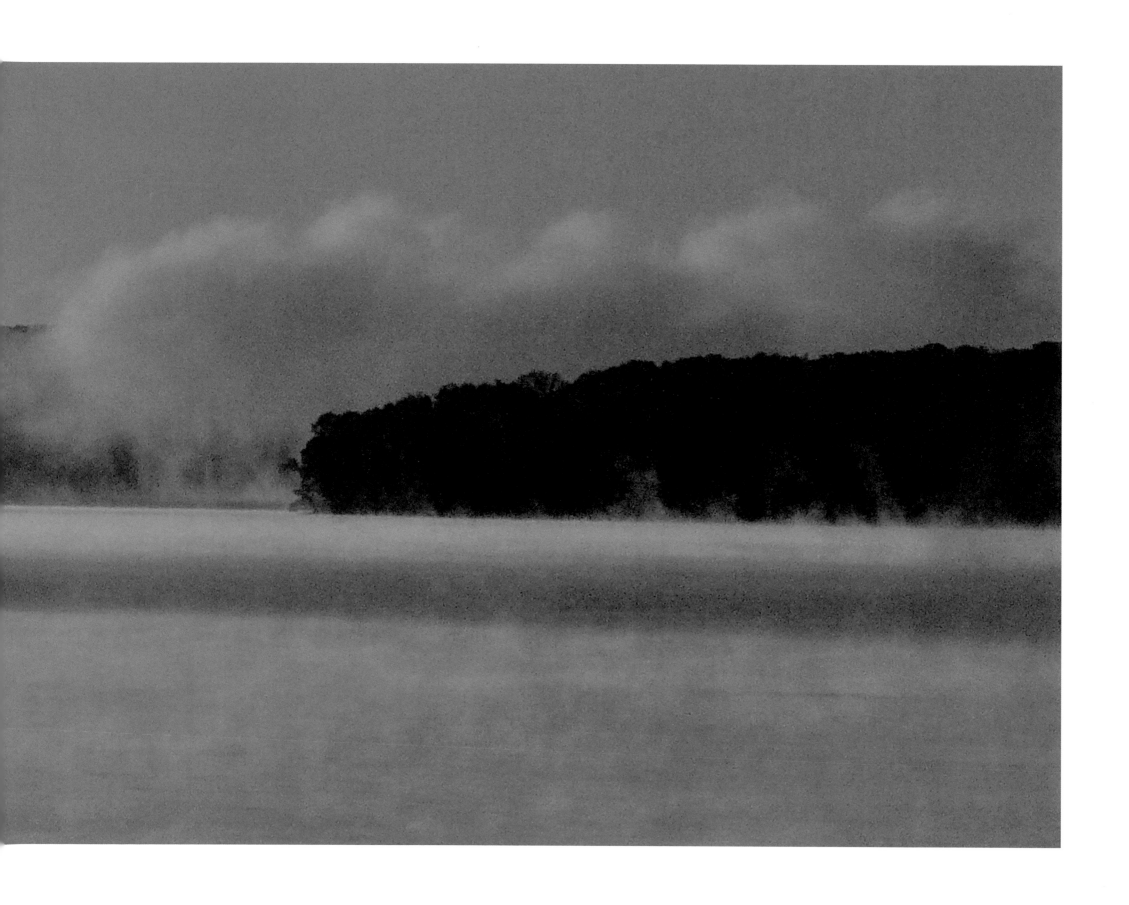

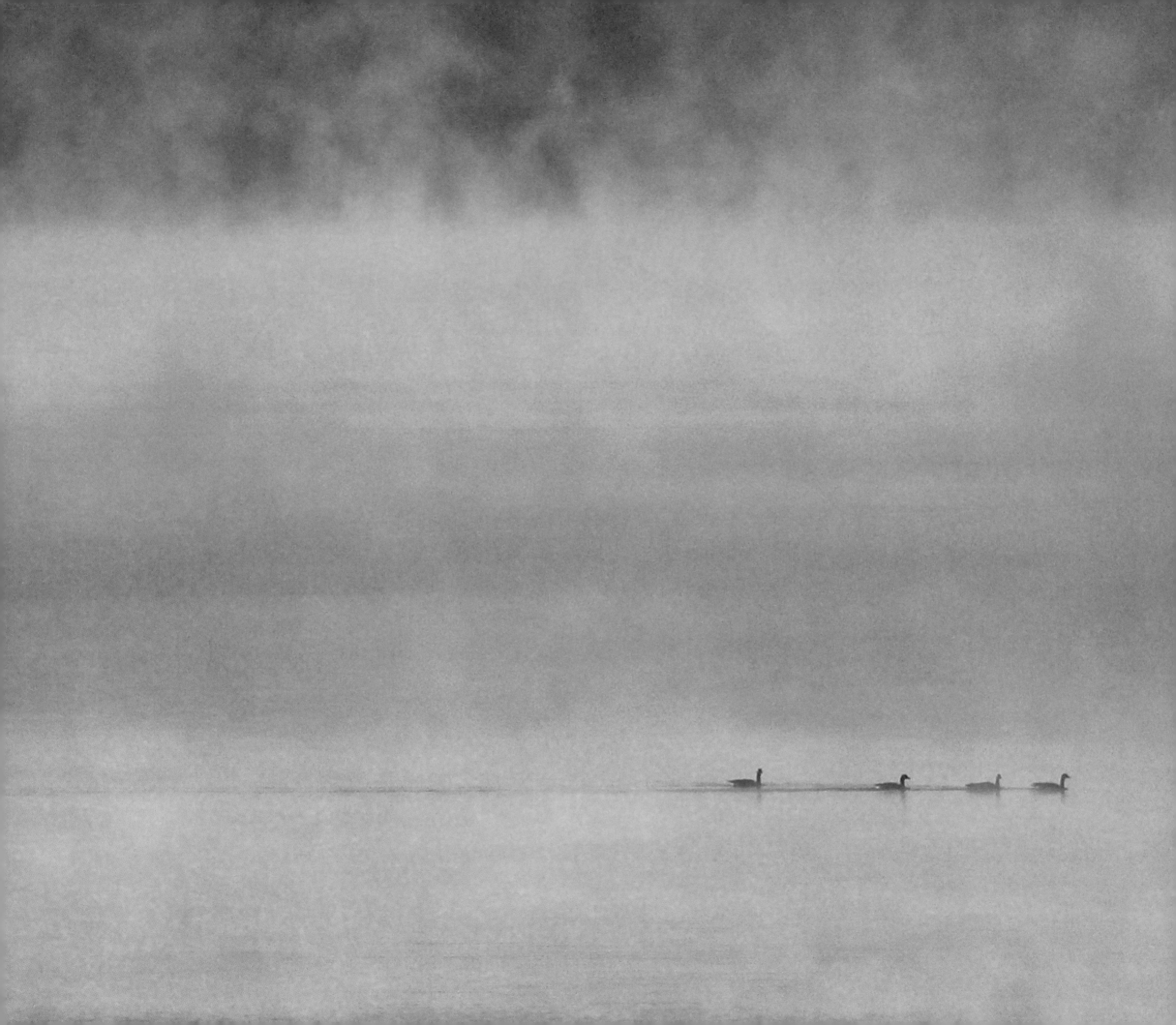

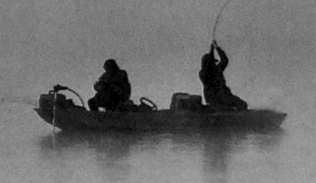

Good morning, indeed.

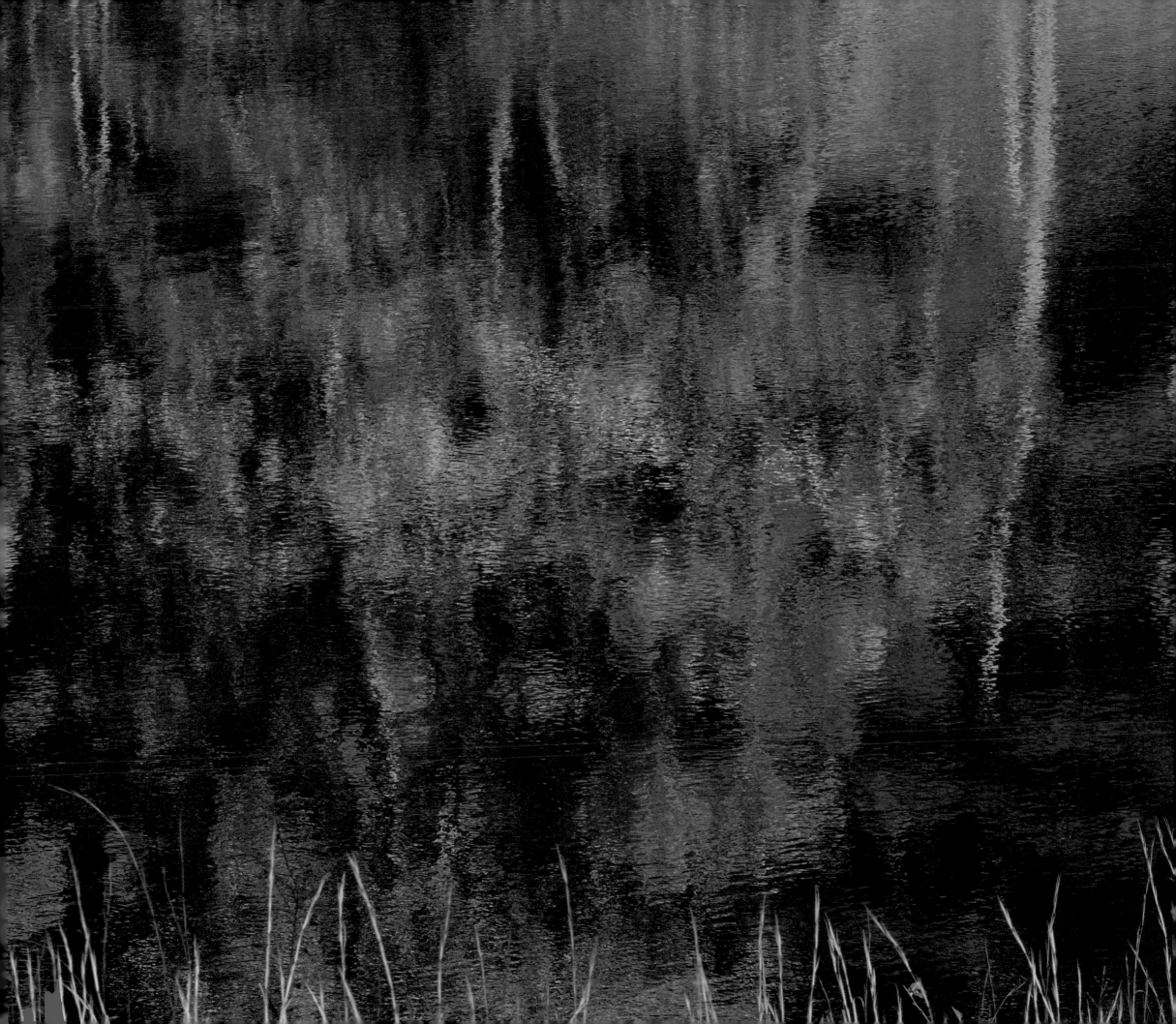

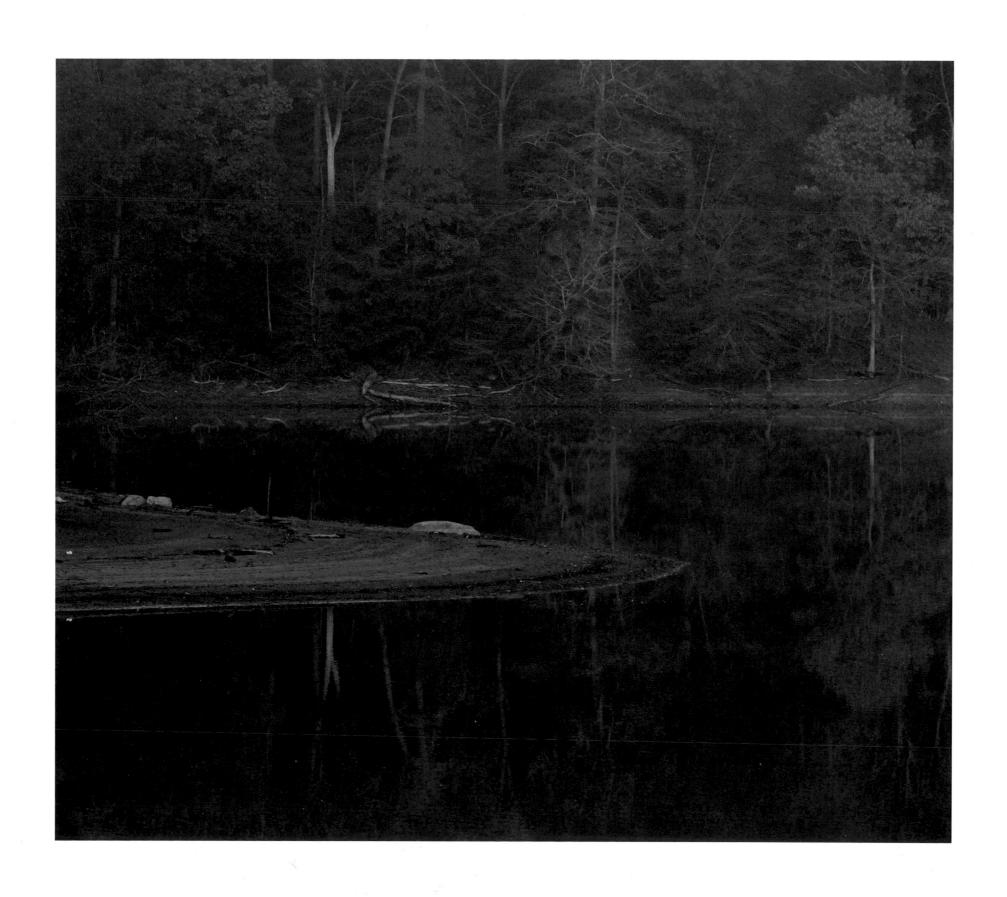

Autumn 2007 was not the most colorful Autumn but it was the most beautiful.
It was like nature put a burnt umber layer over the lens.

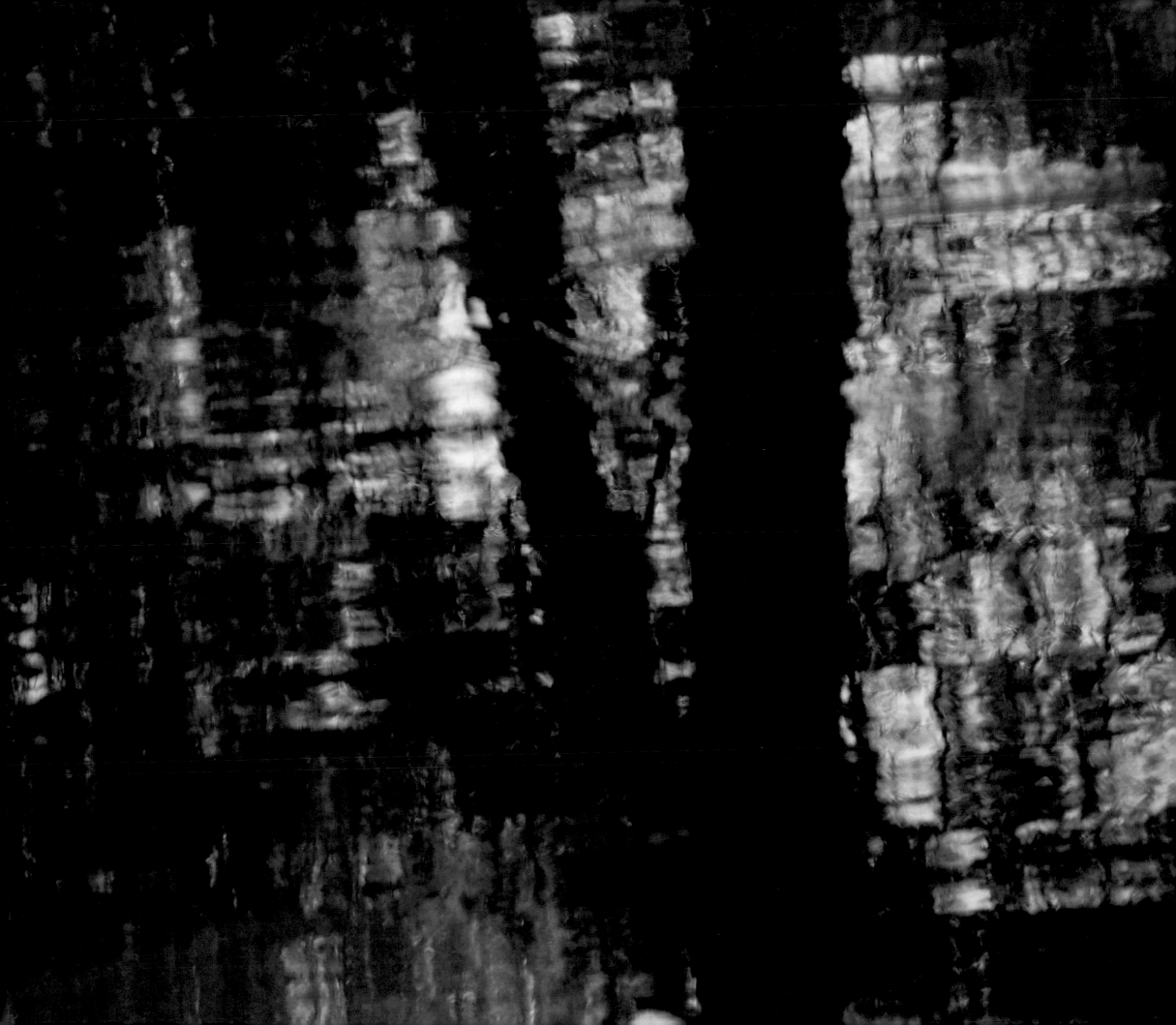

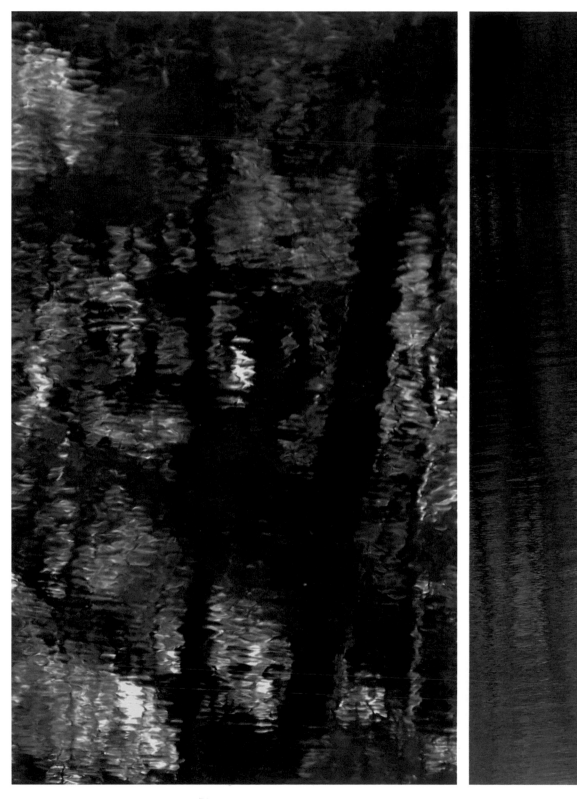
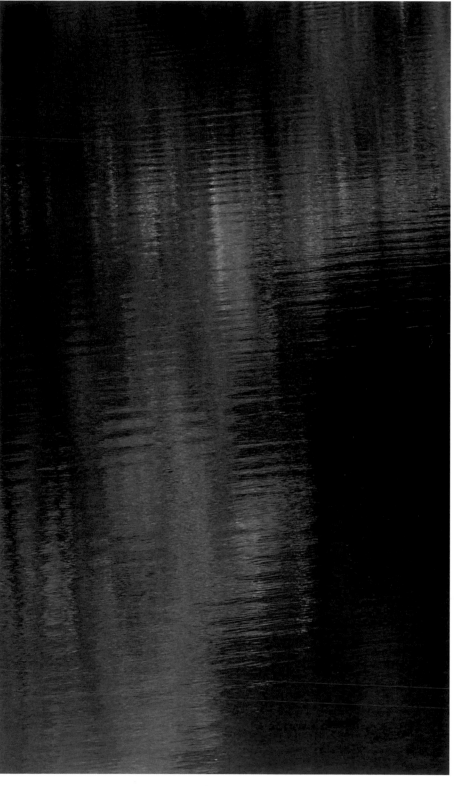

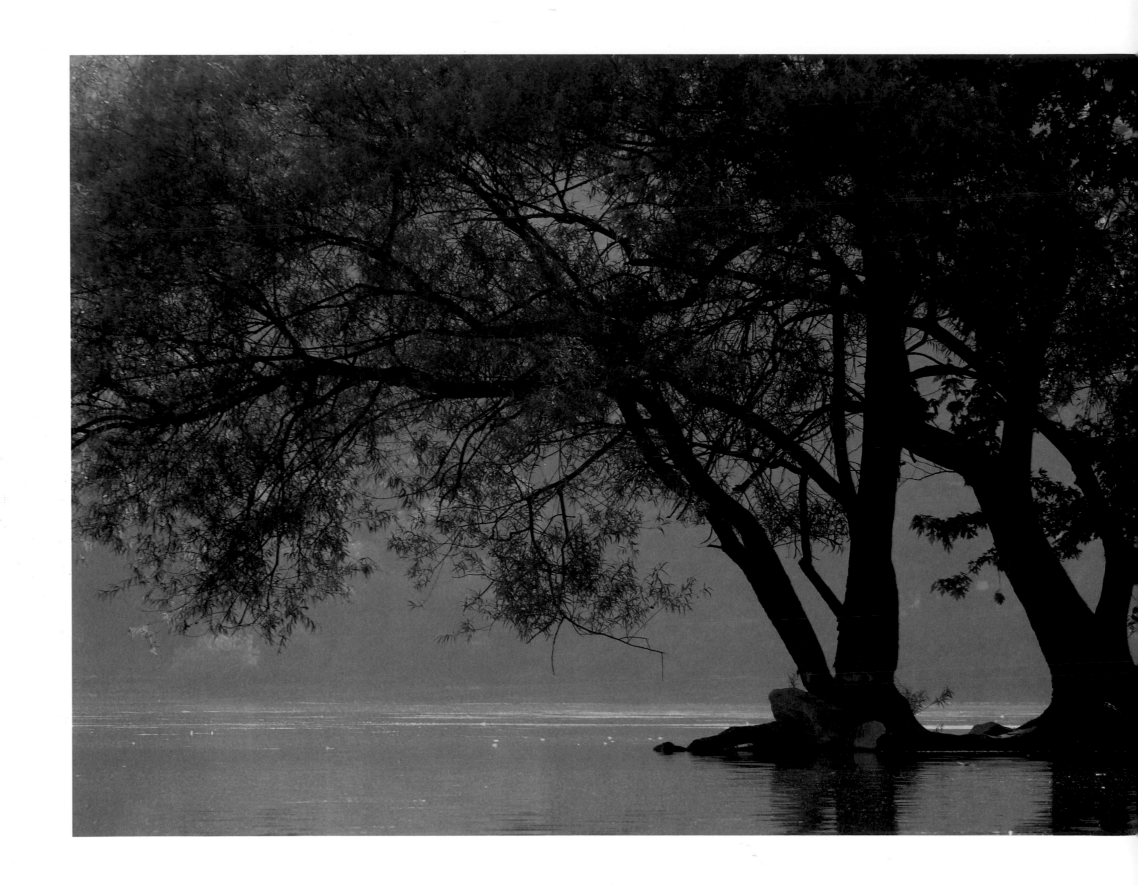

Loch Raven at kayak eye level.

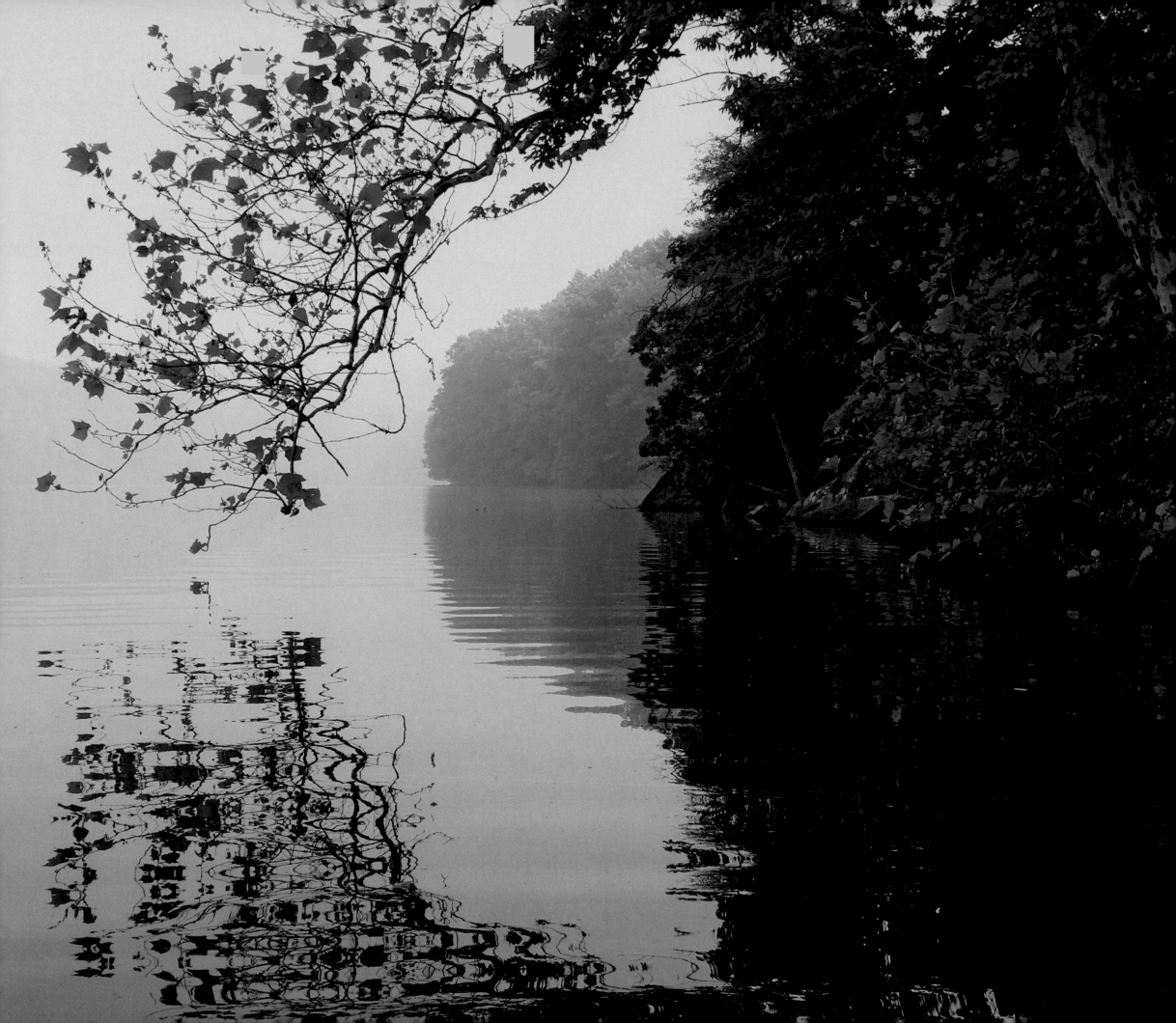

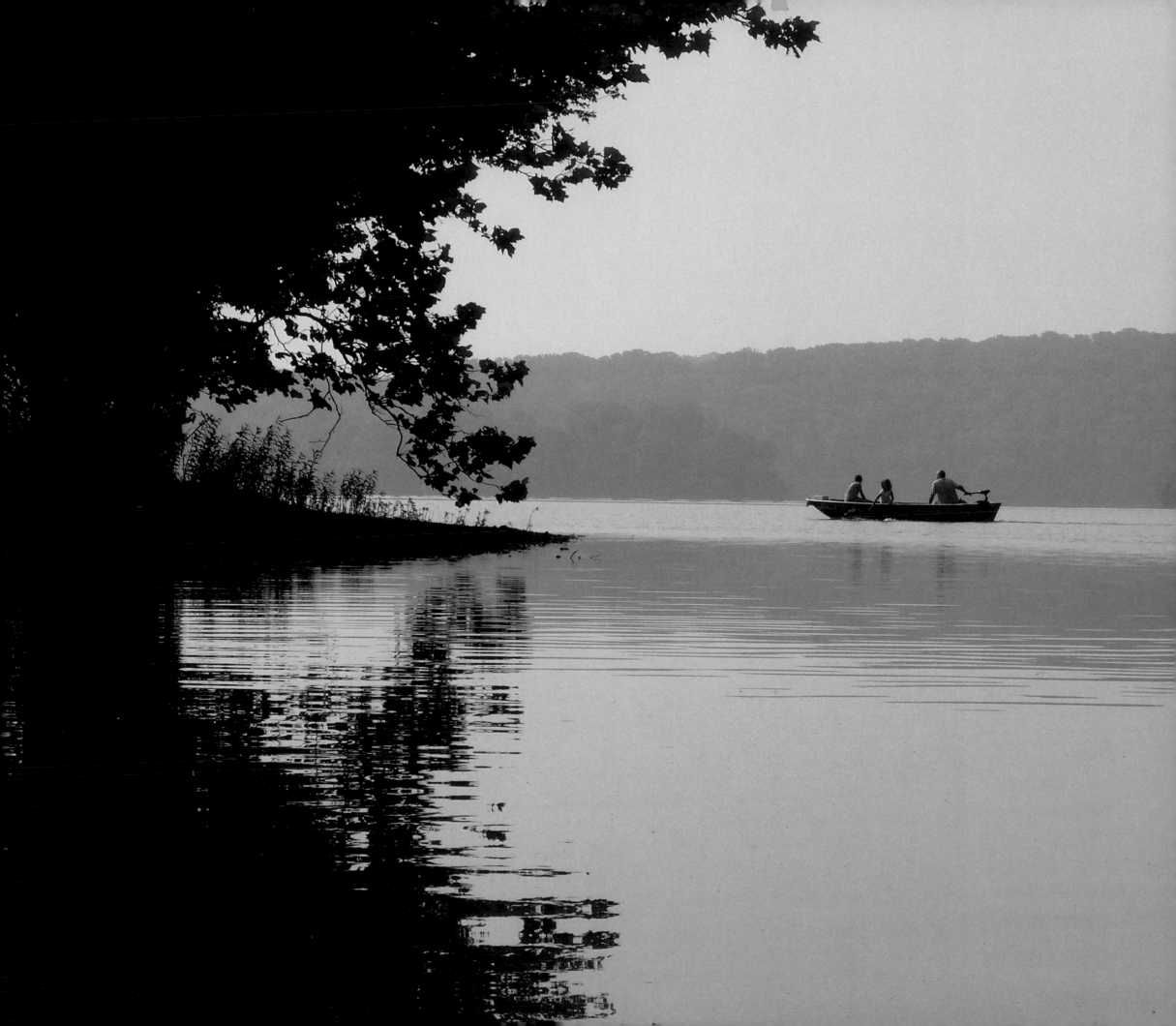

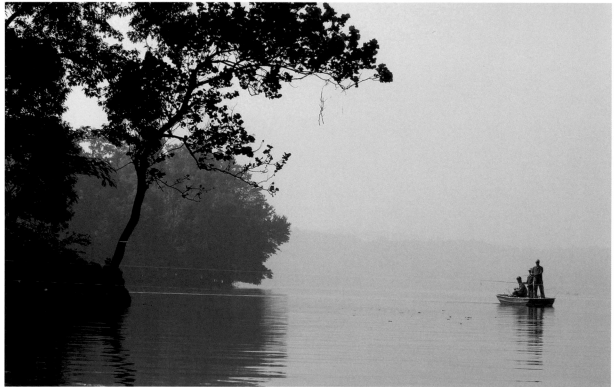

"Electric motors only." In truth, canoe paddles are actually louder.

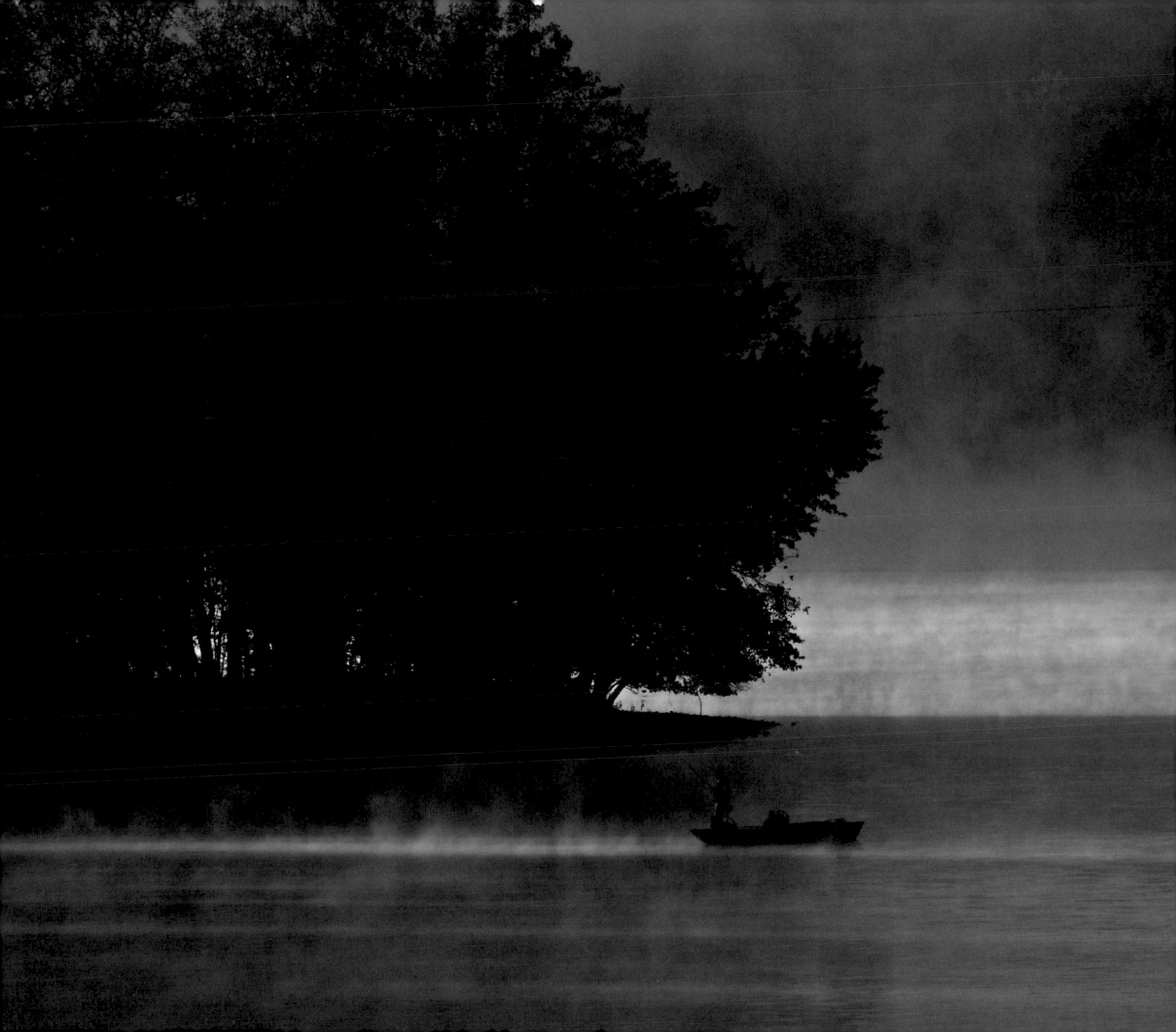

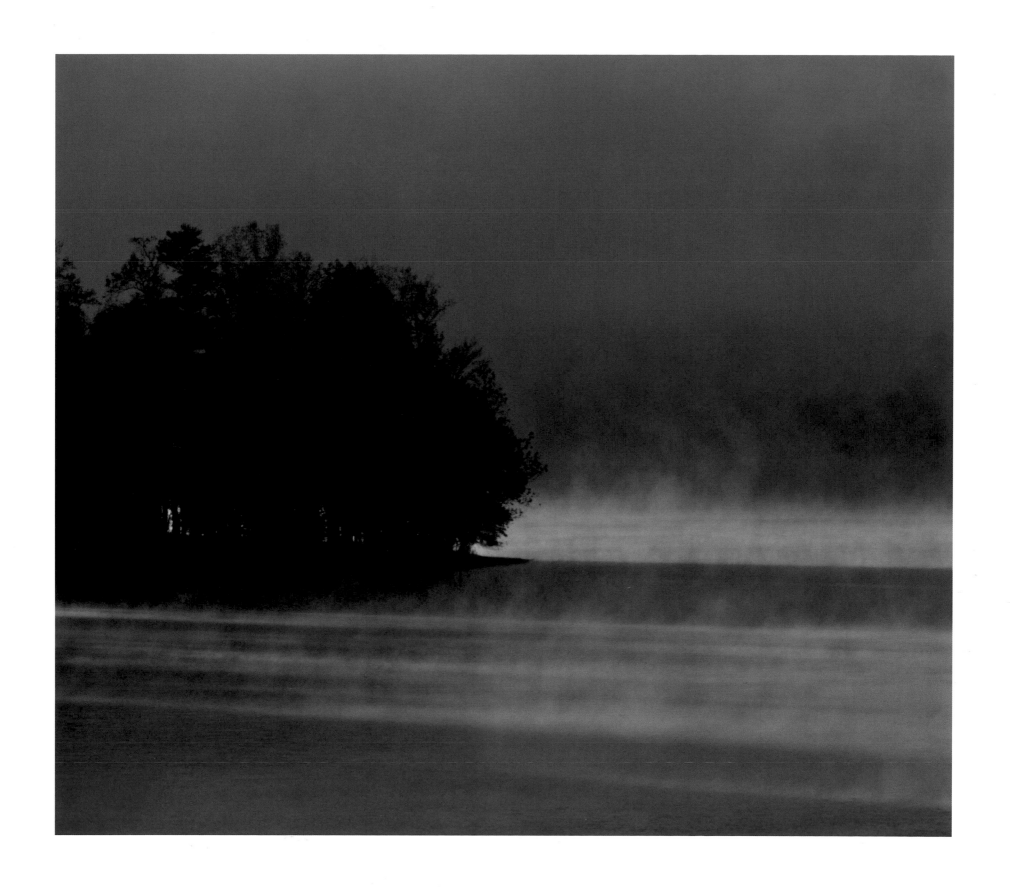

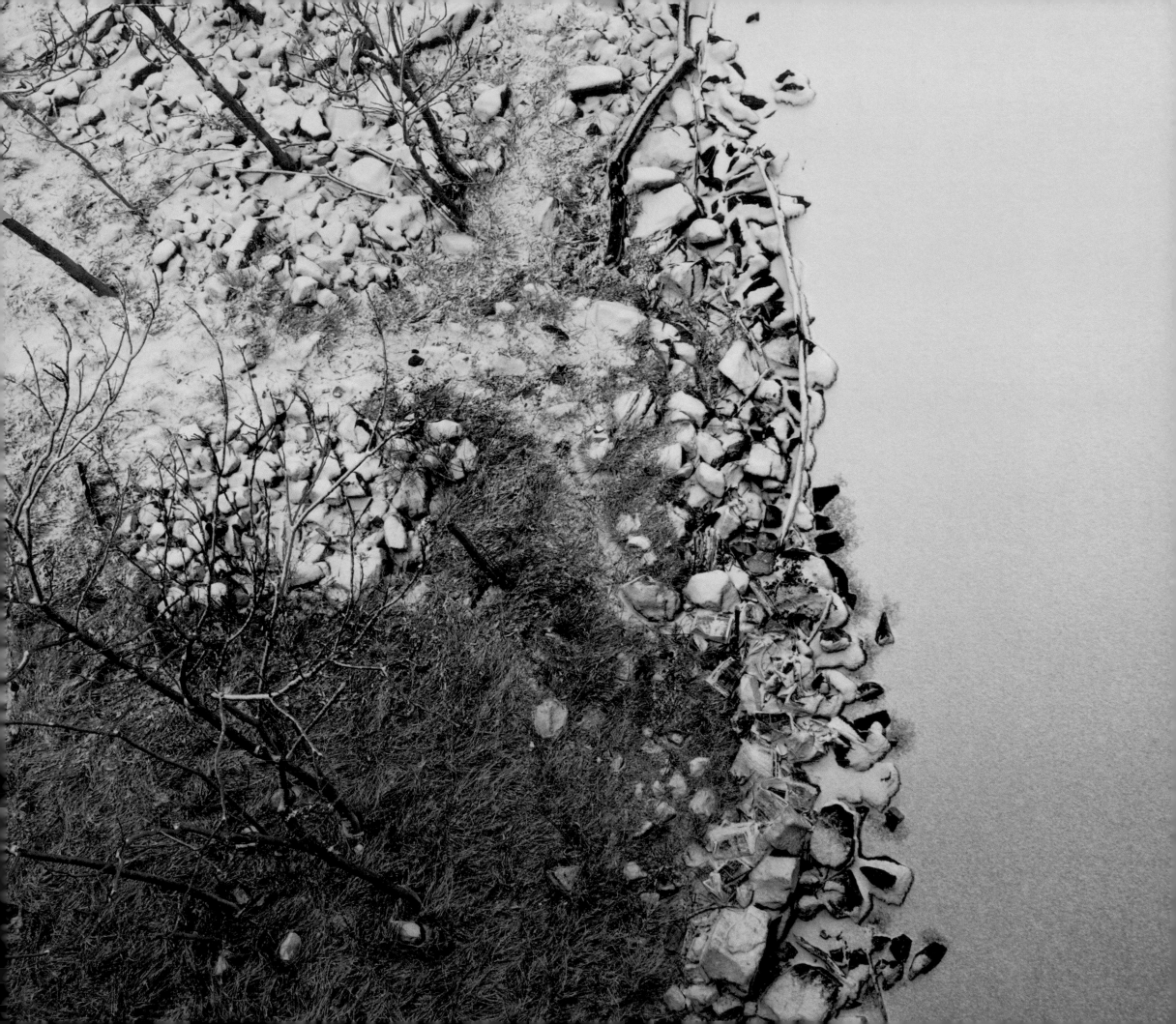

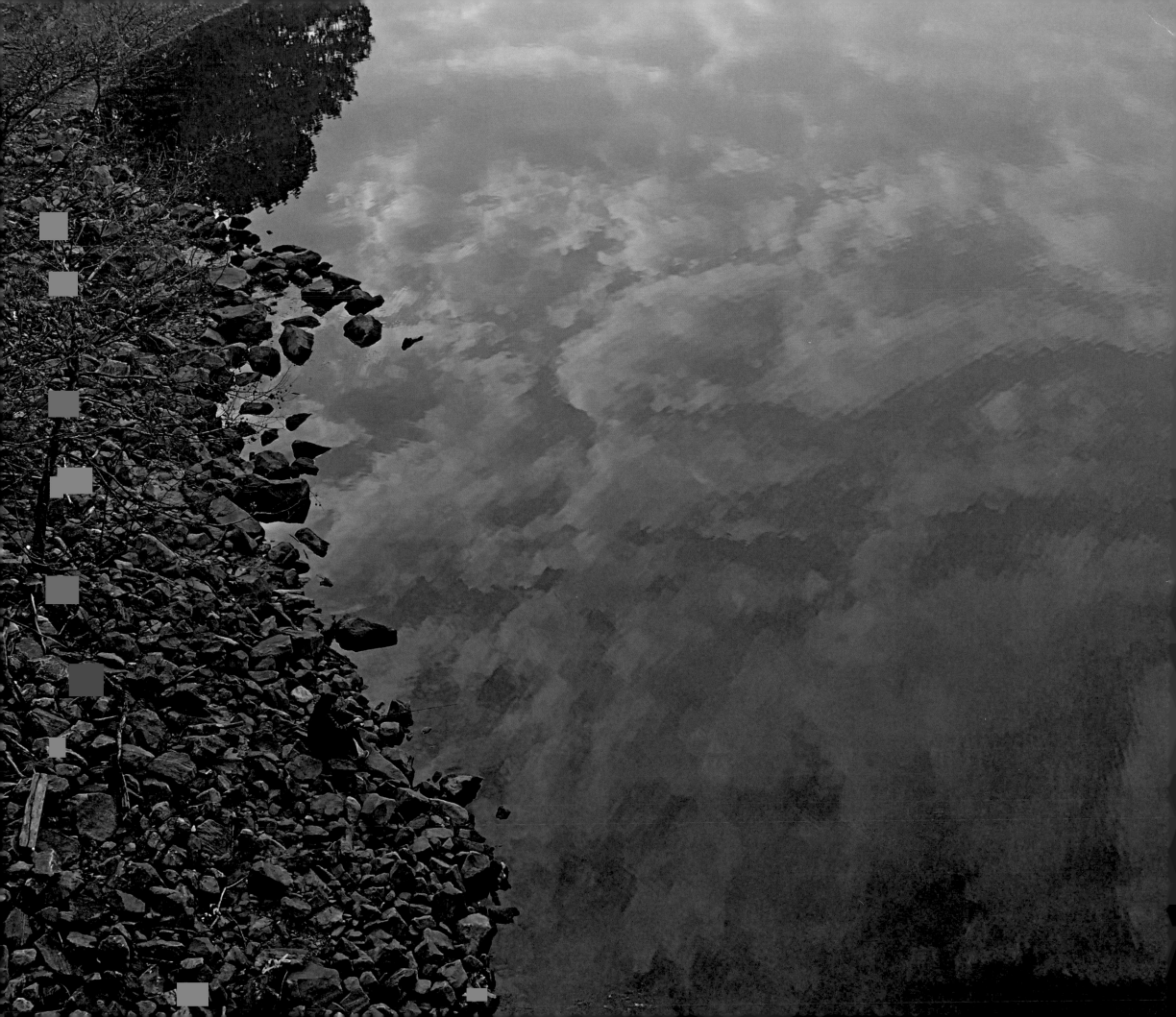

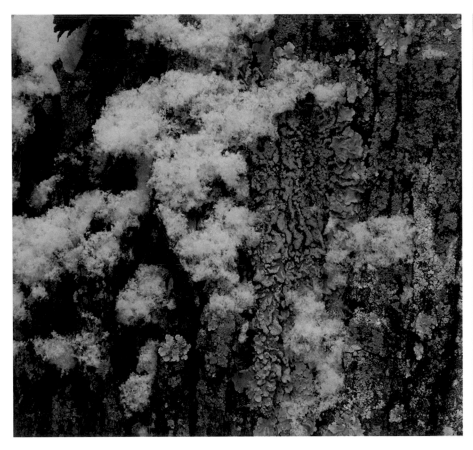

First snowfall of '09. The water hadn't frozen over in years. Took this on my way back from a business meeting. Not dressed to get theses photographs. Resulting in first chest cold of '09.

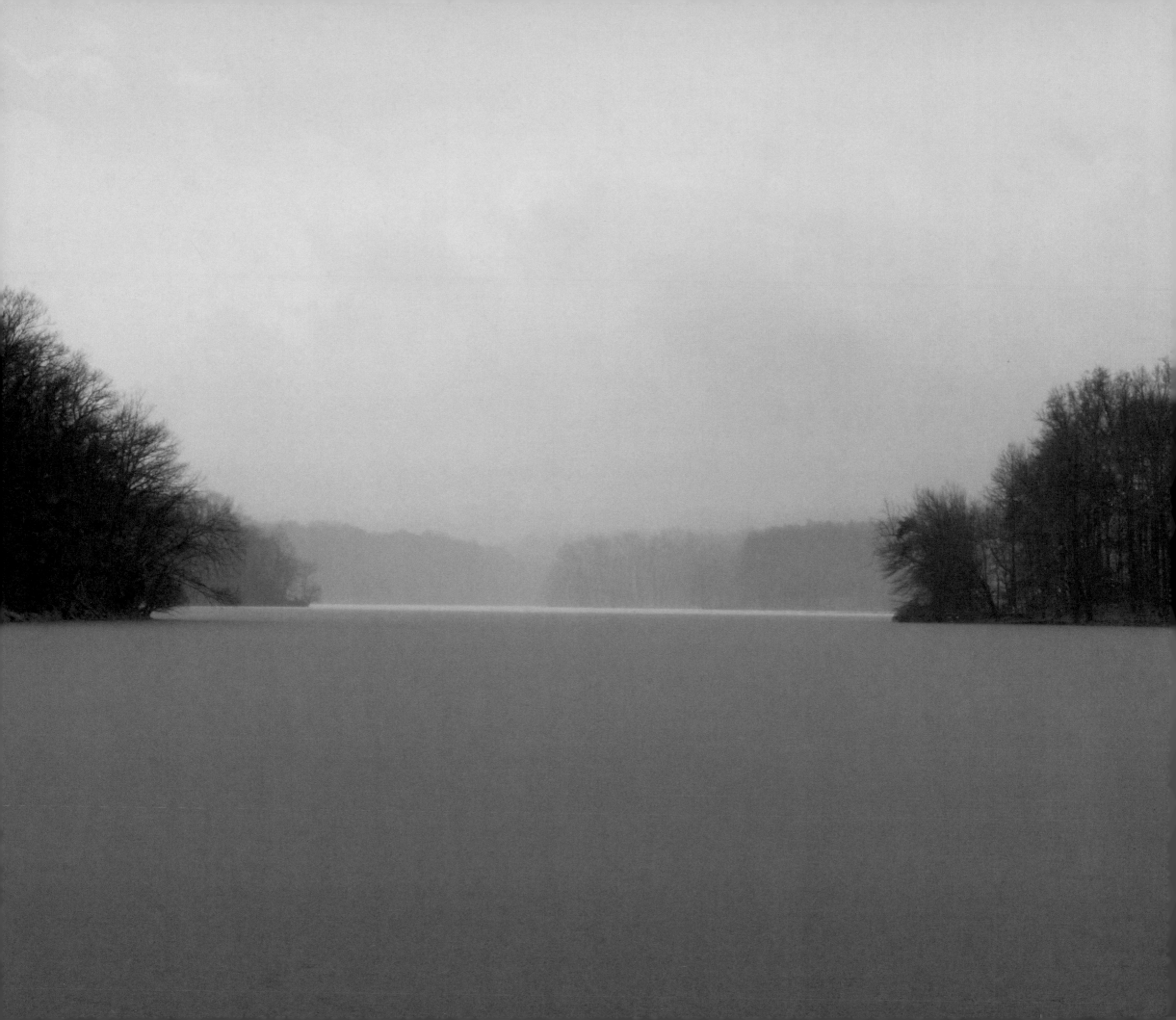

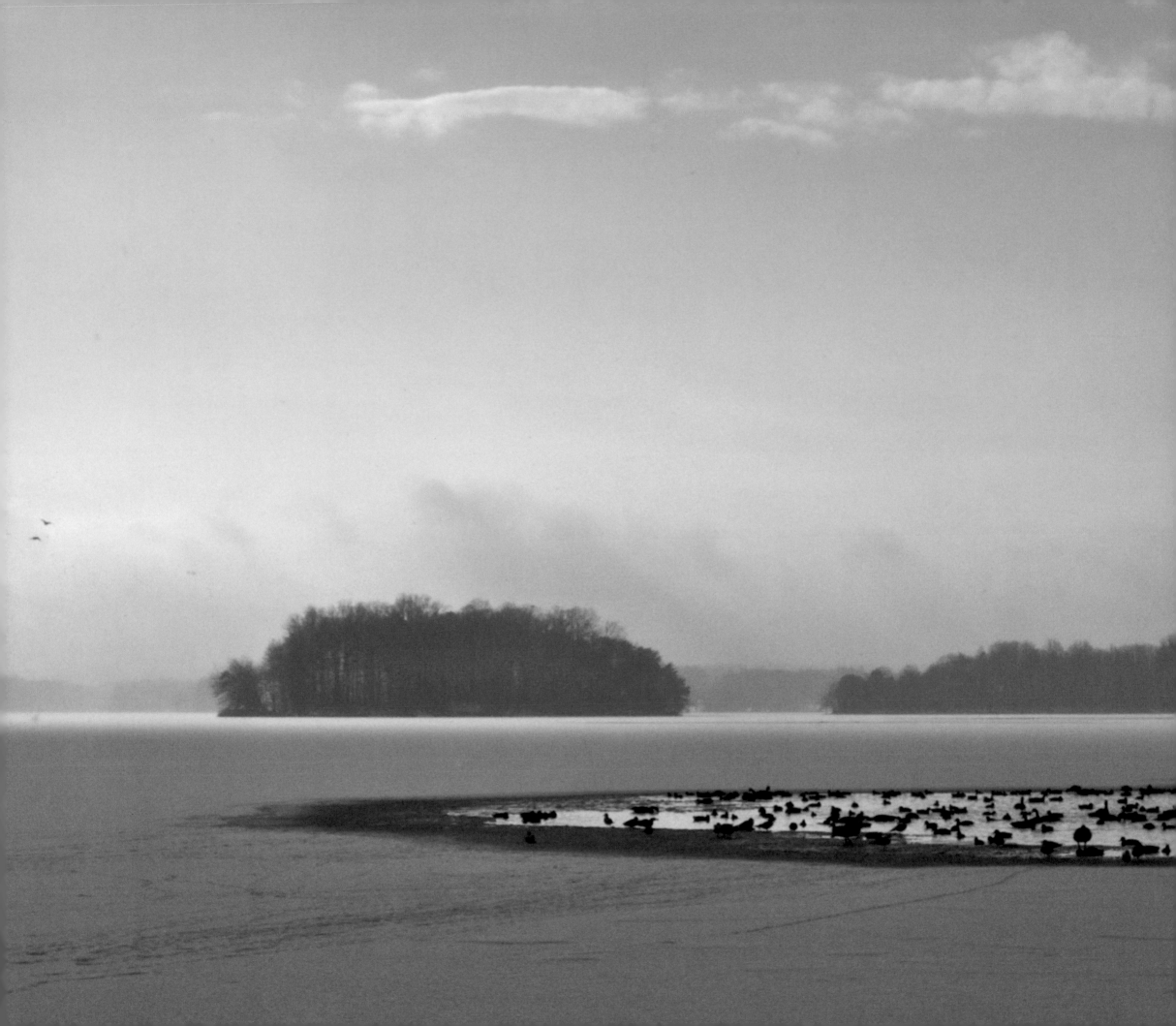

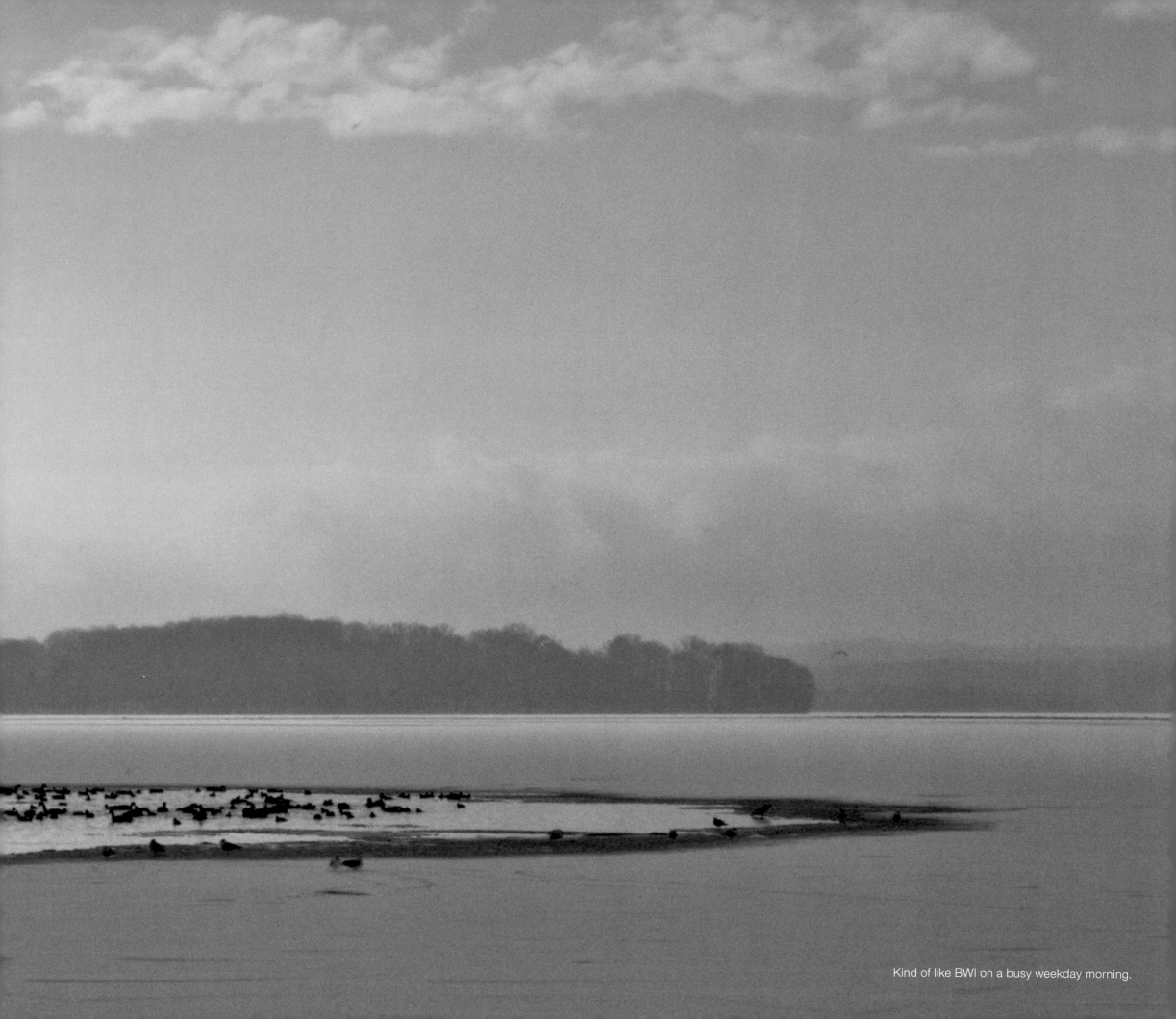

Kind of like BWI on a busy weekday morning.

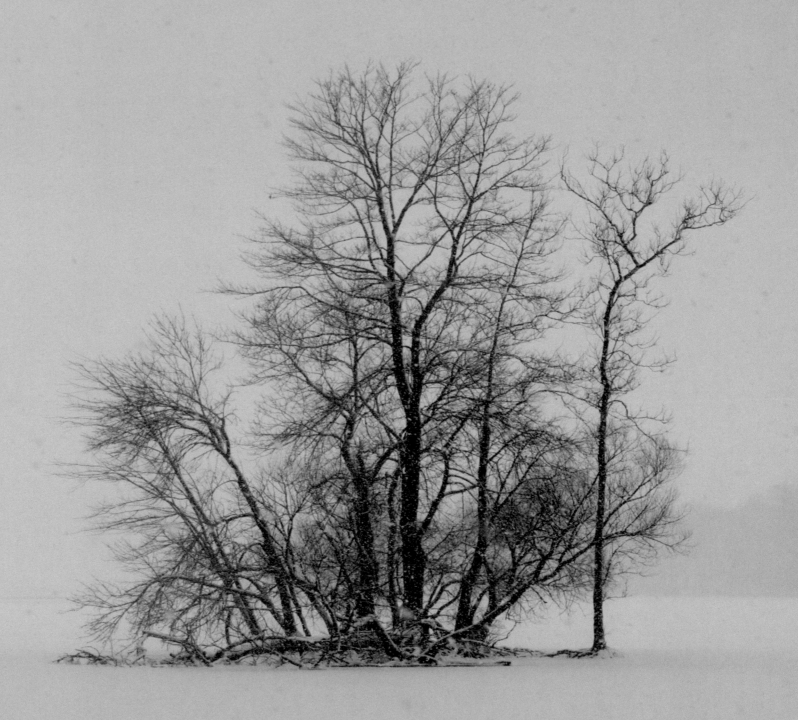

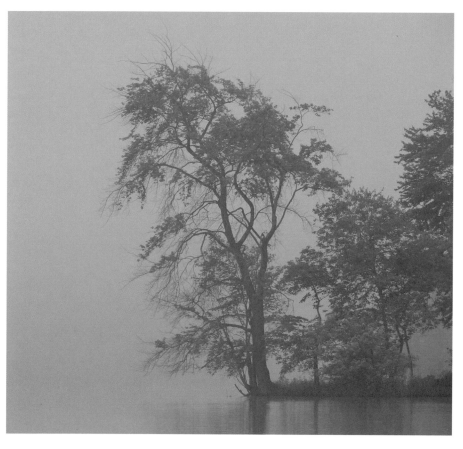 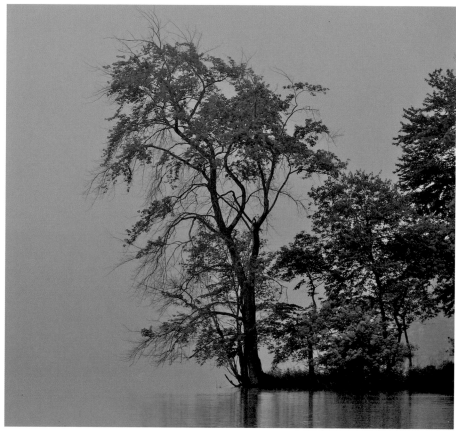

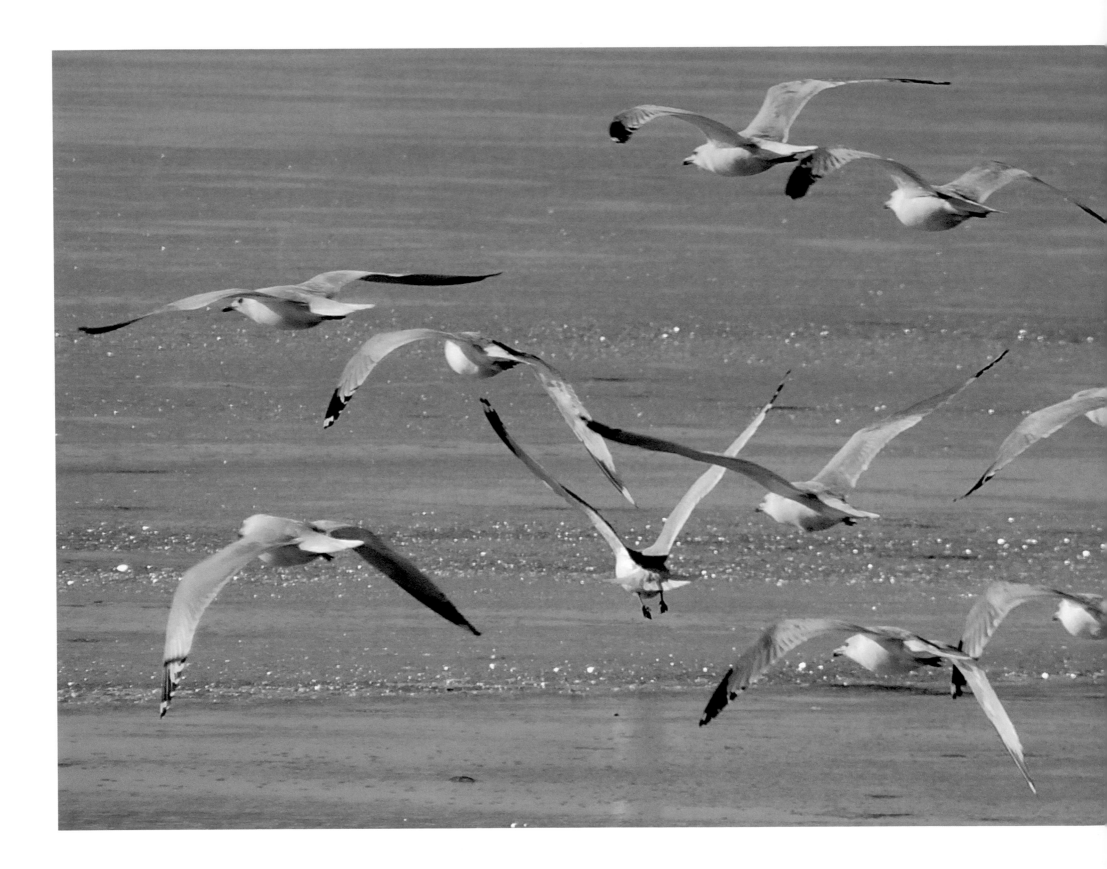

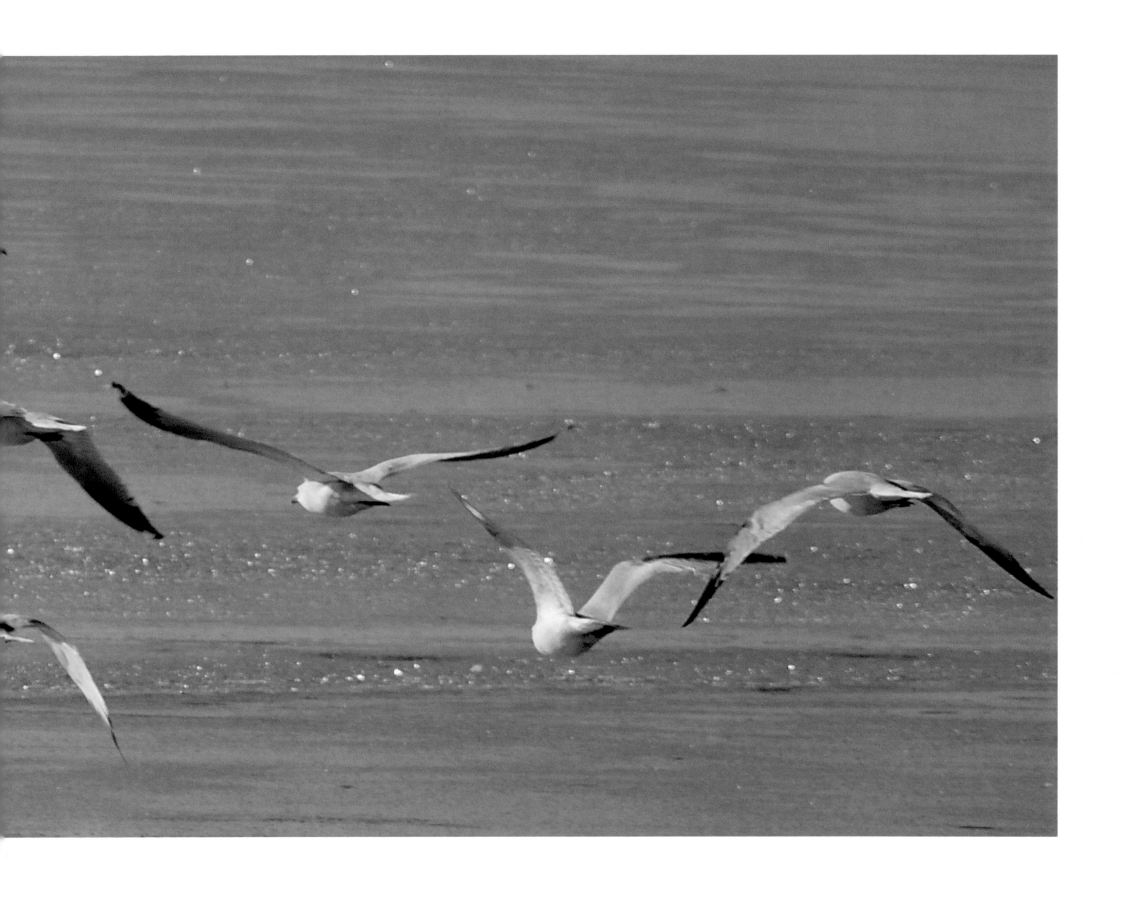

If Carl Sandberg had been a photographer. Nearly poetic.

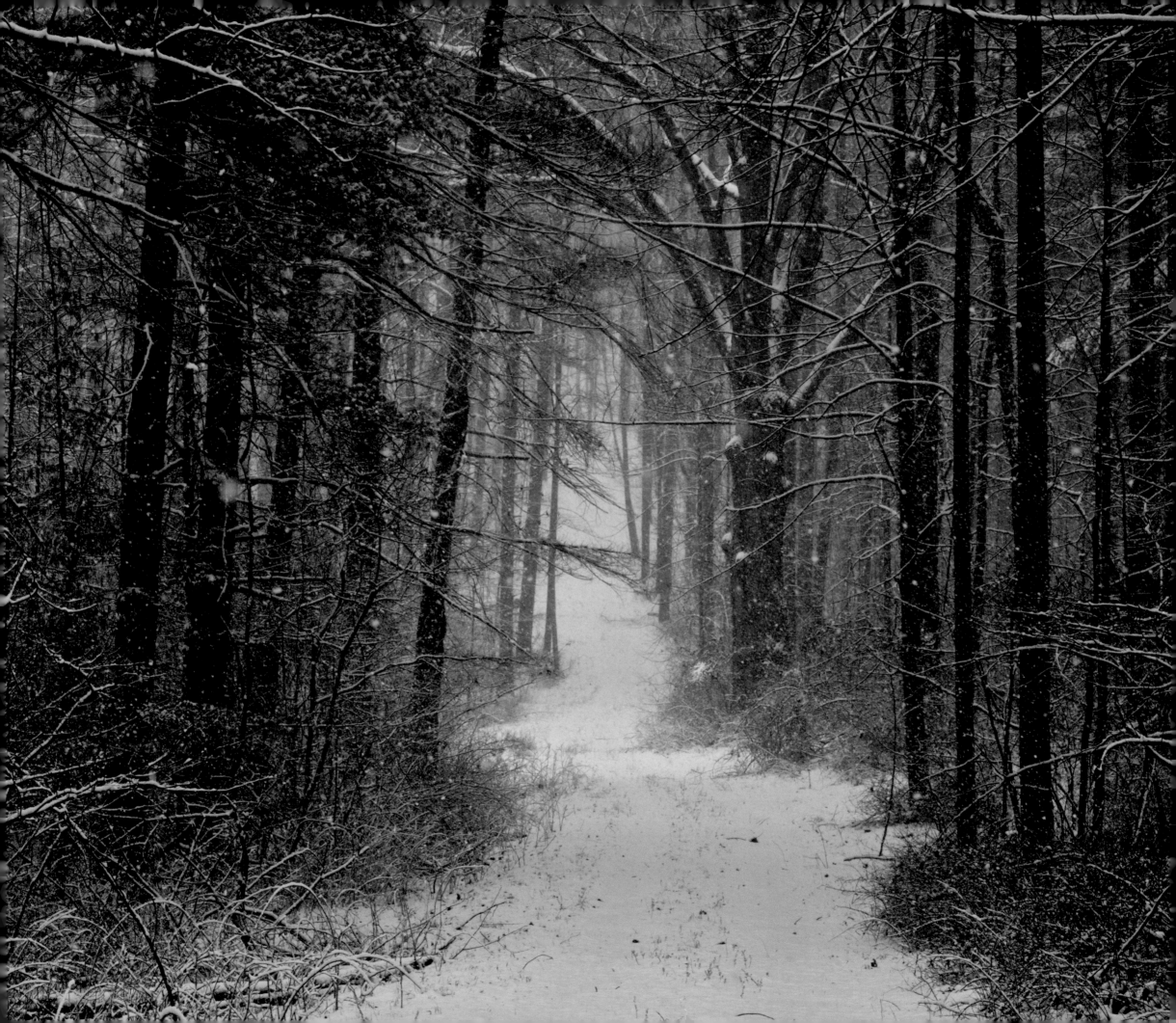

Photographer's dream.

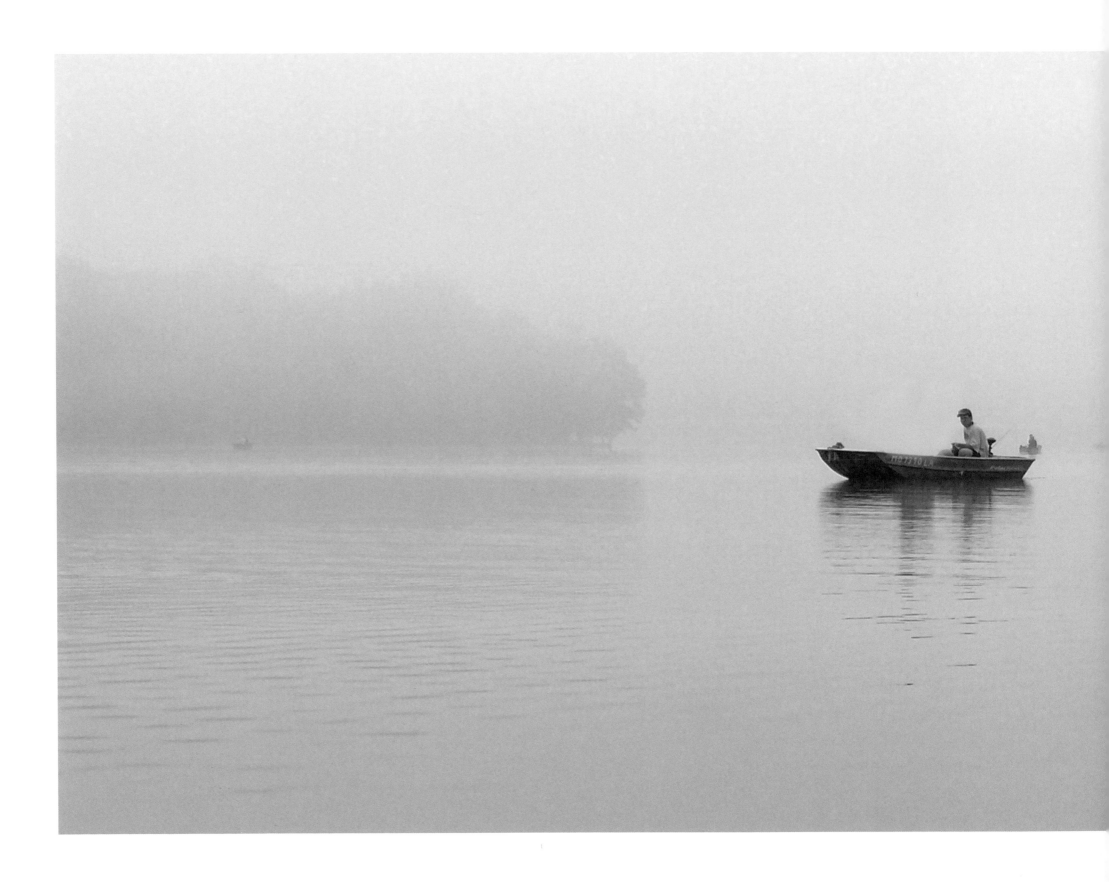

Hot, muggy, 95°+.
I circled and he posed — what a model.

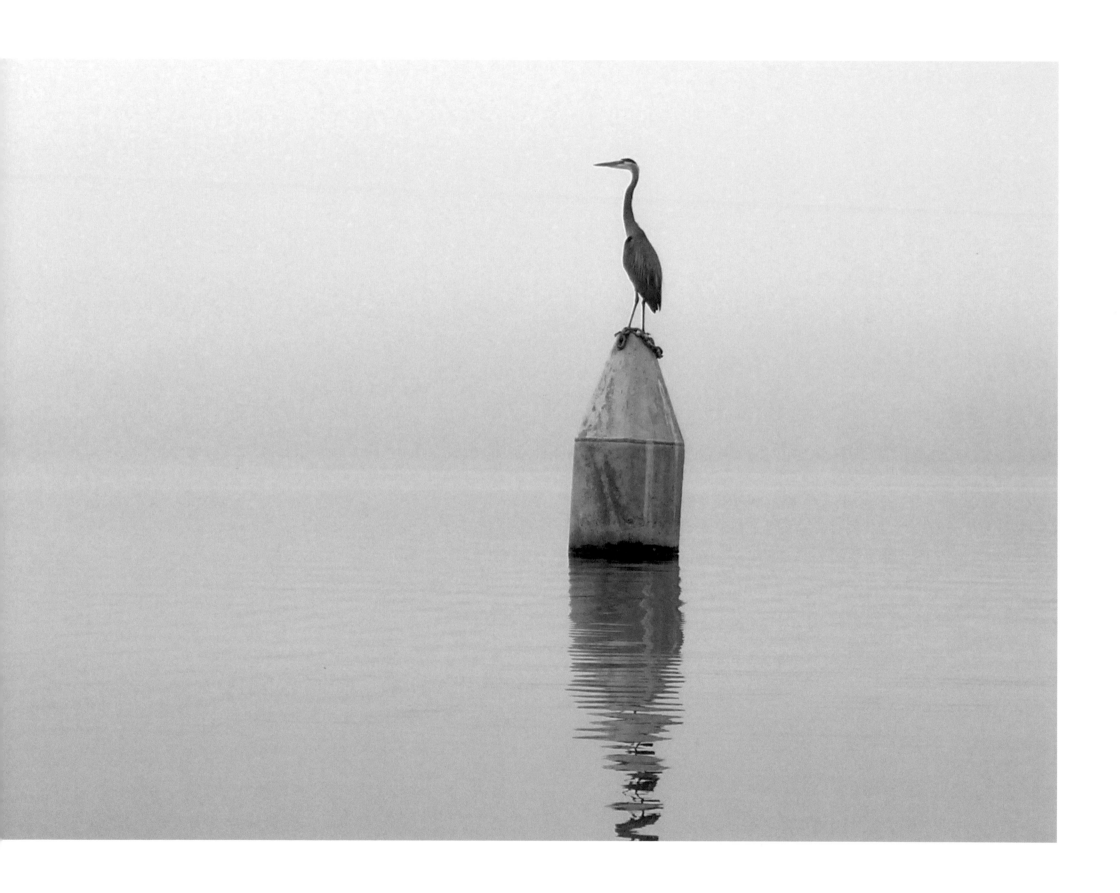

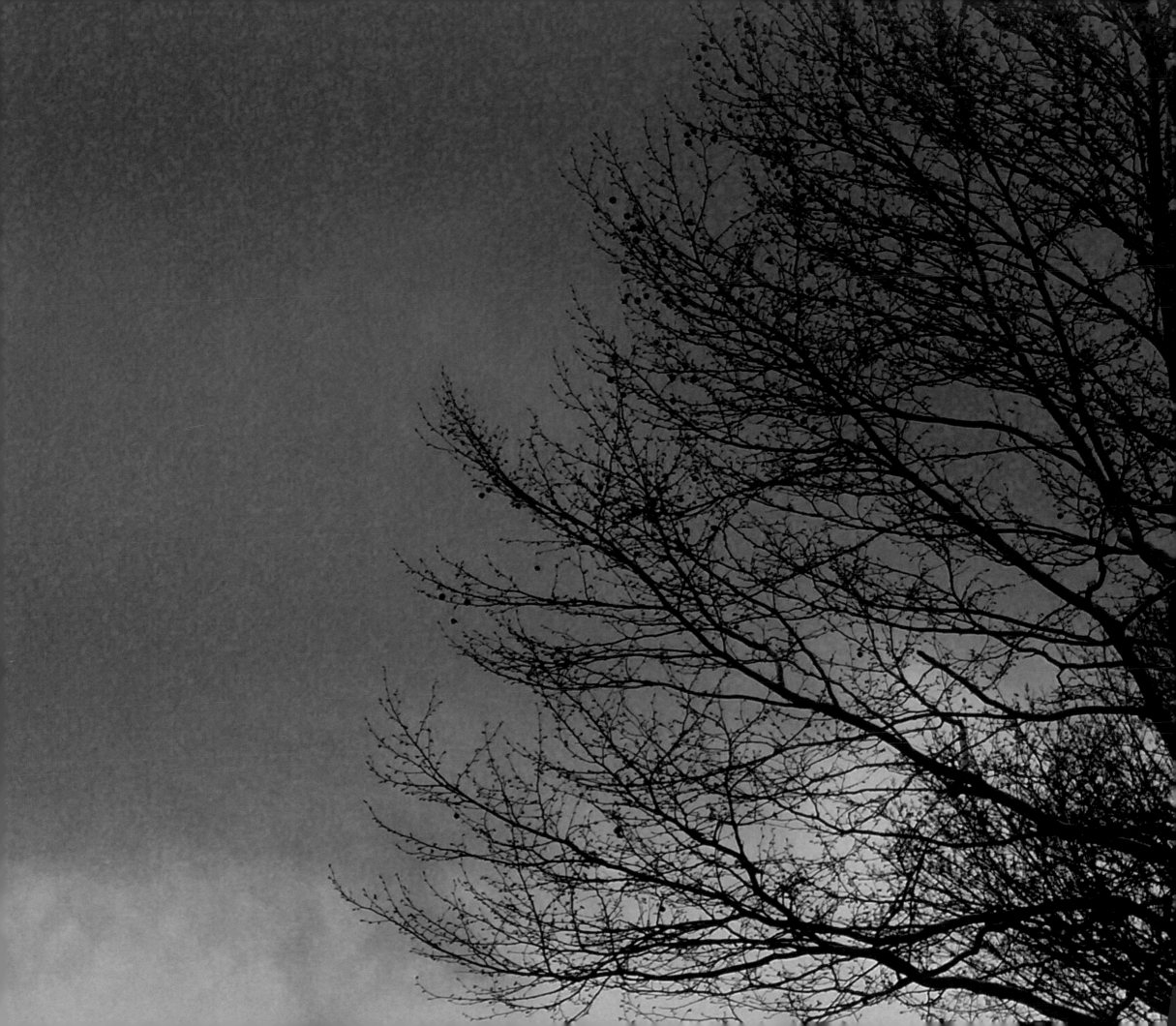

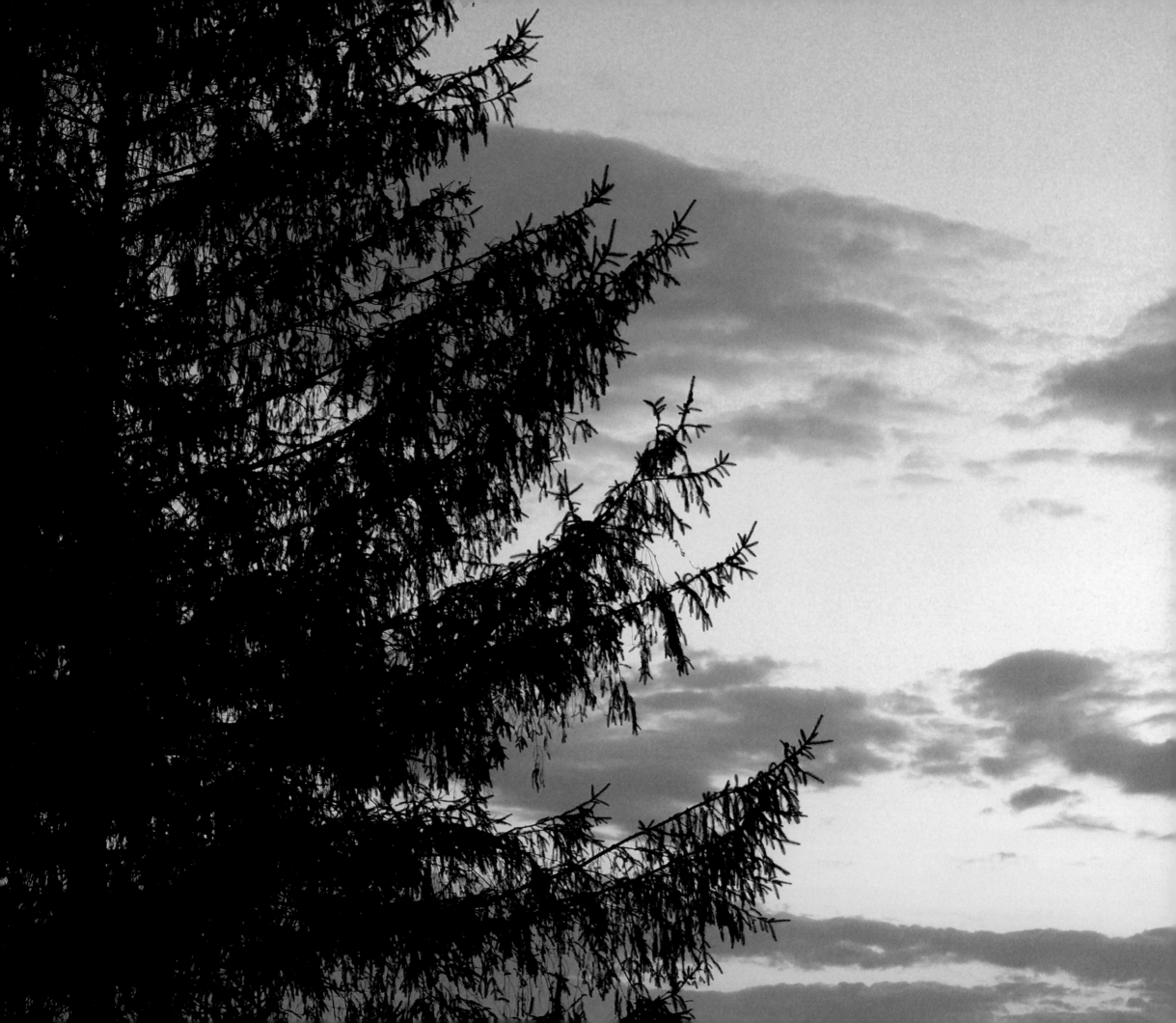

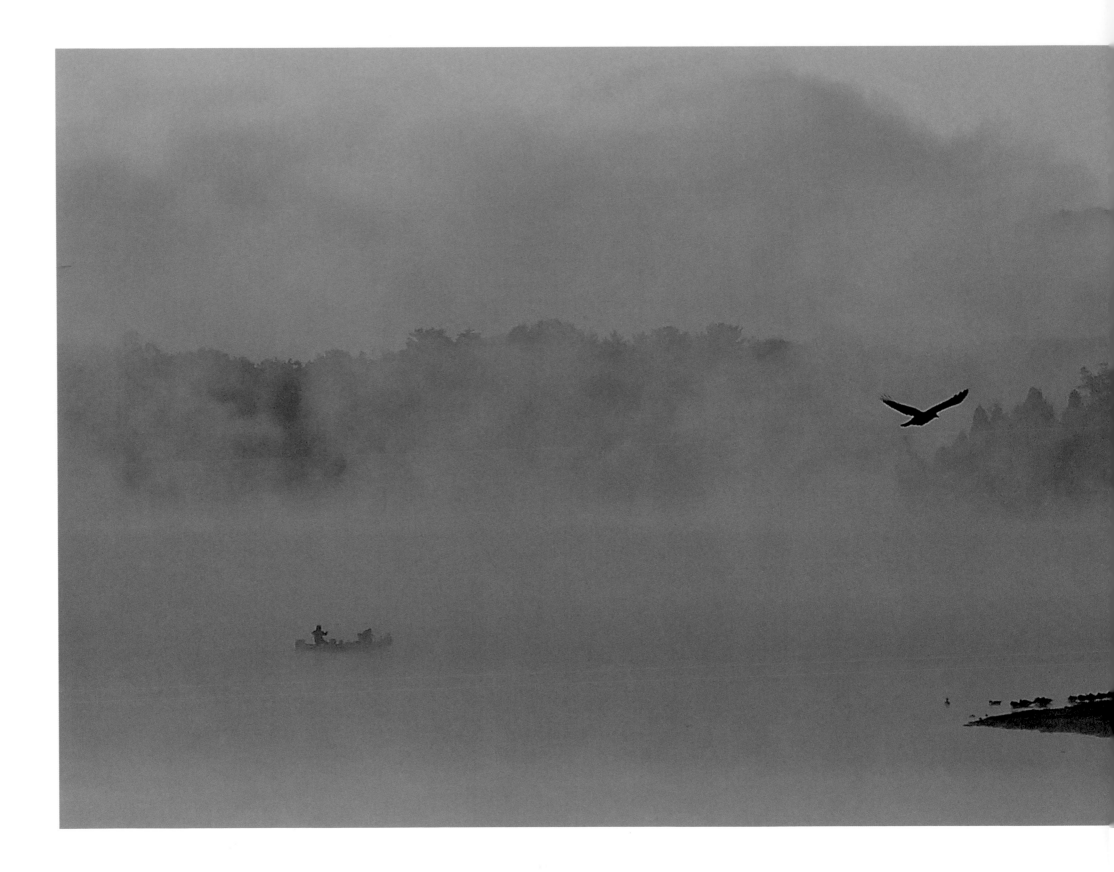

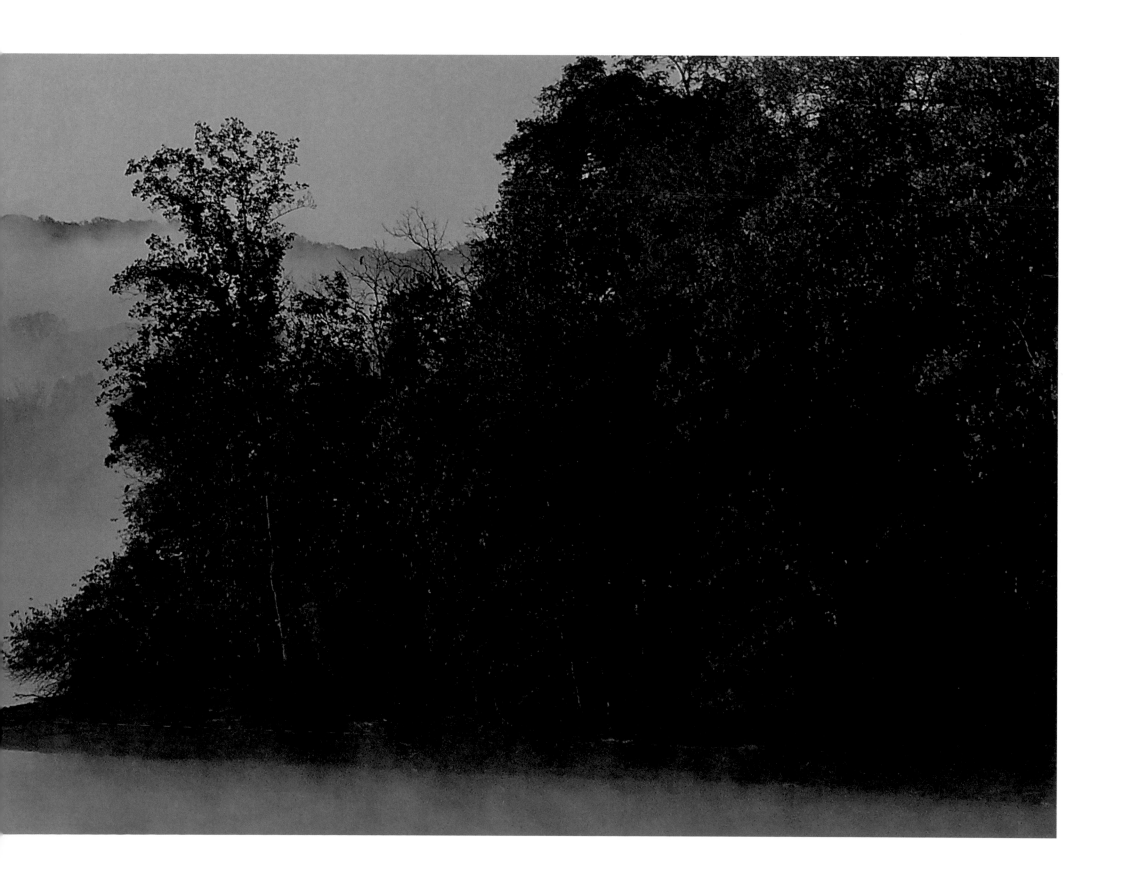

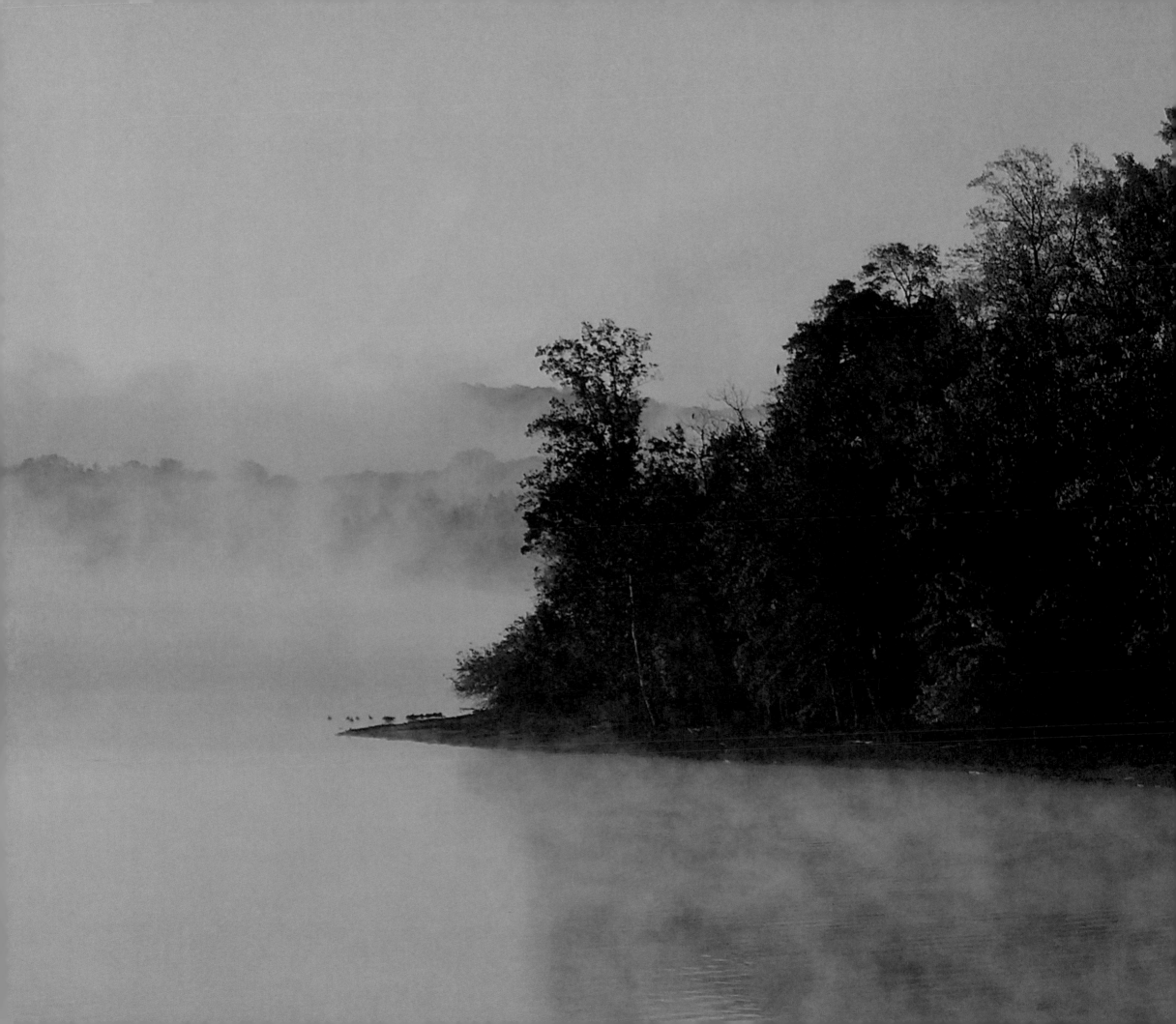

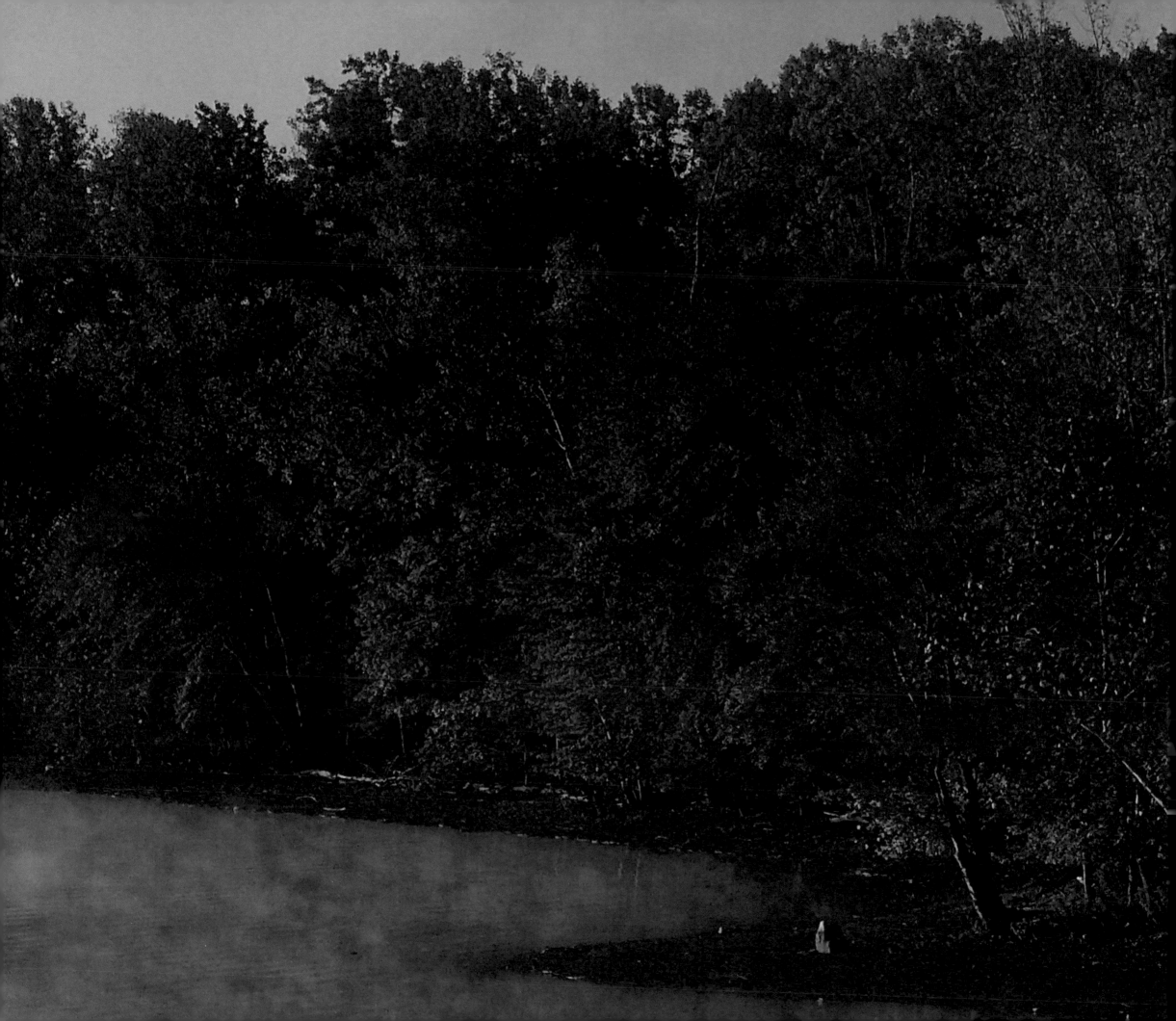

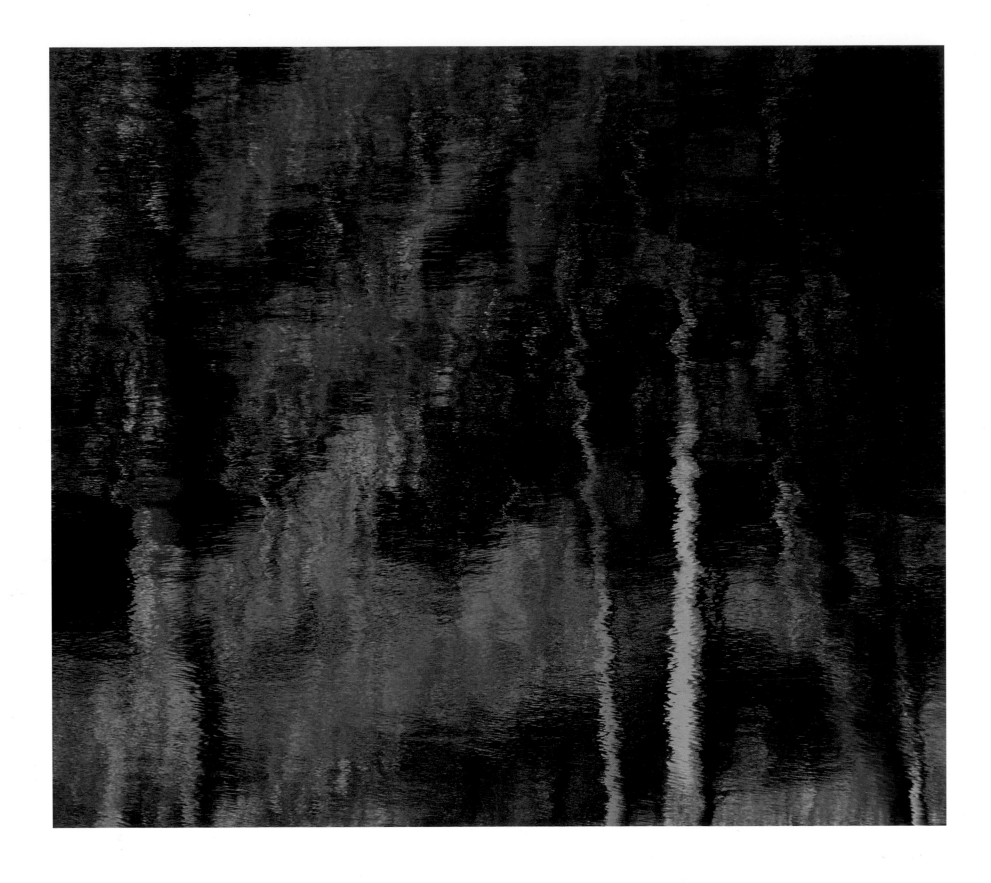

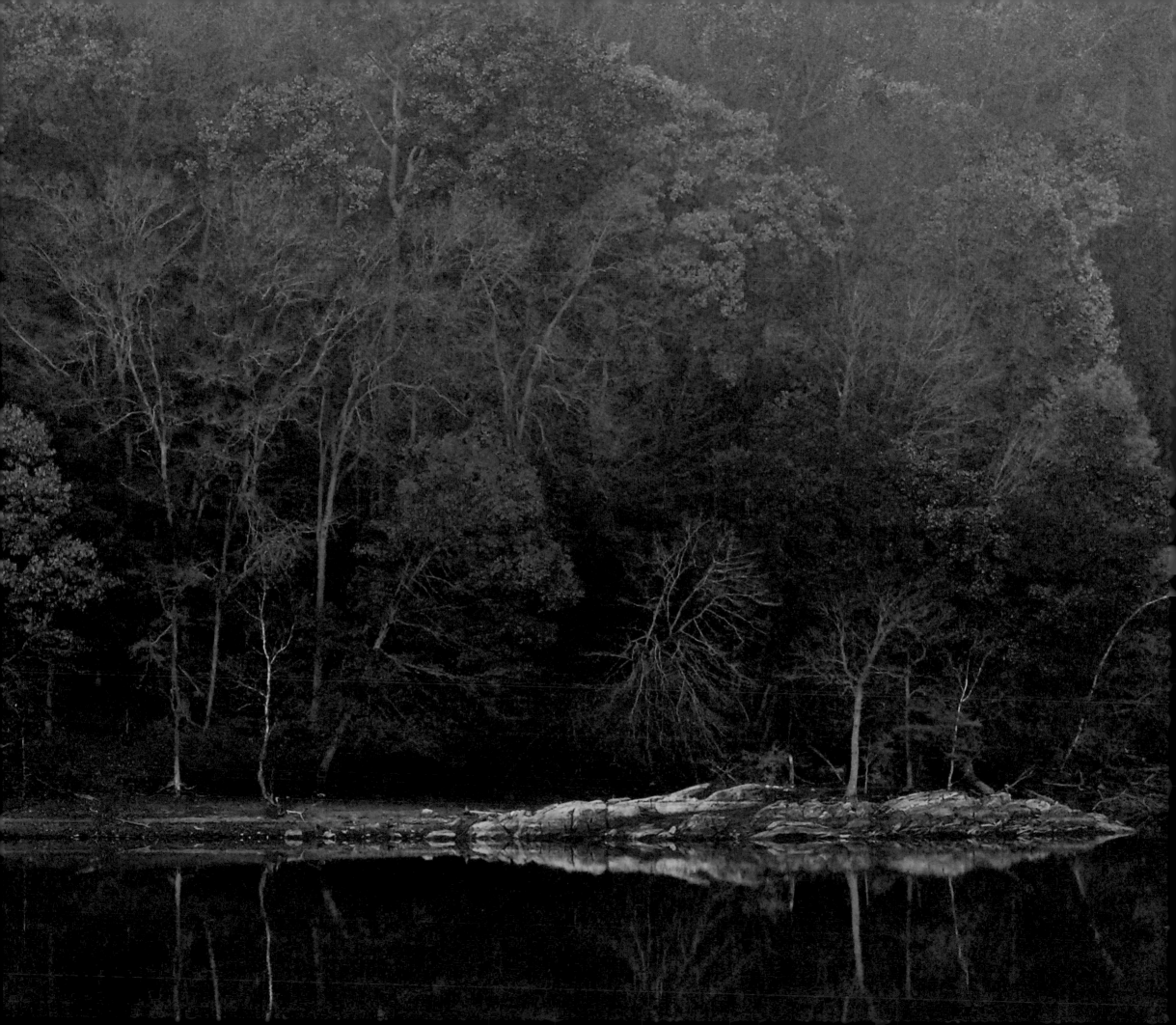

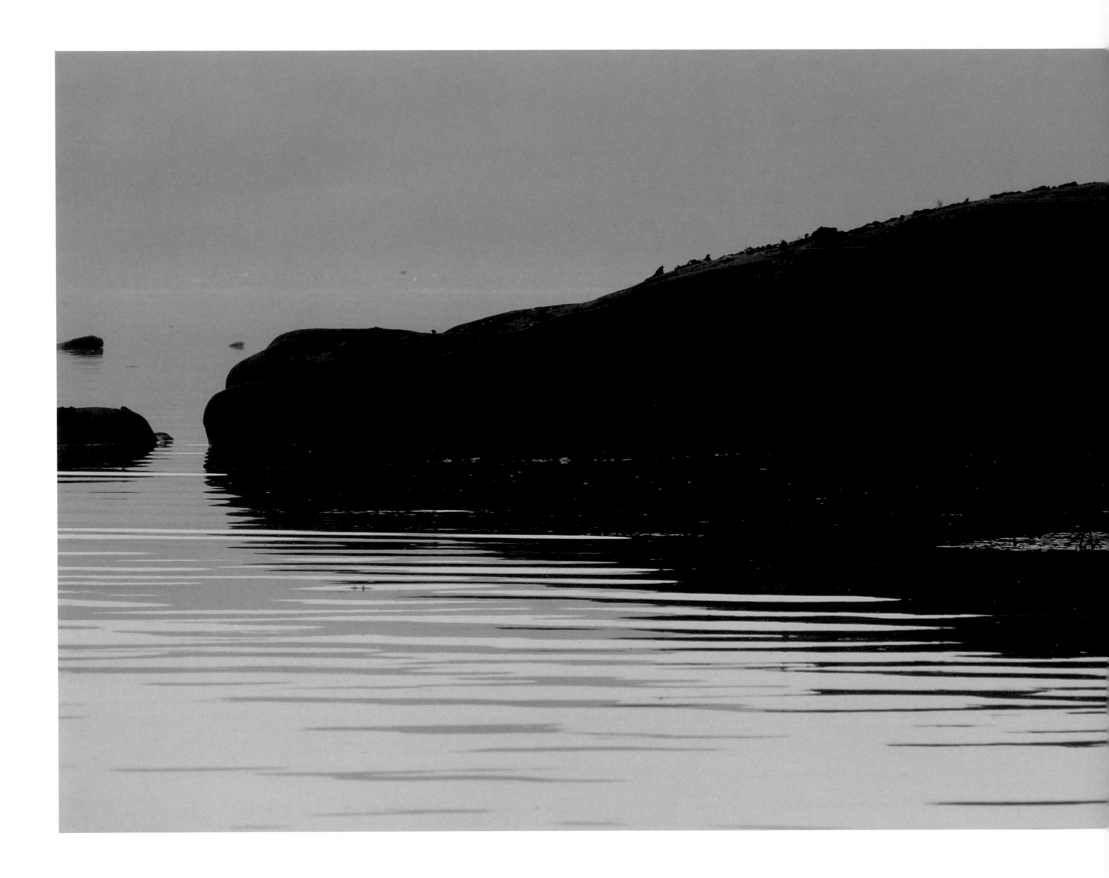

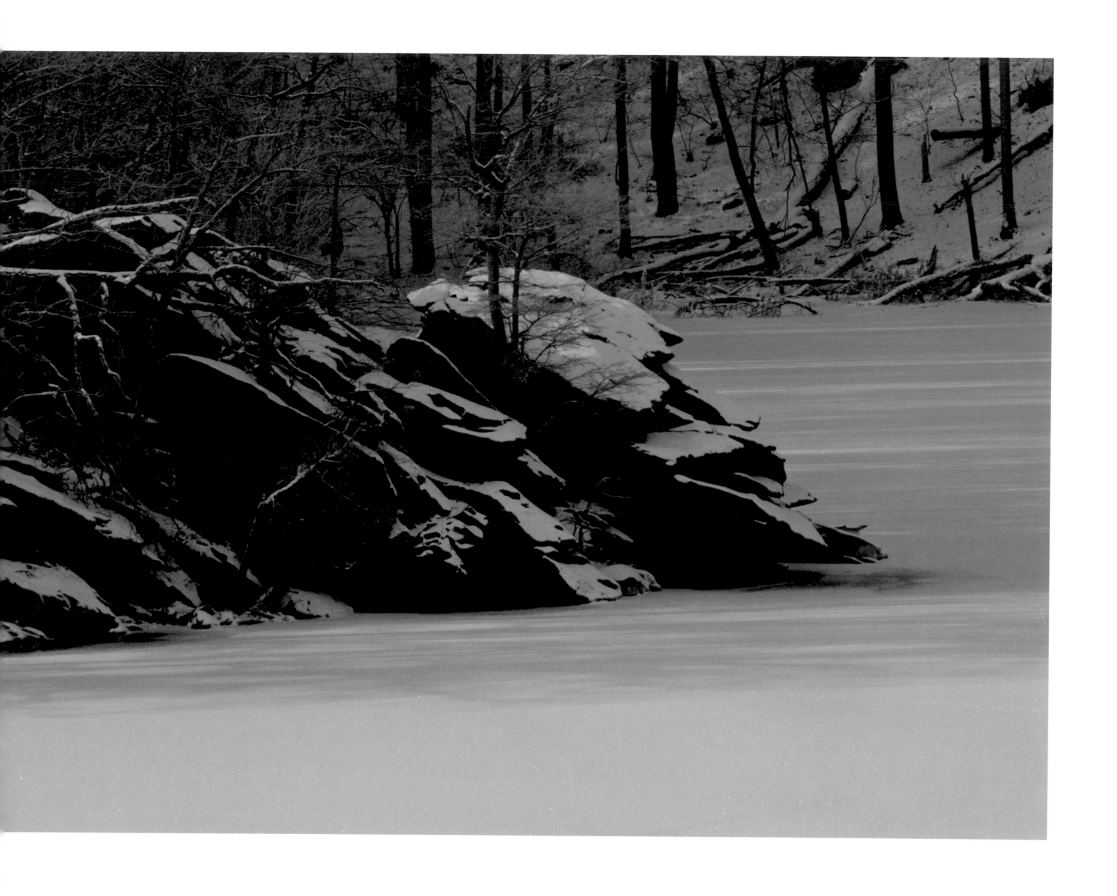

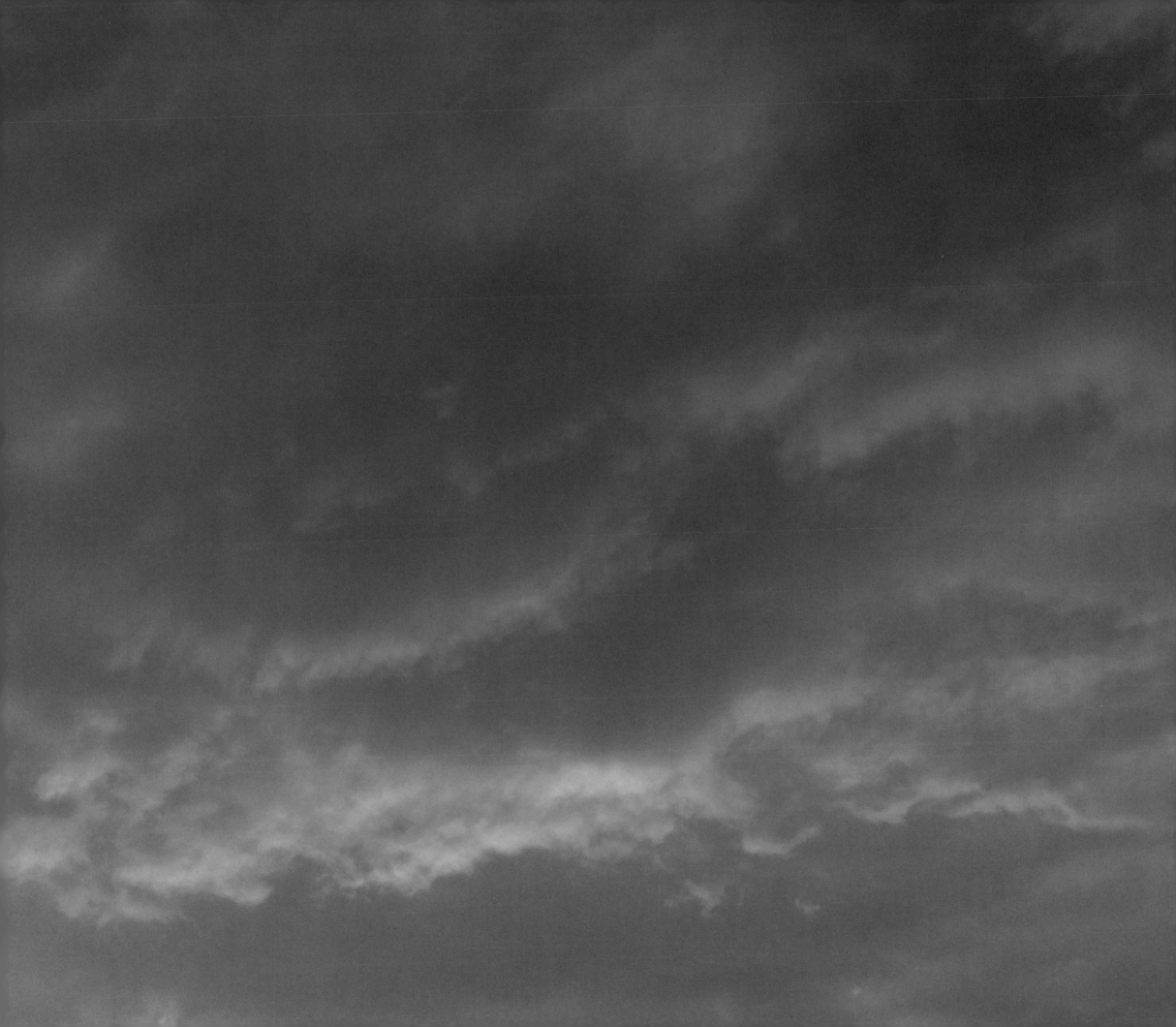

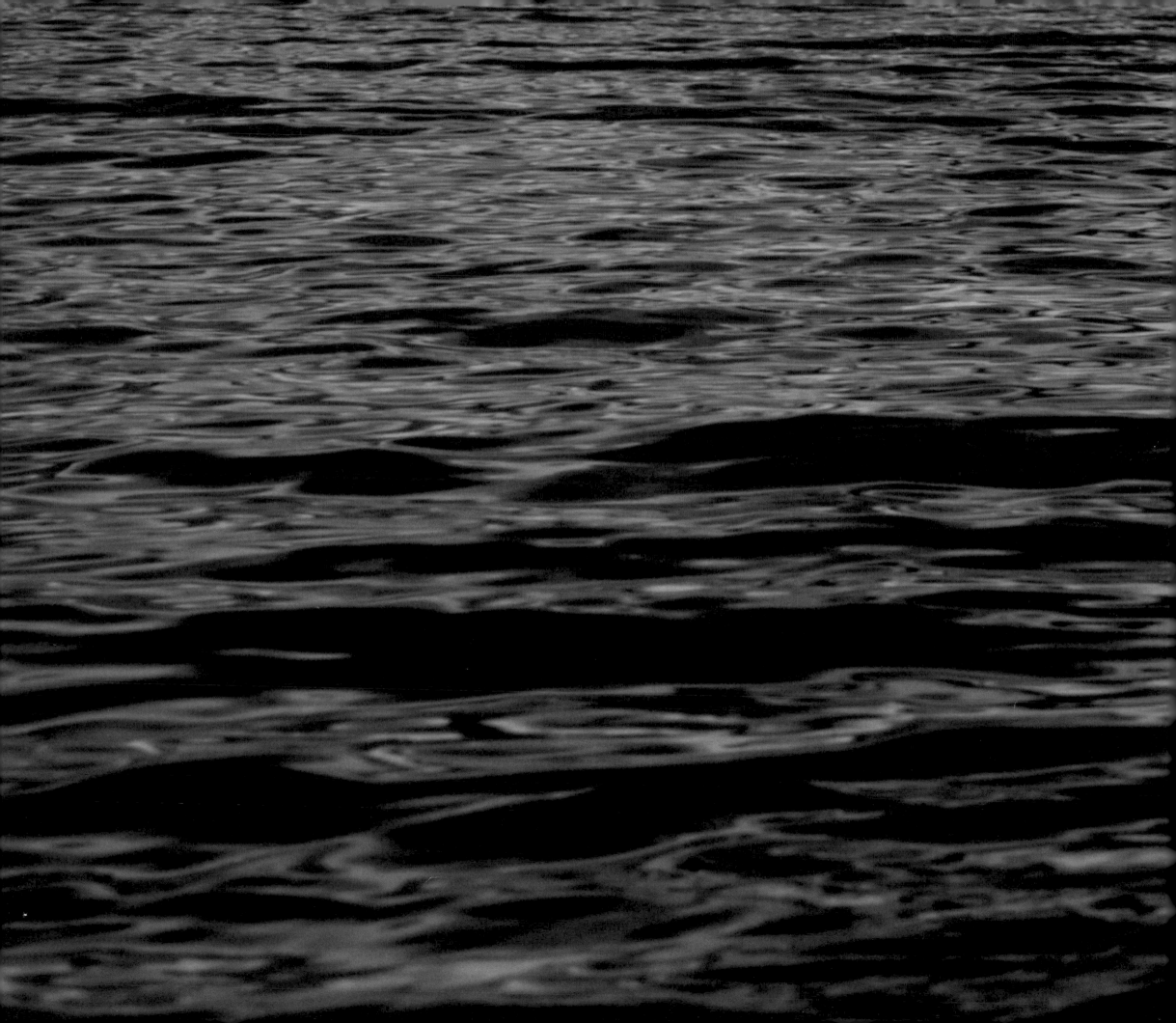

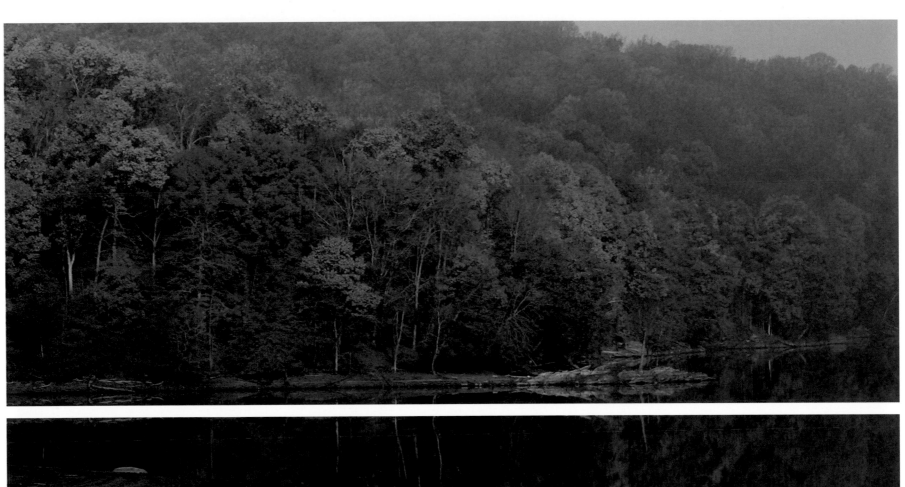

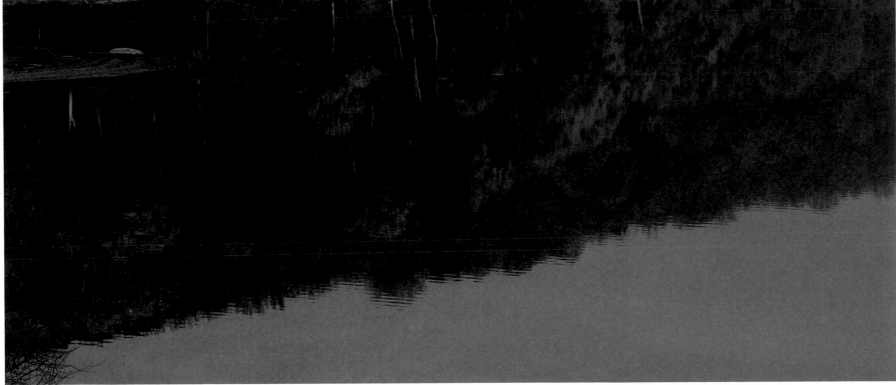

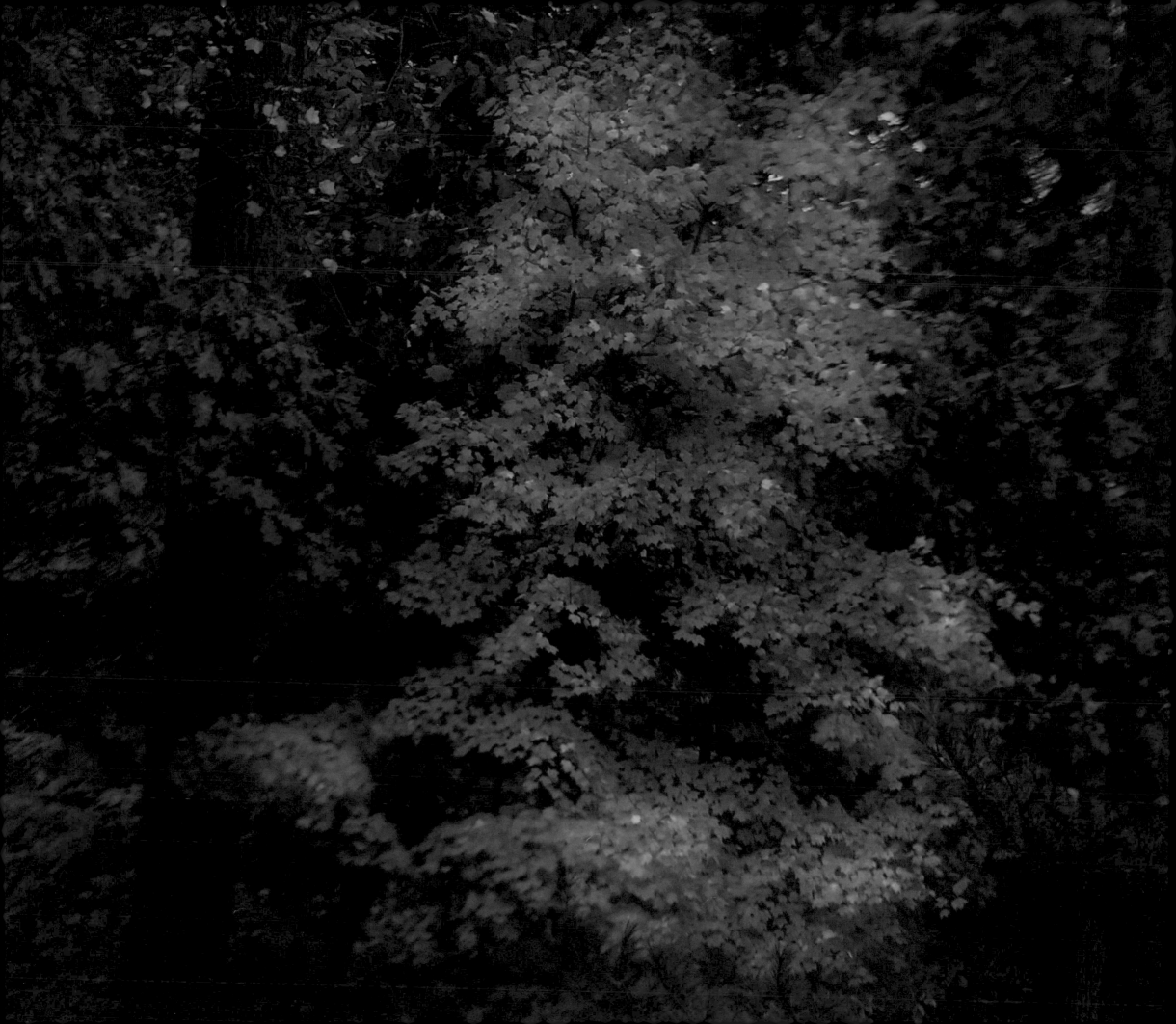

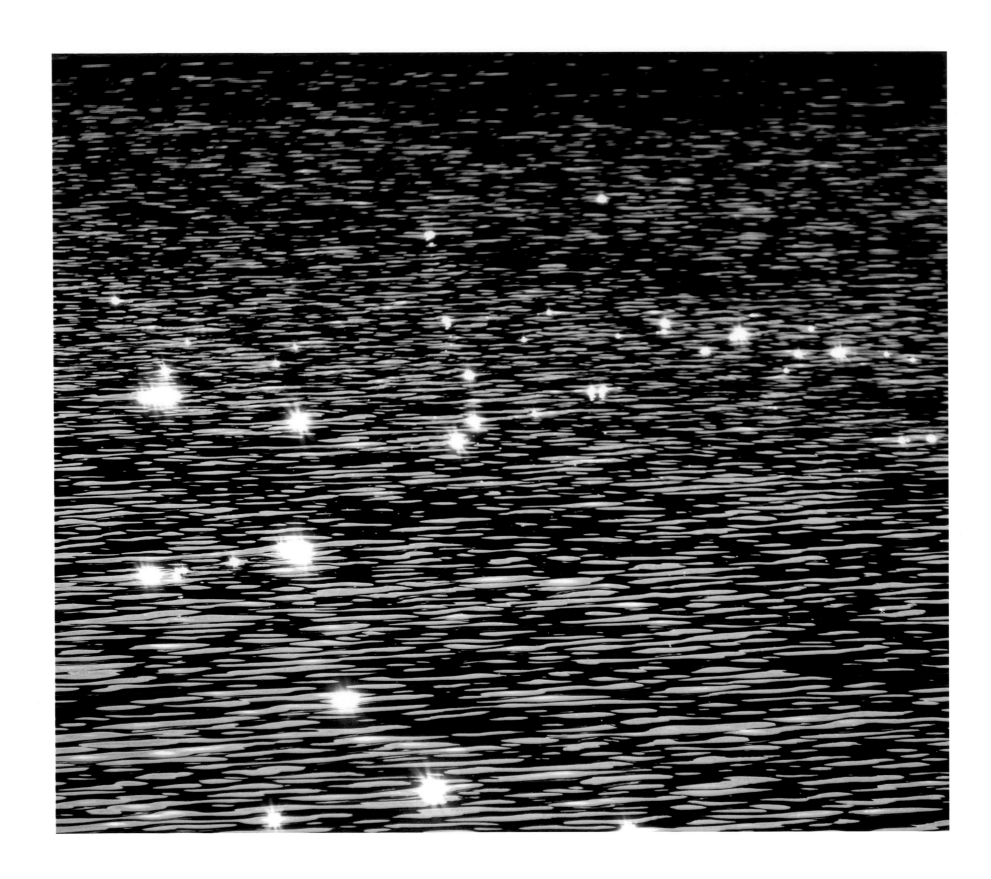

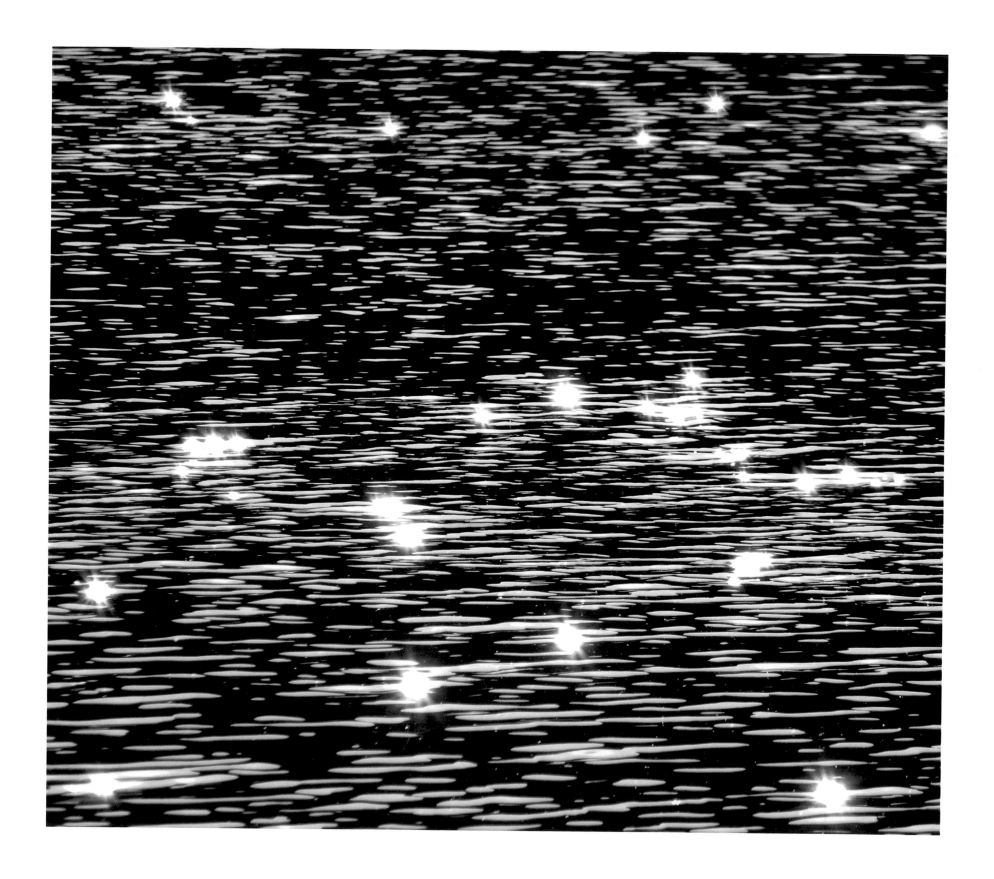

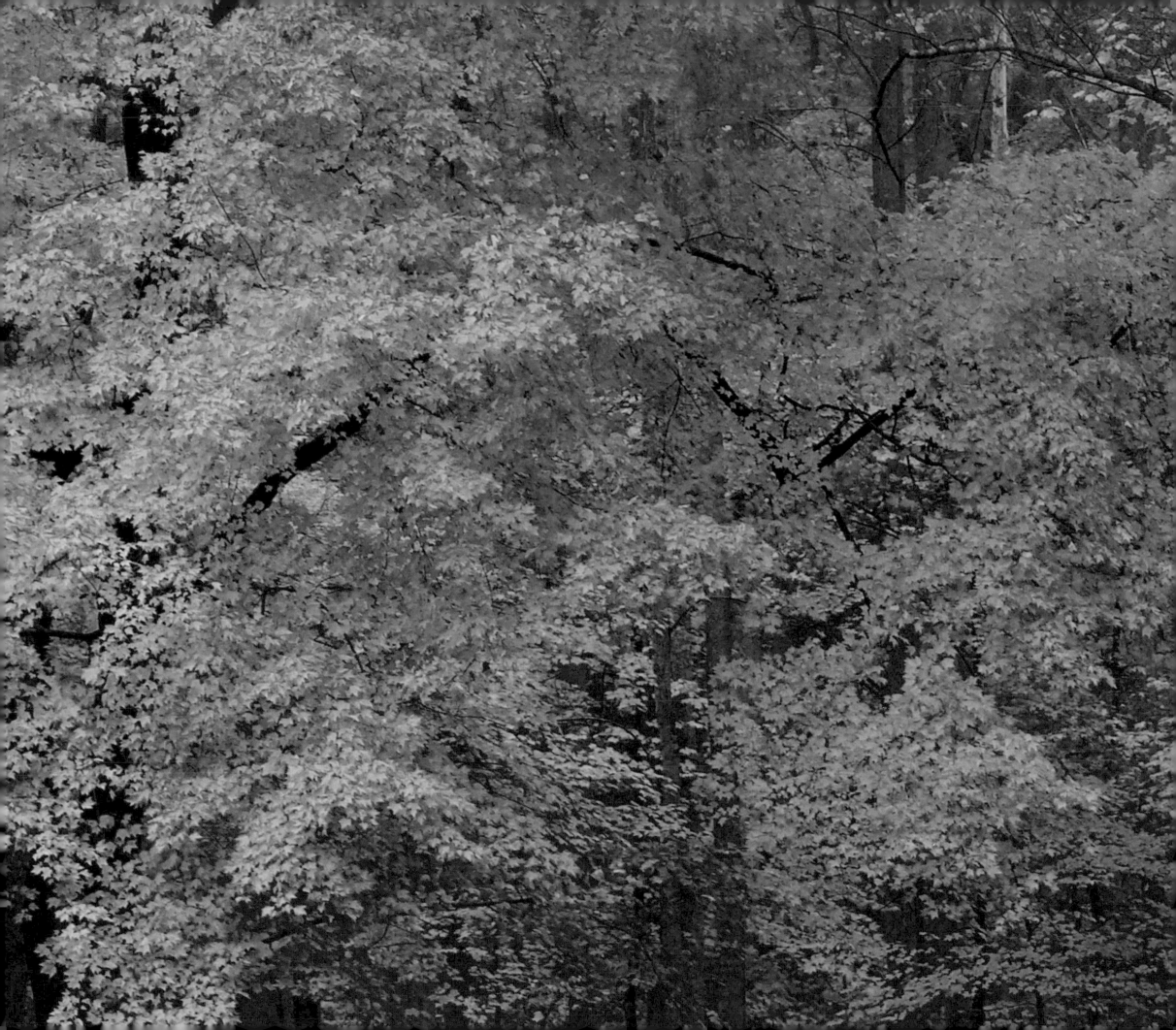

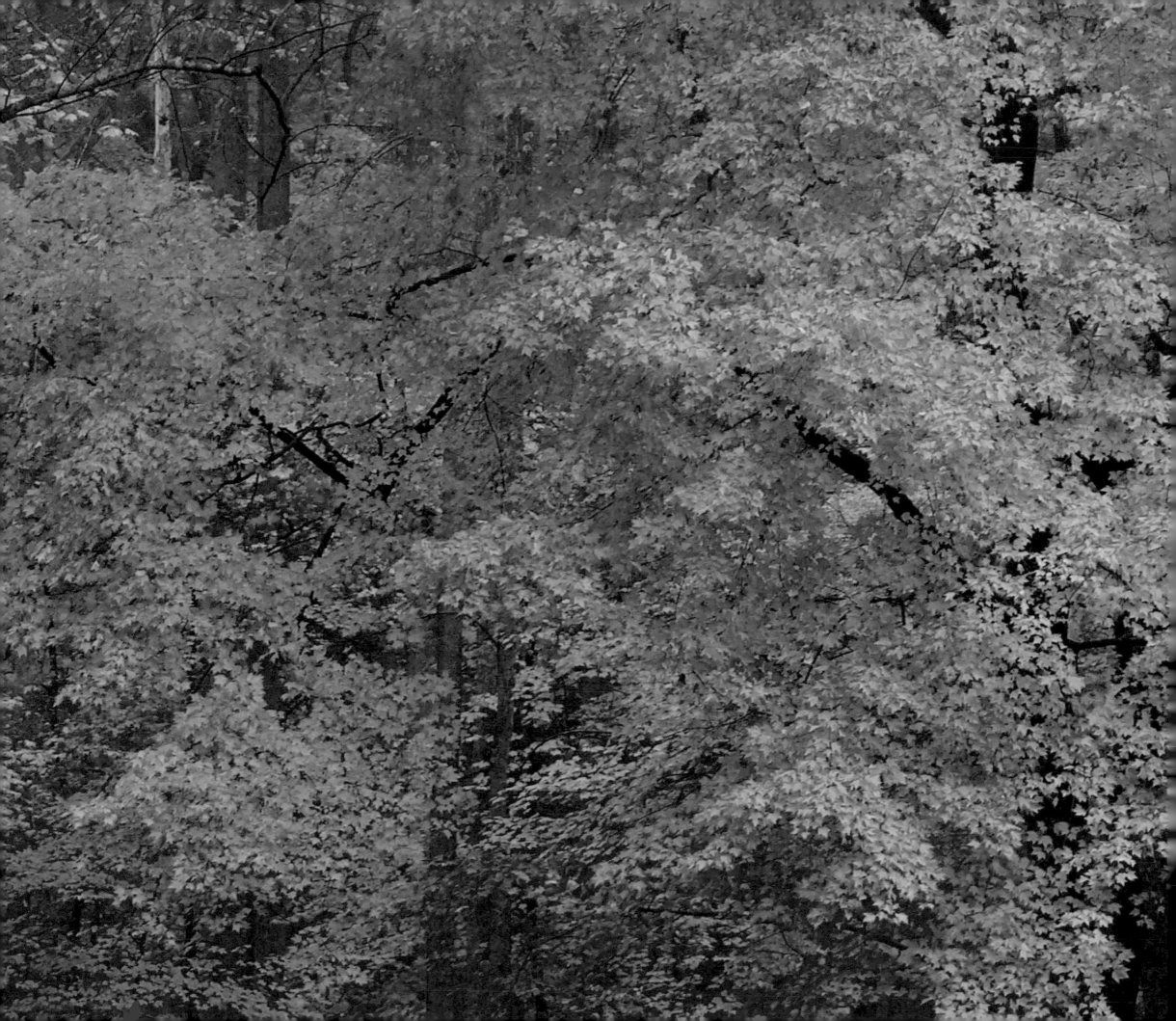

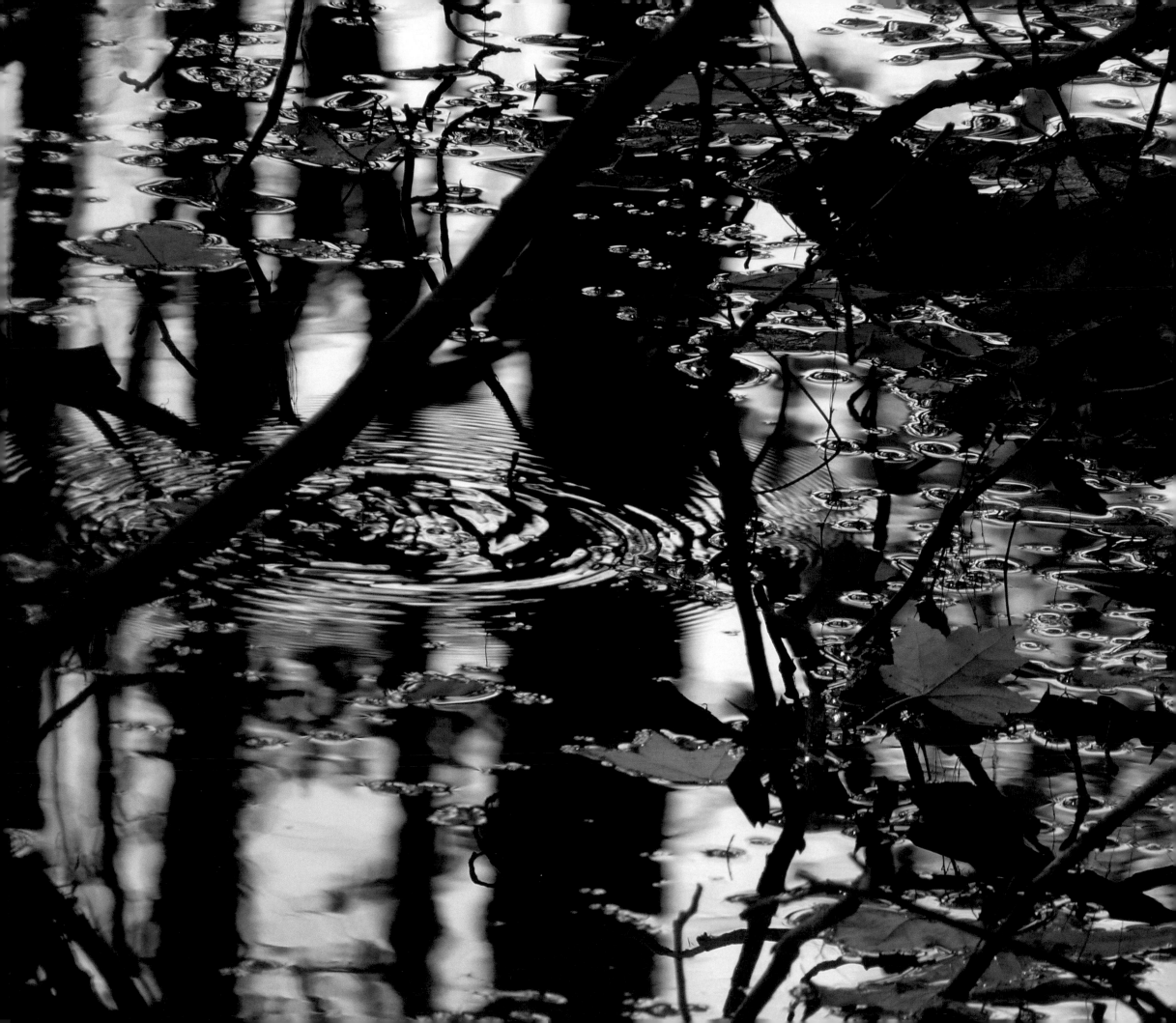

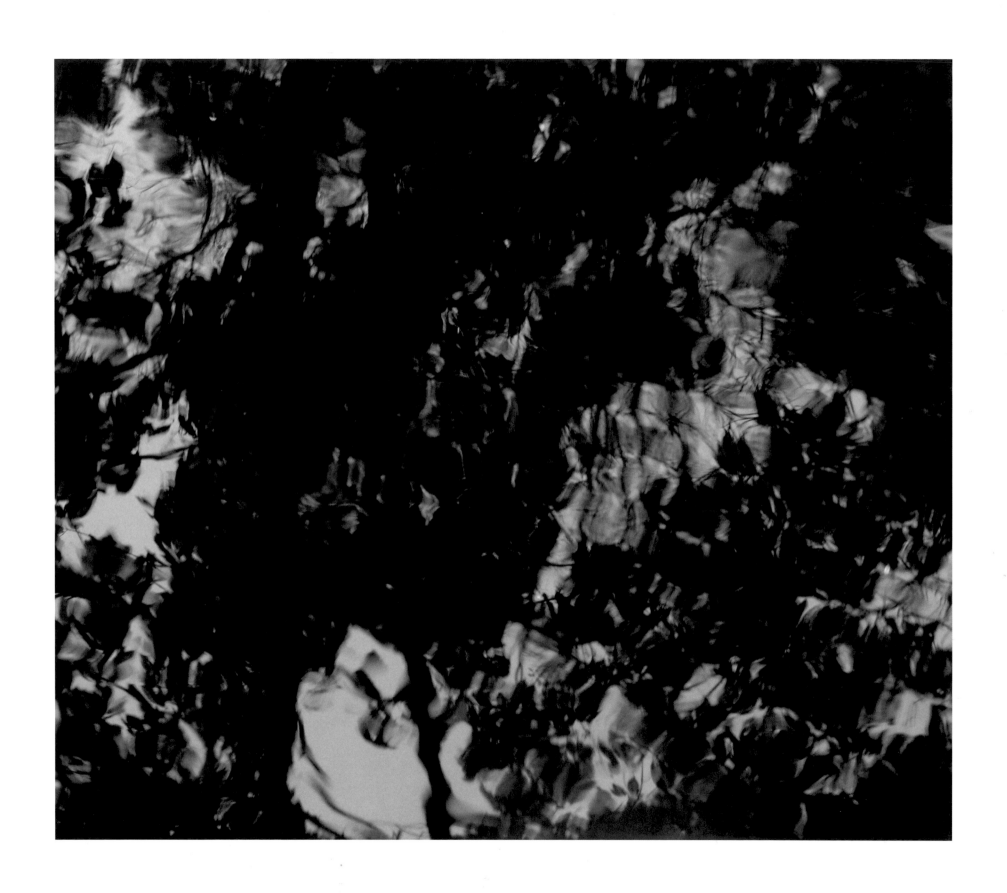

More from Autumn '07.

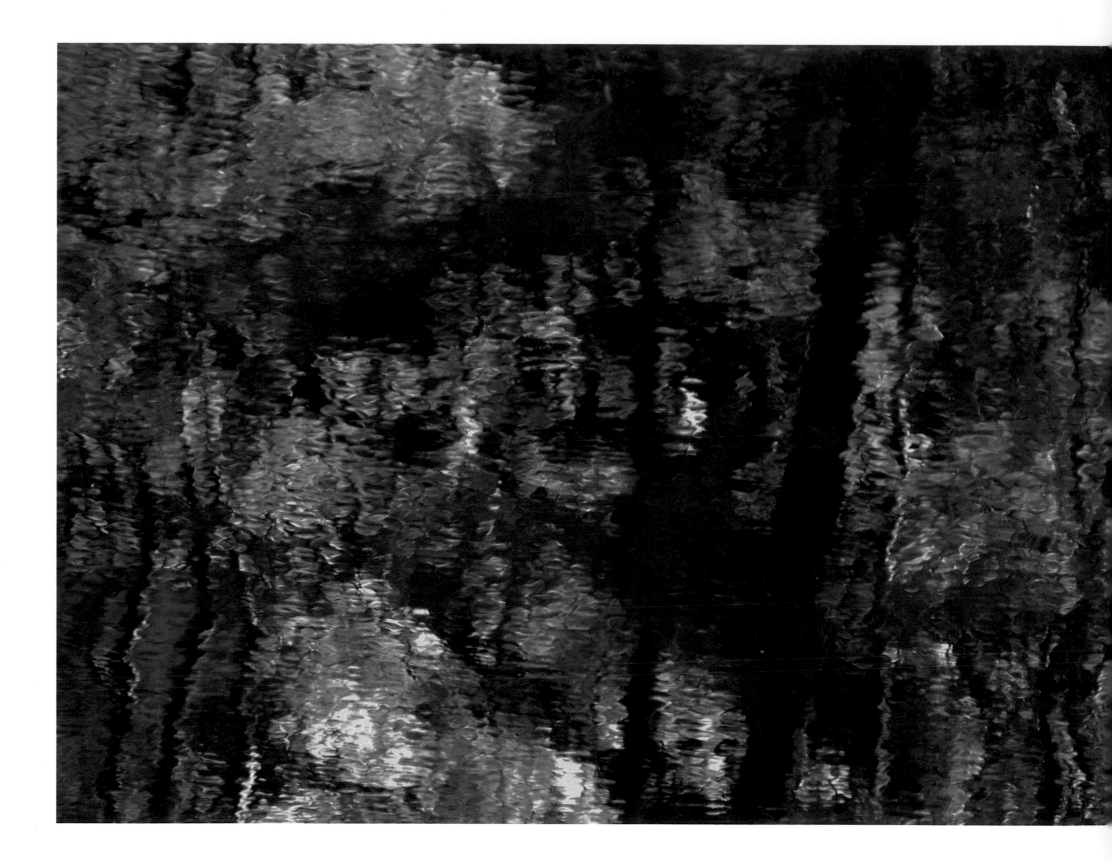

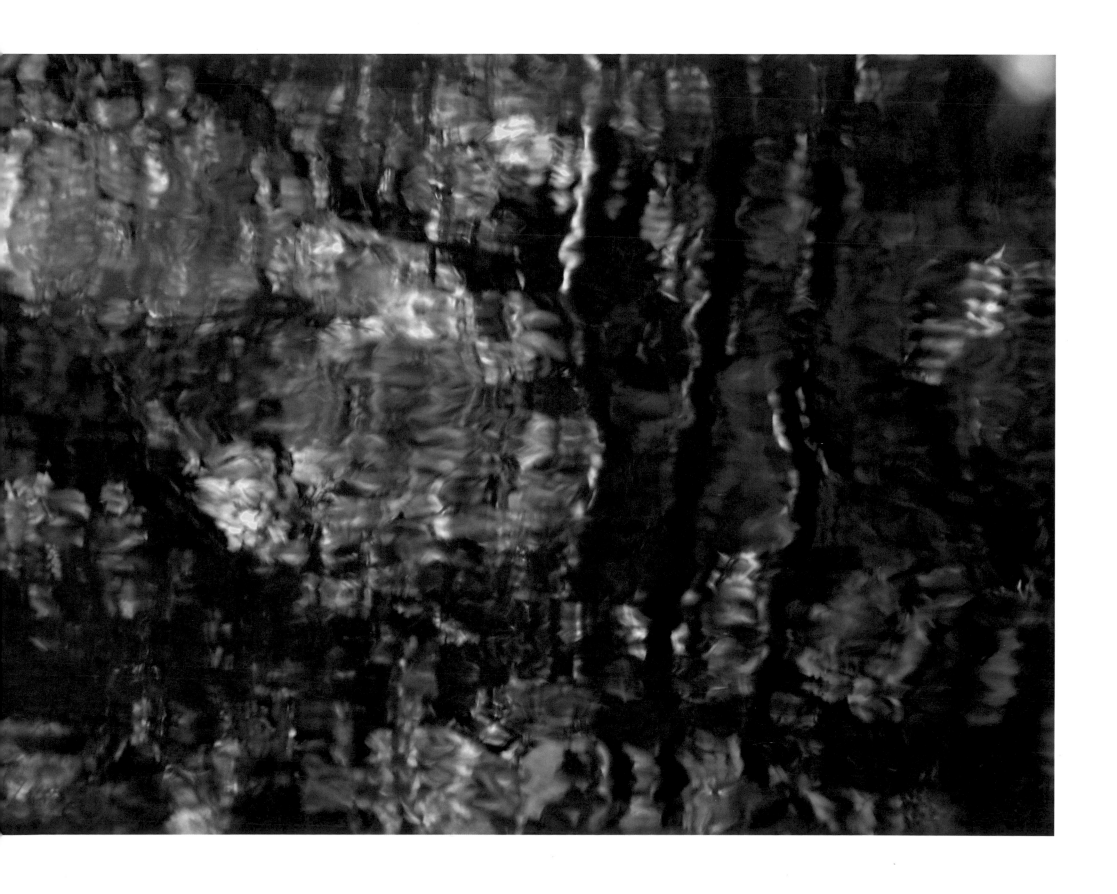

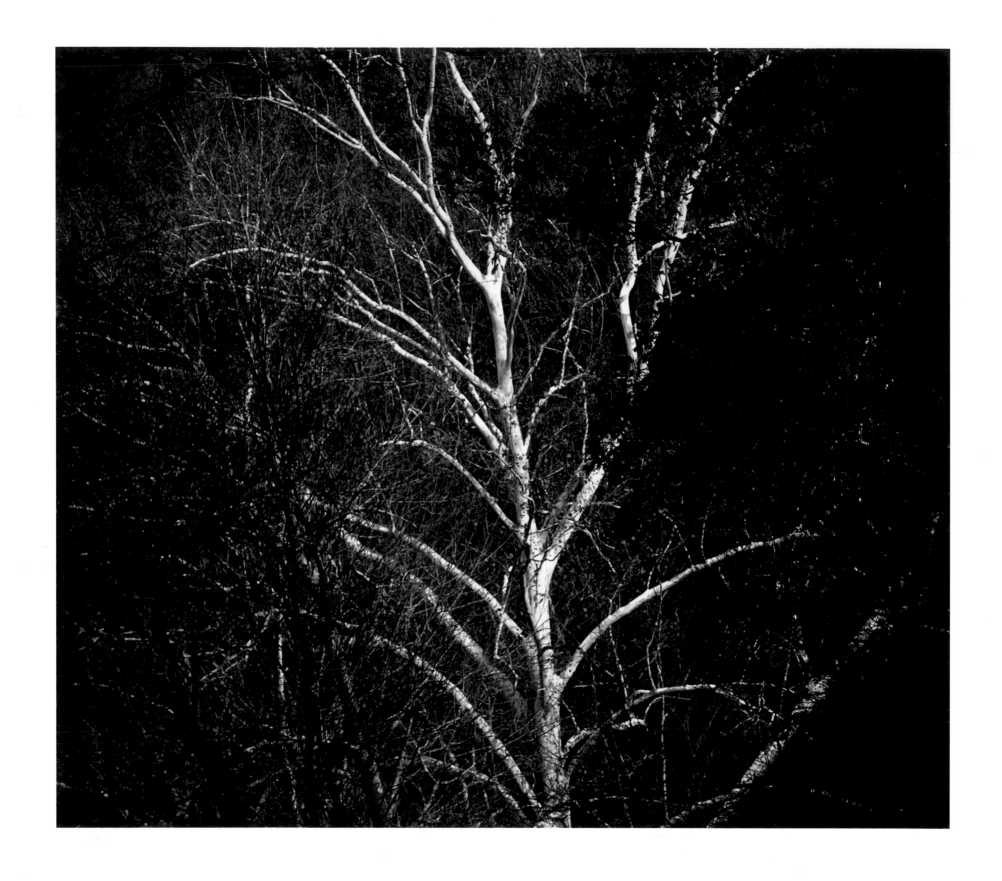

Birch trees.

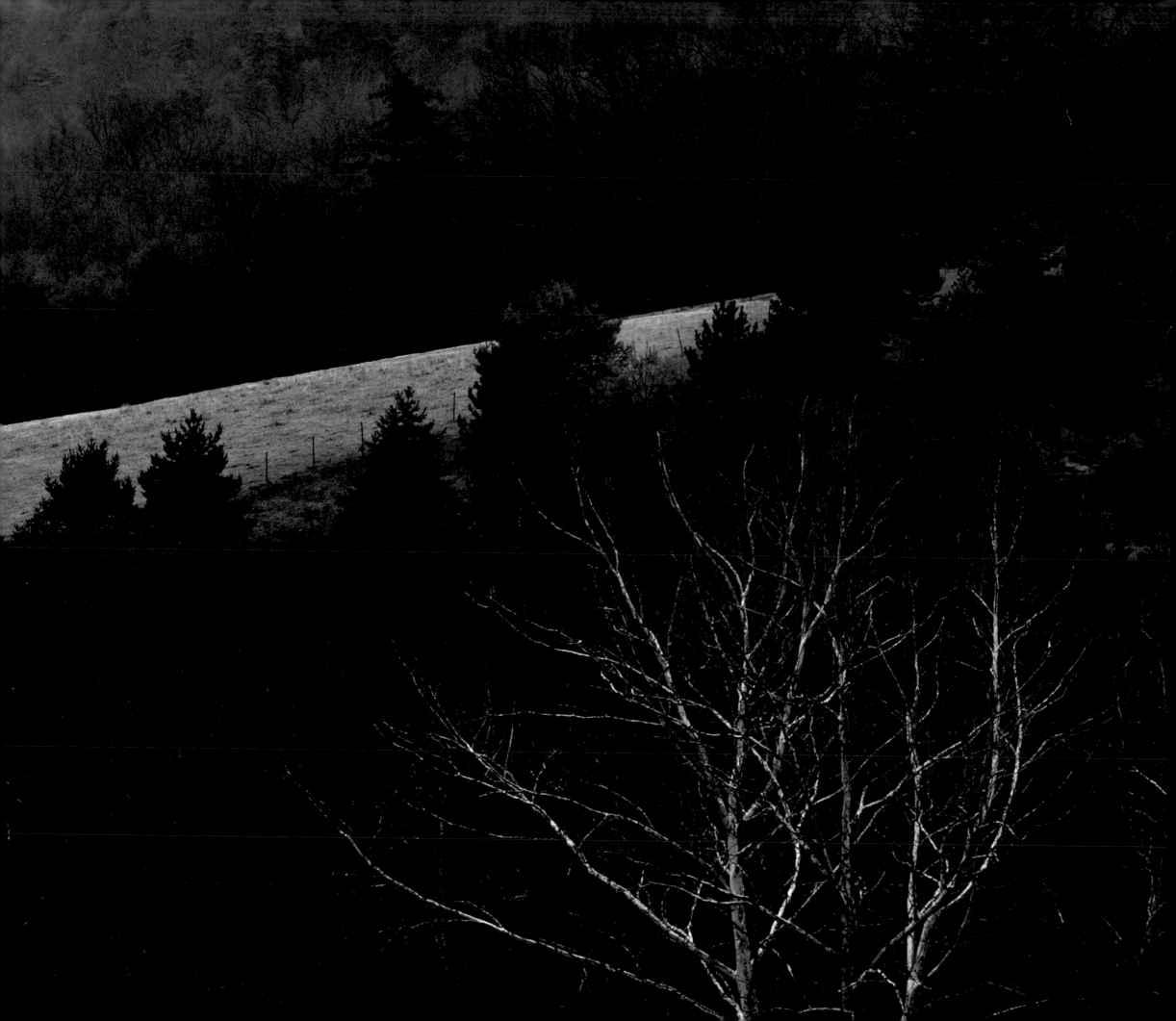

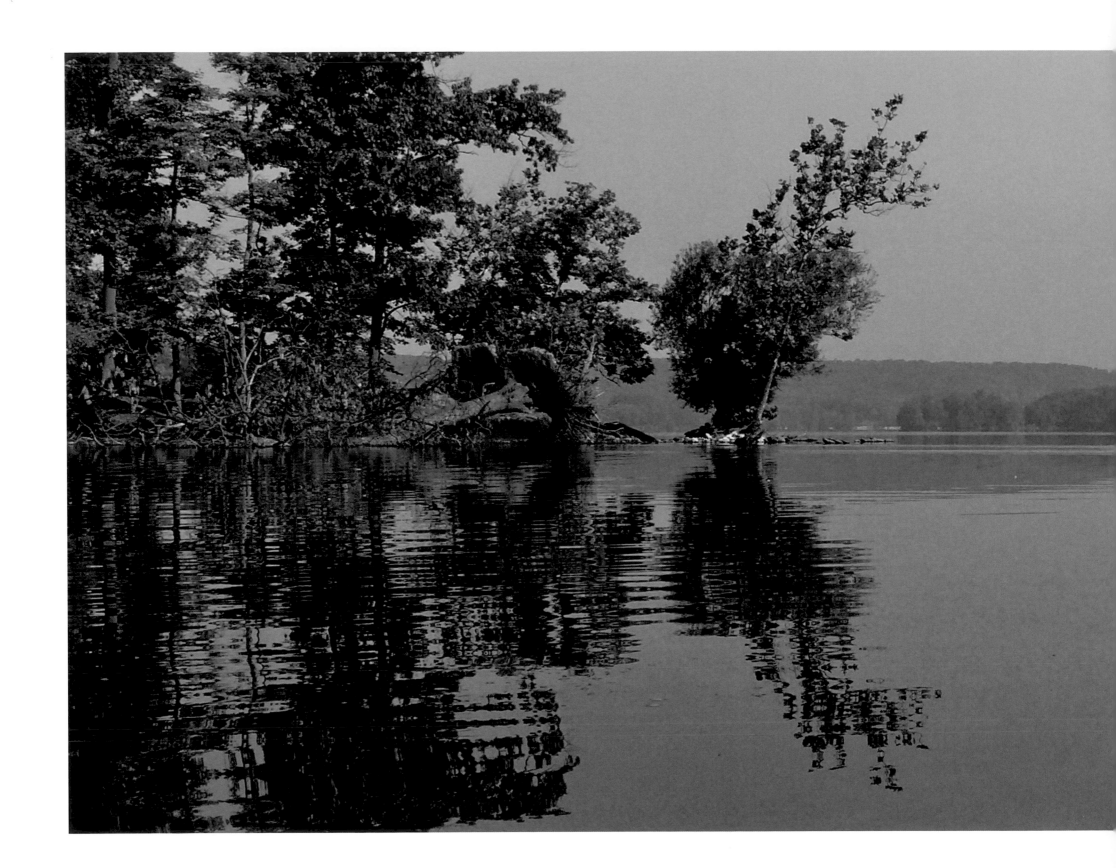

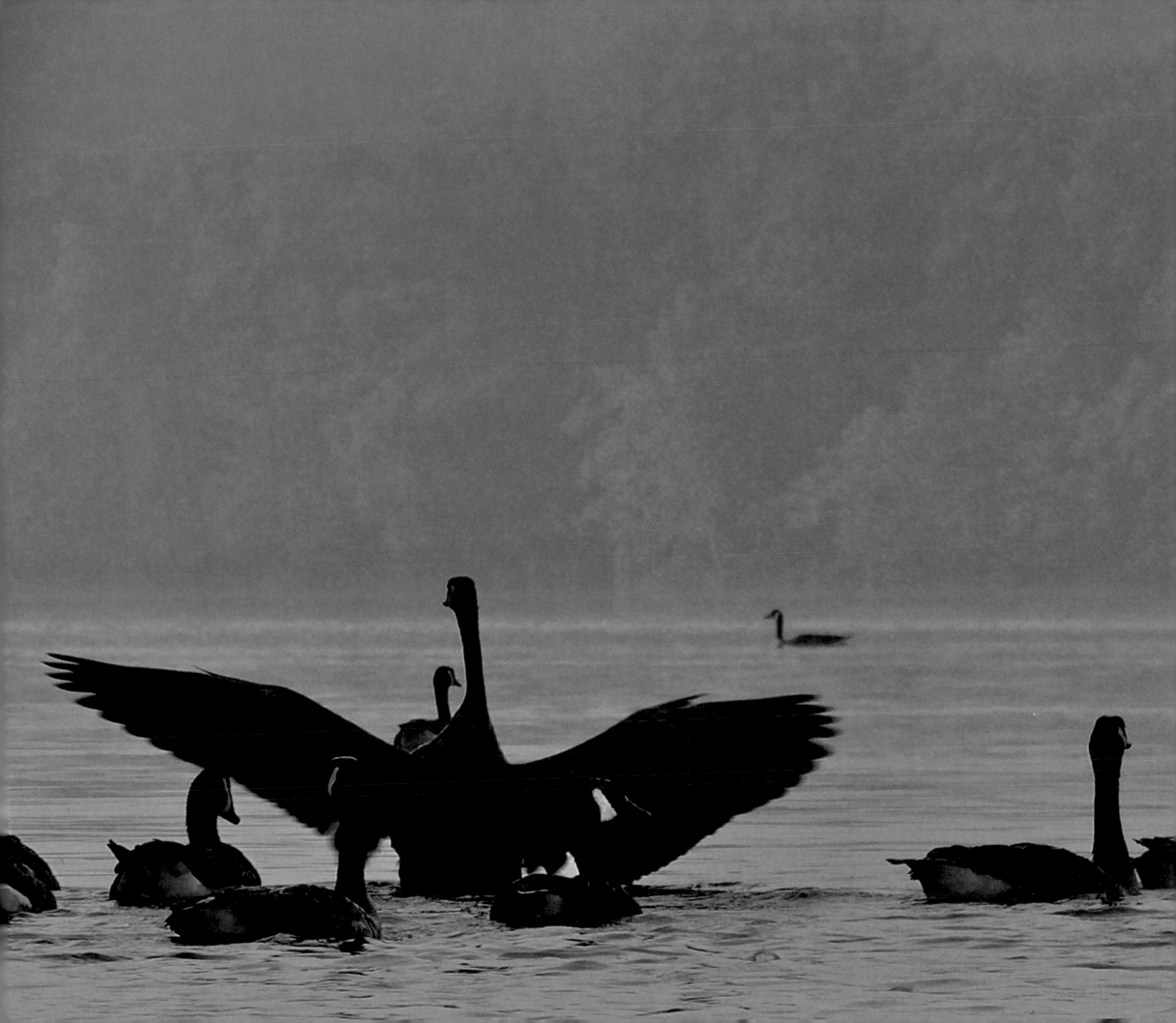

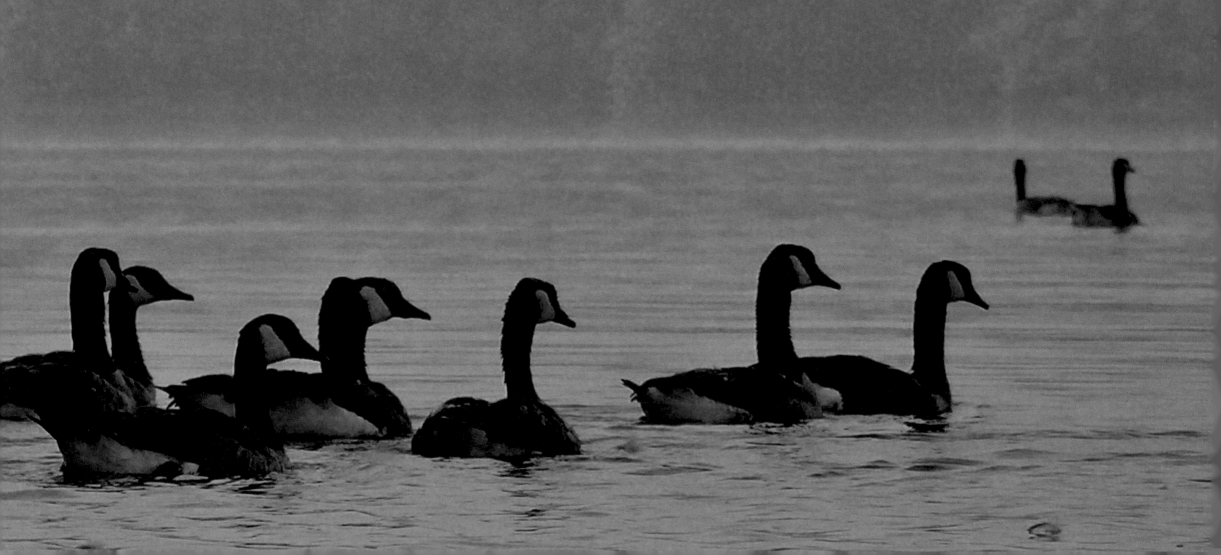

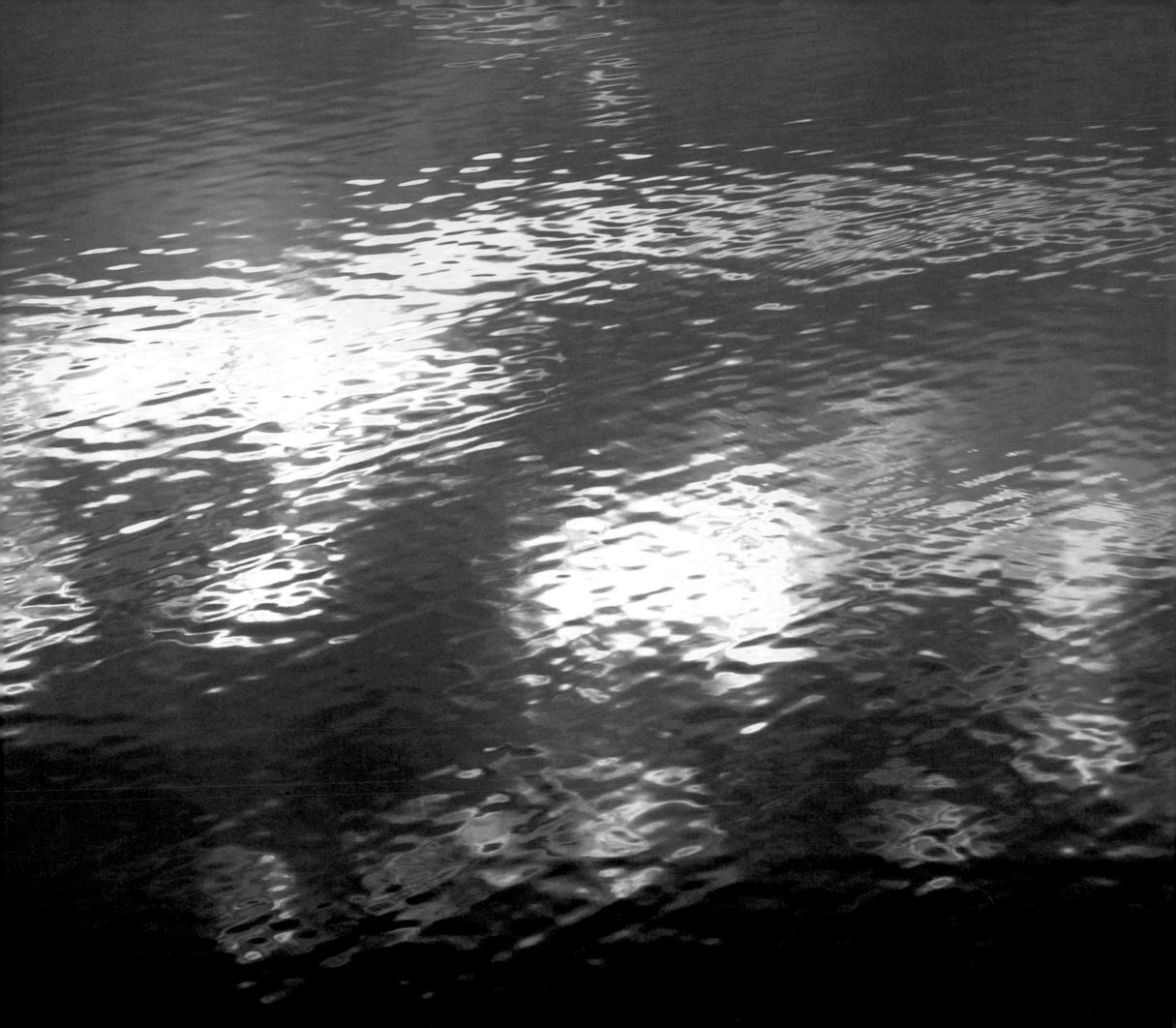

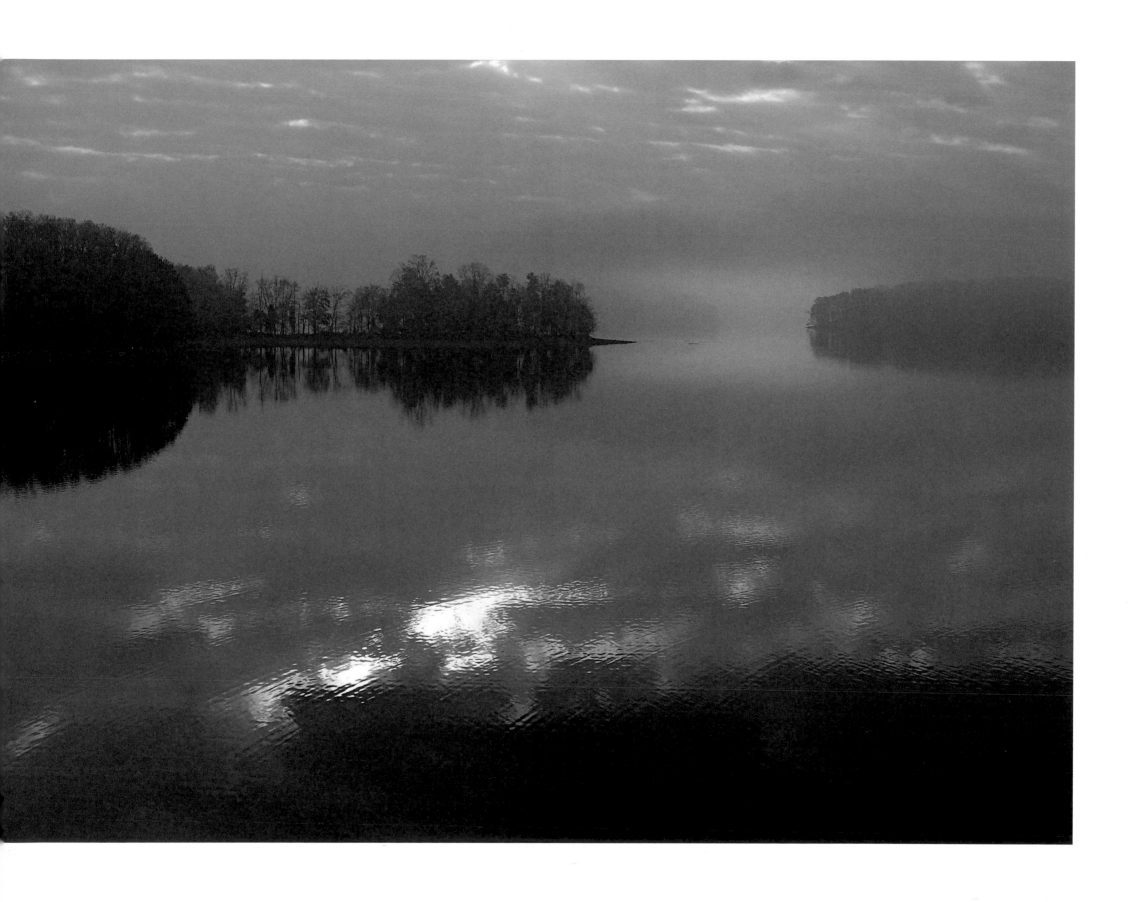

Should the truth be known, I don't think I'm done photographing this place. Nor will I ever be.

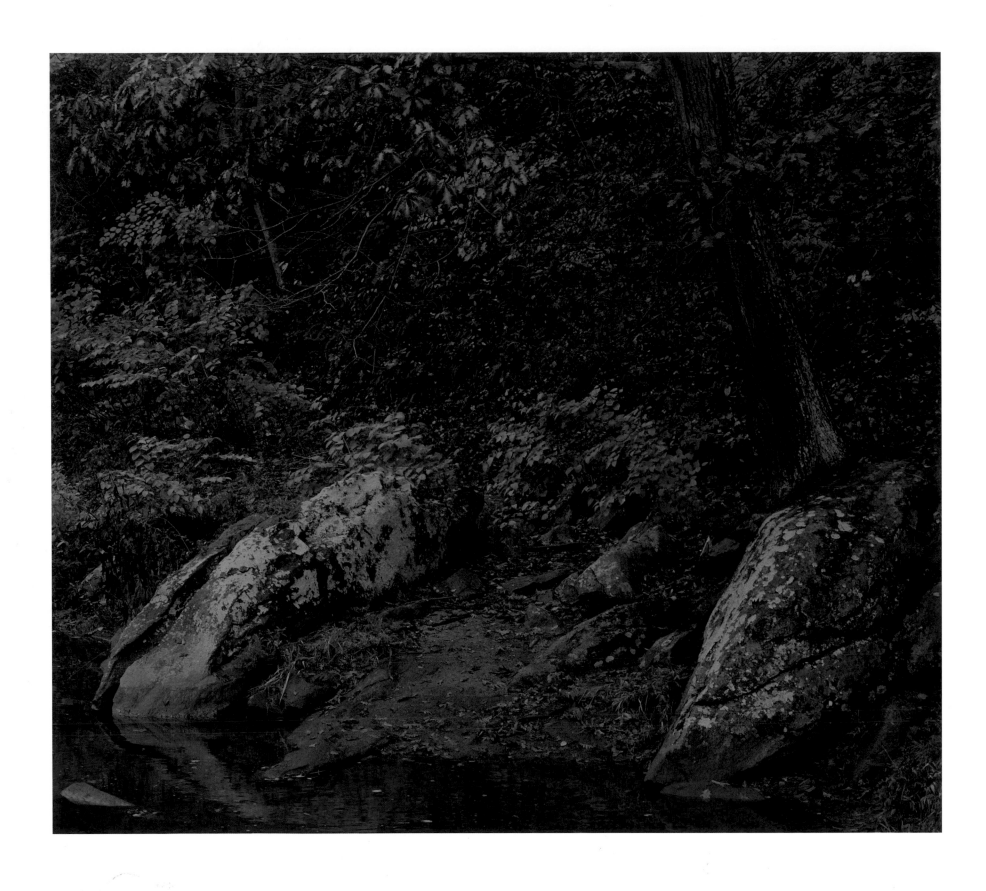

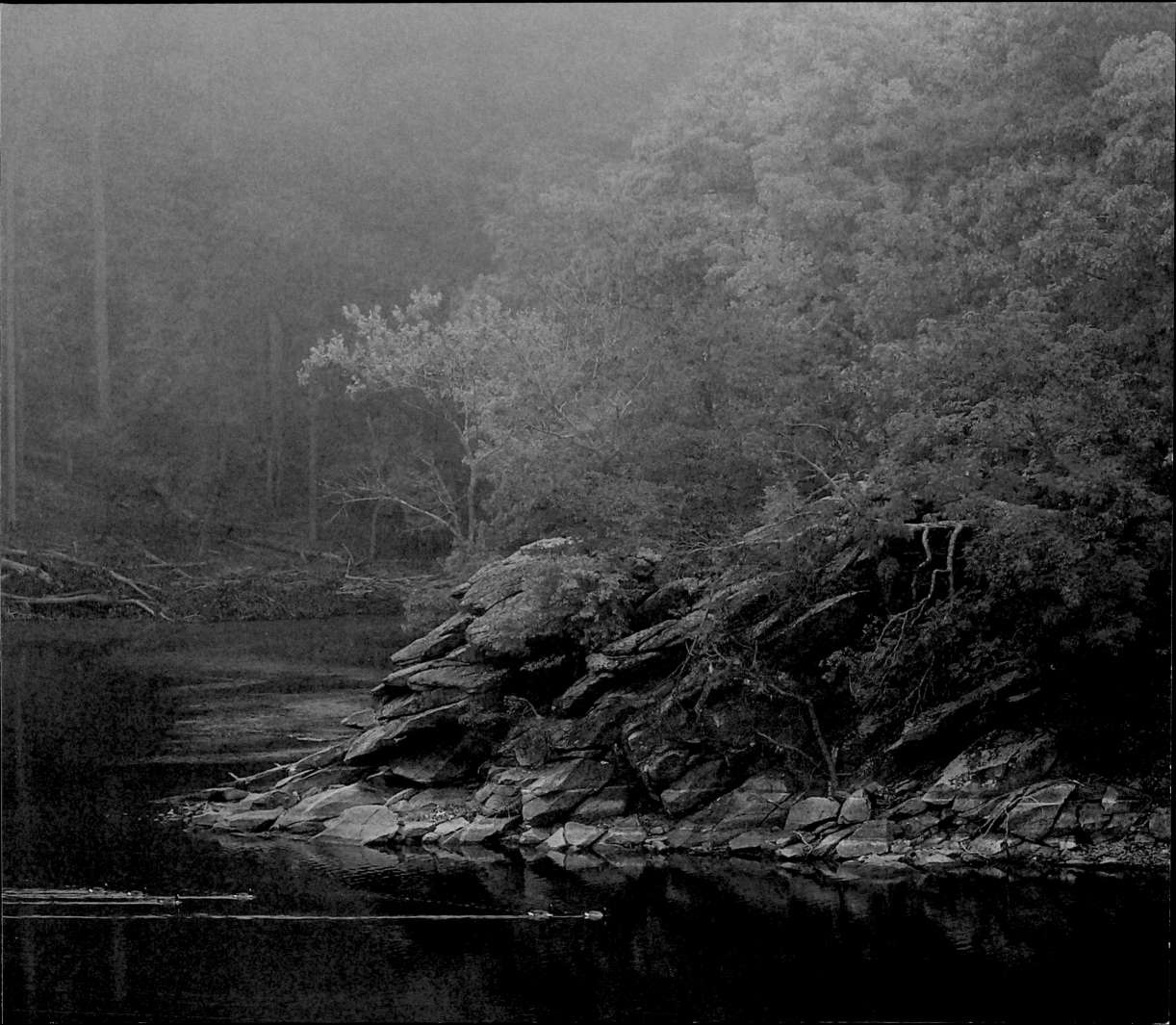

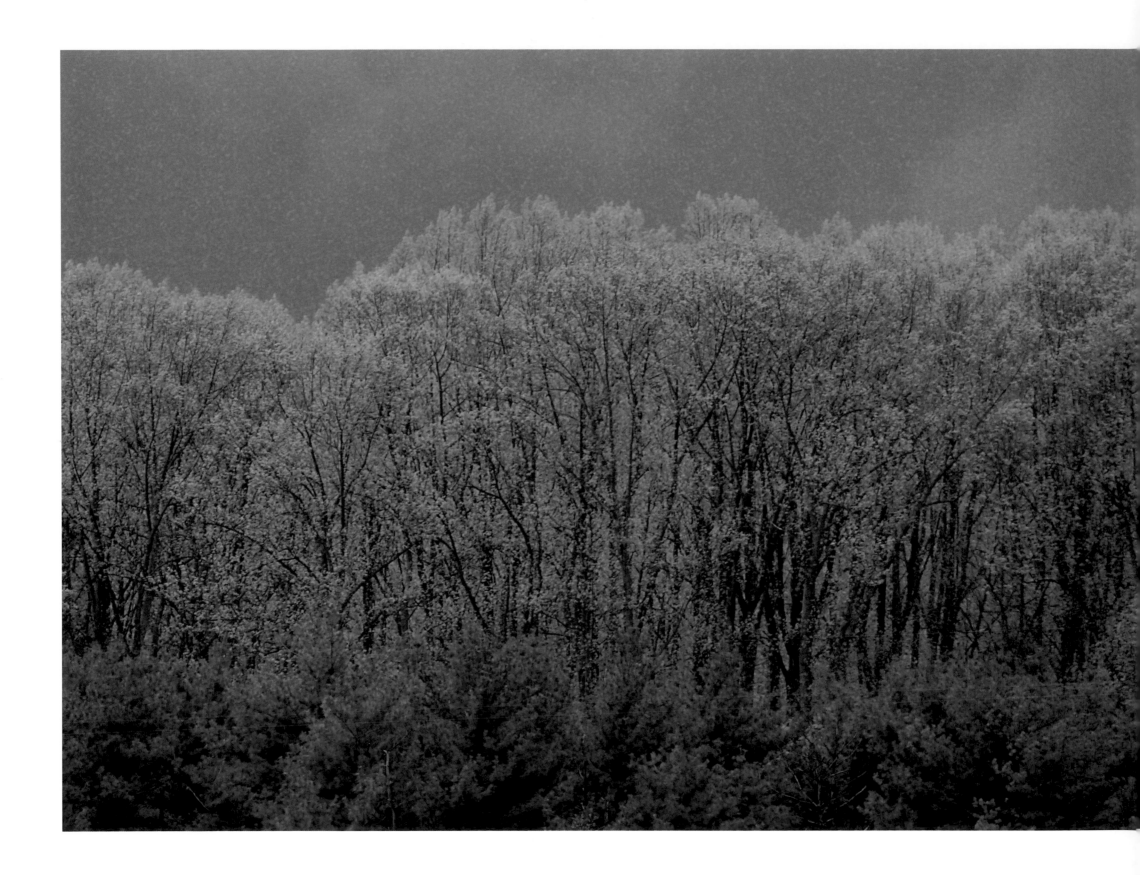

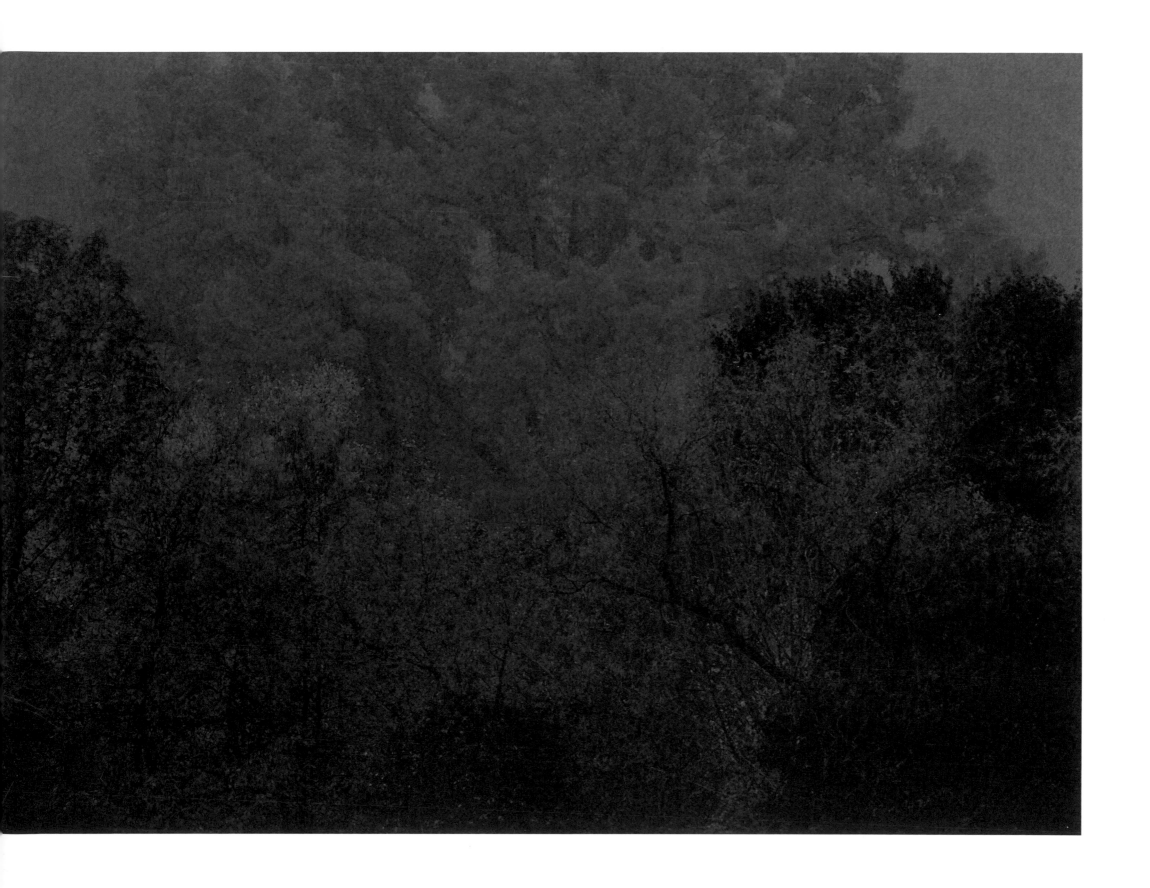

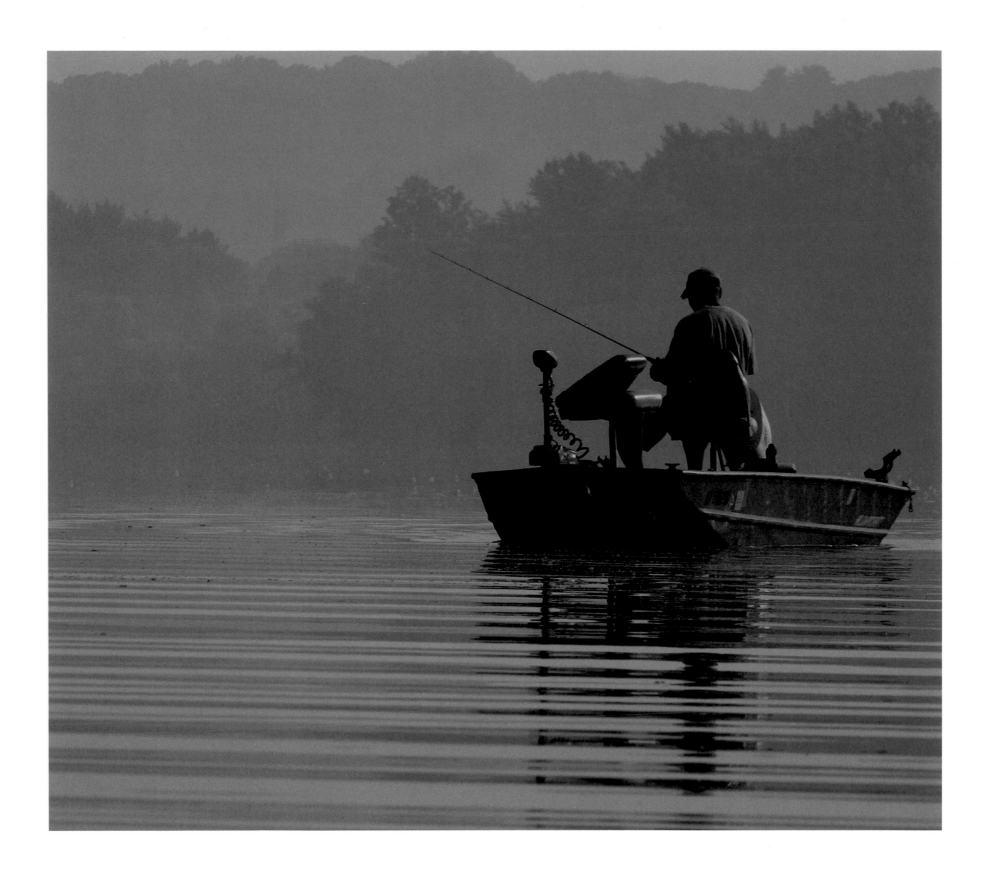

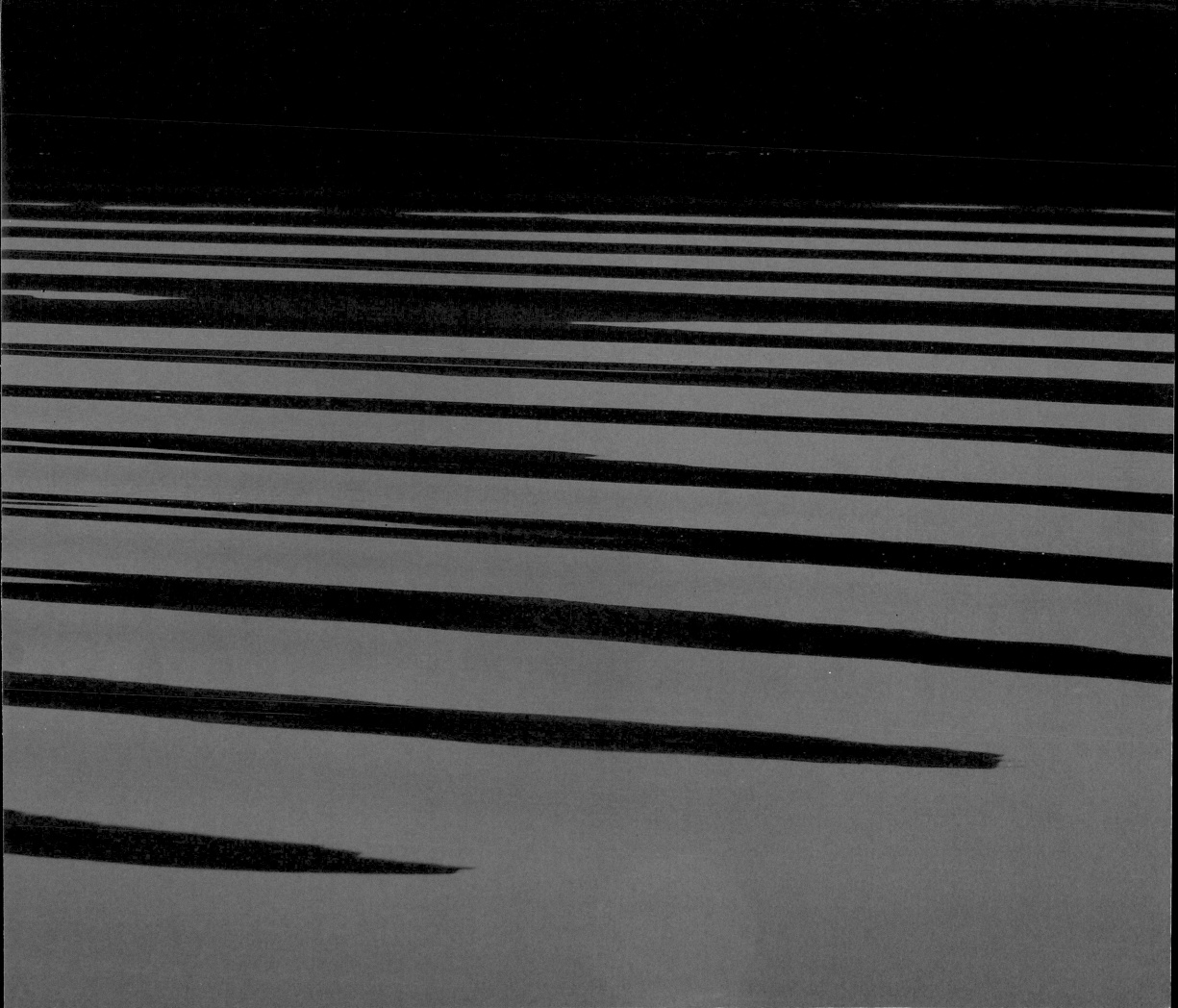

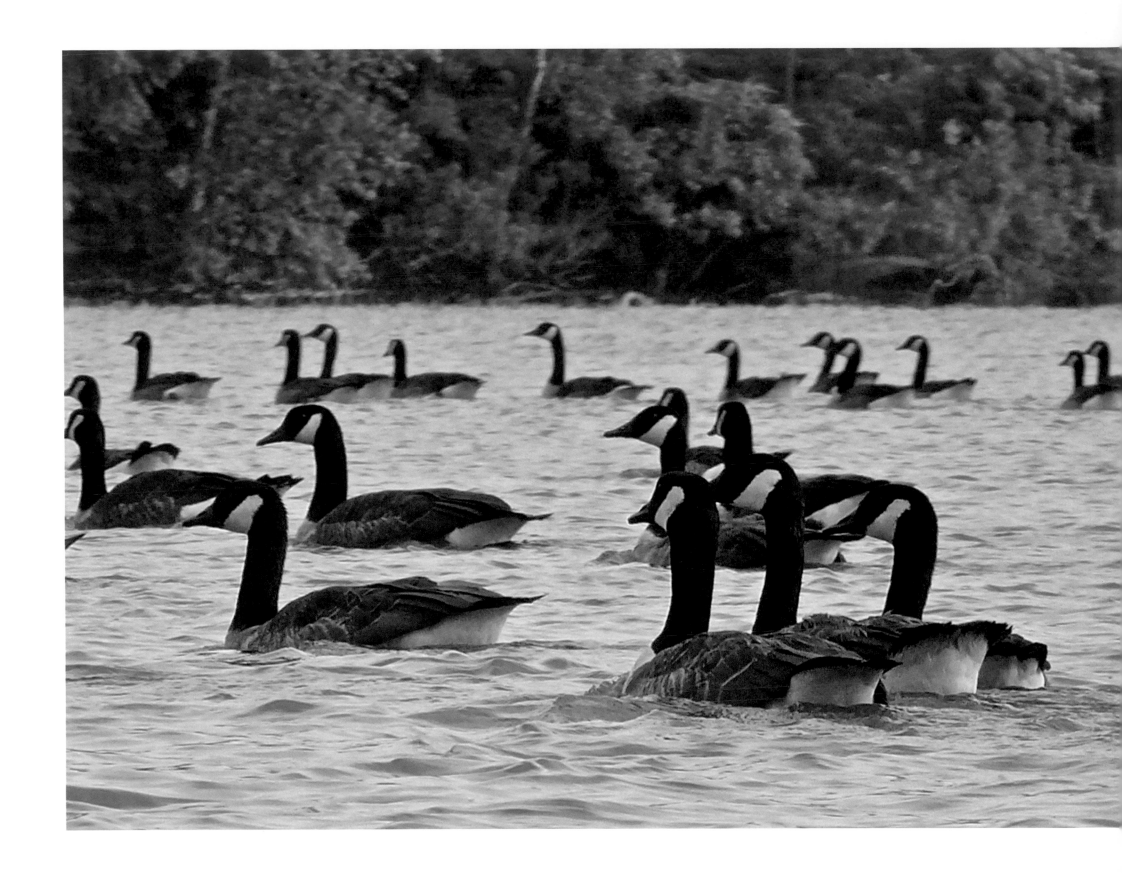

Got this shot after adding a second motor to the kayak. Before that, they were faster than me. Now I could keep up and steer more accurately.

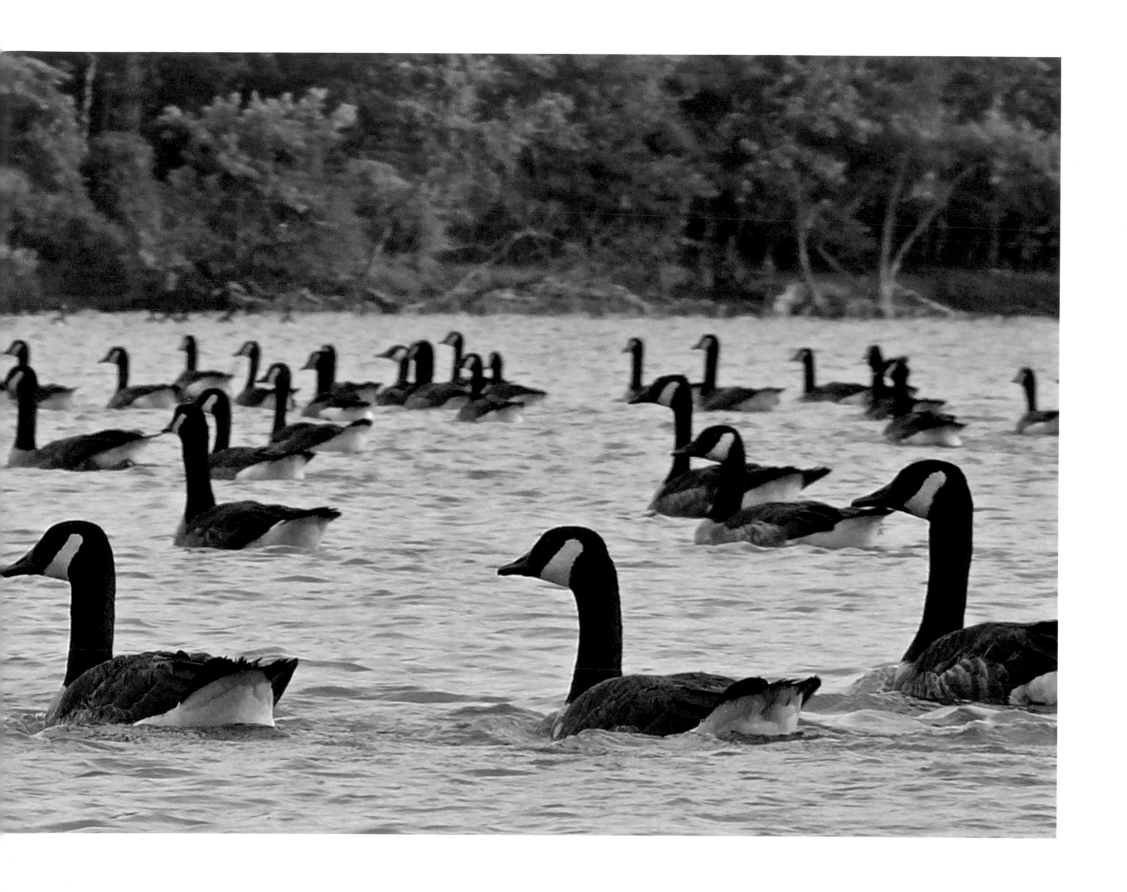

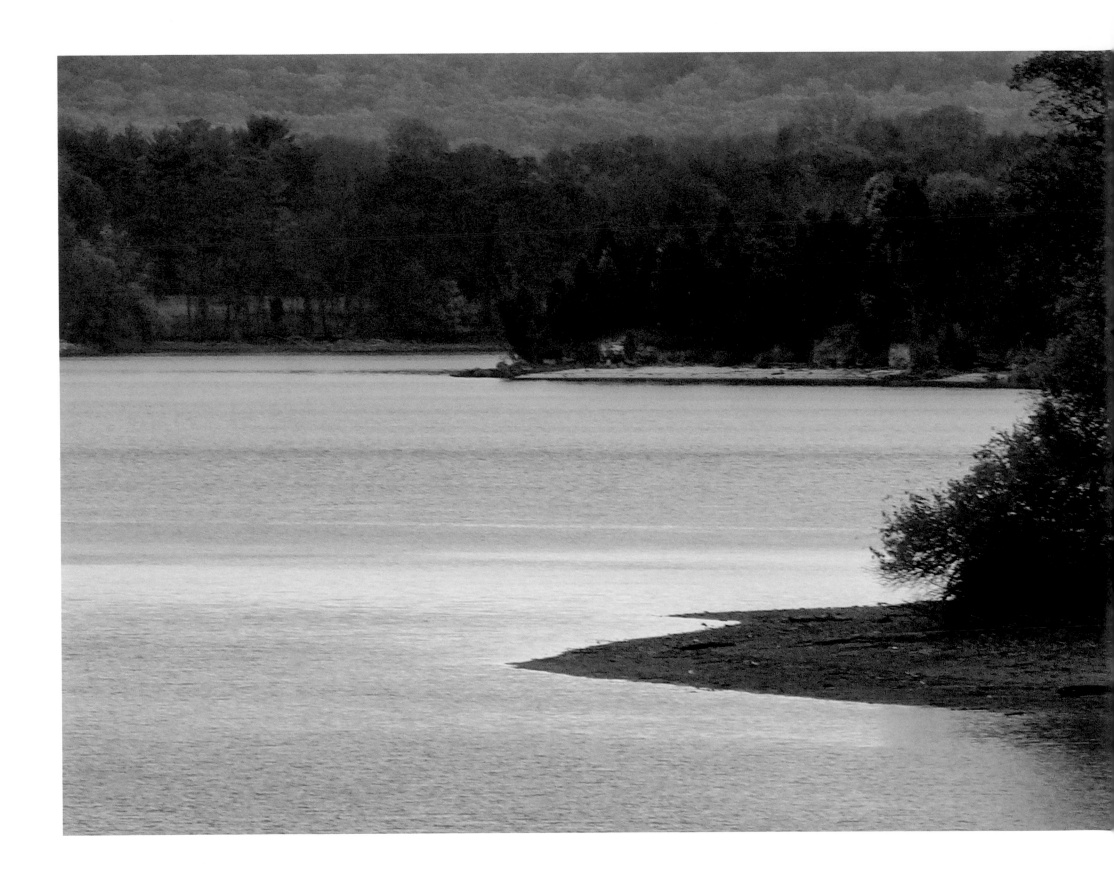

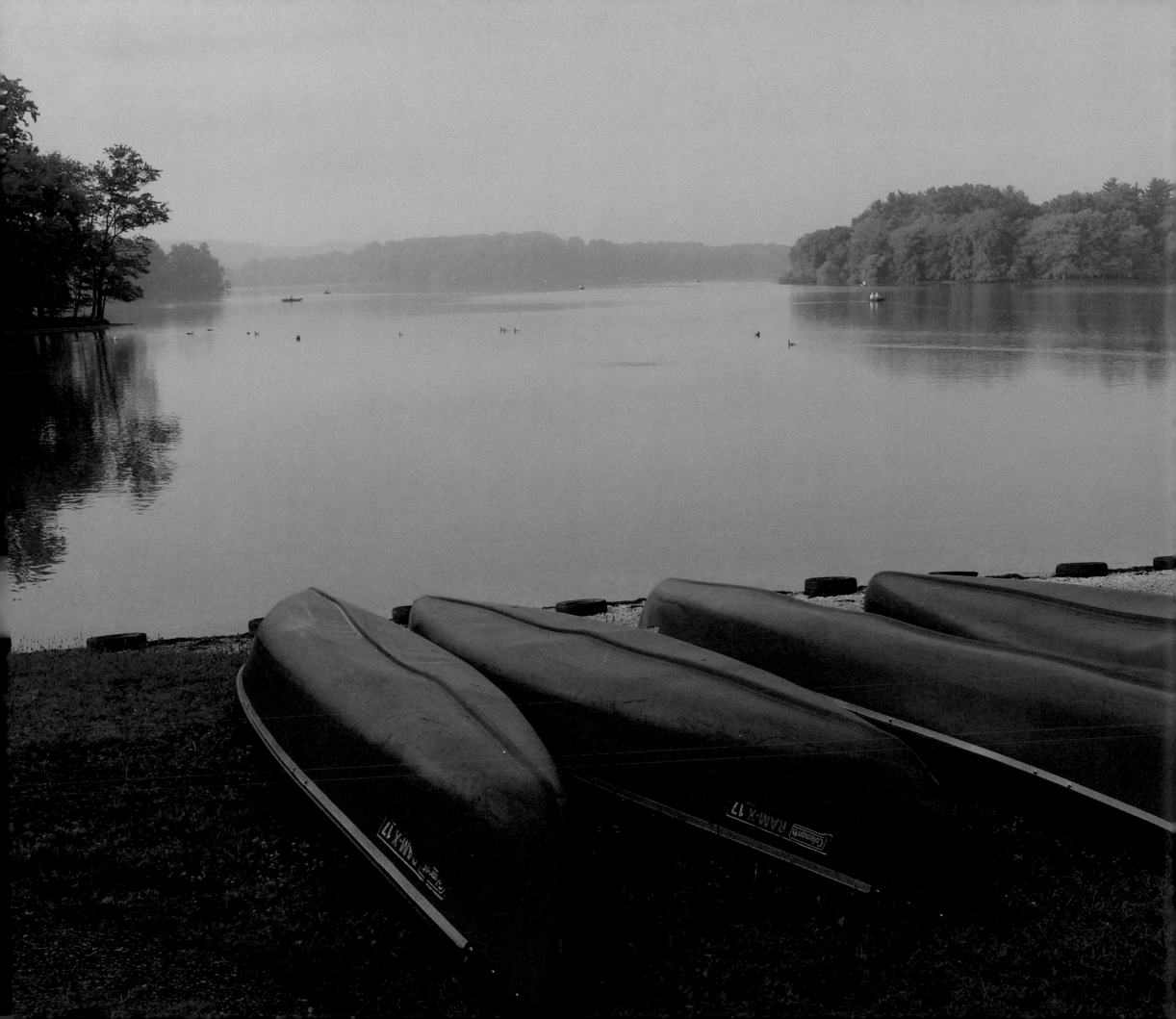

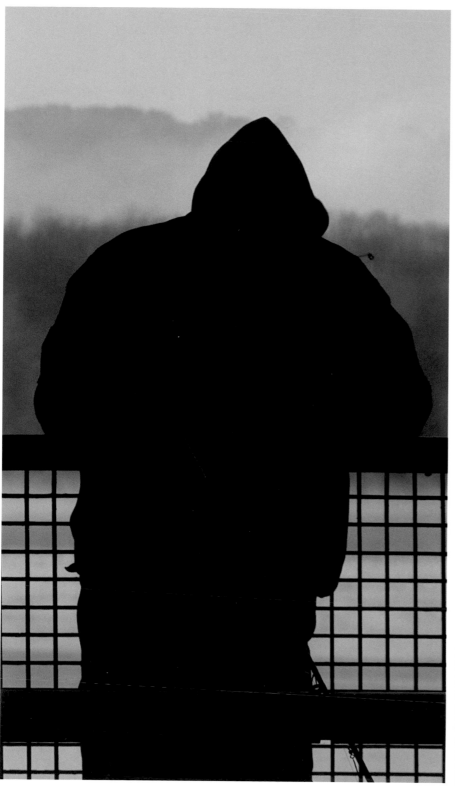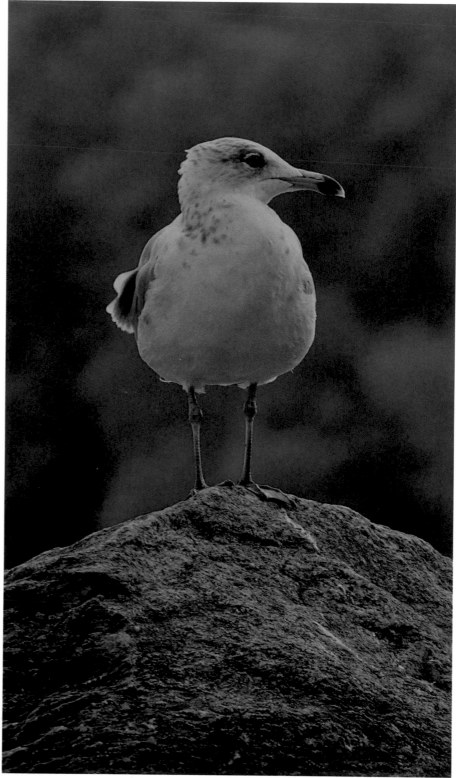

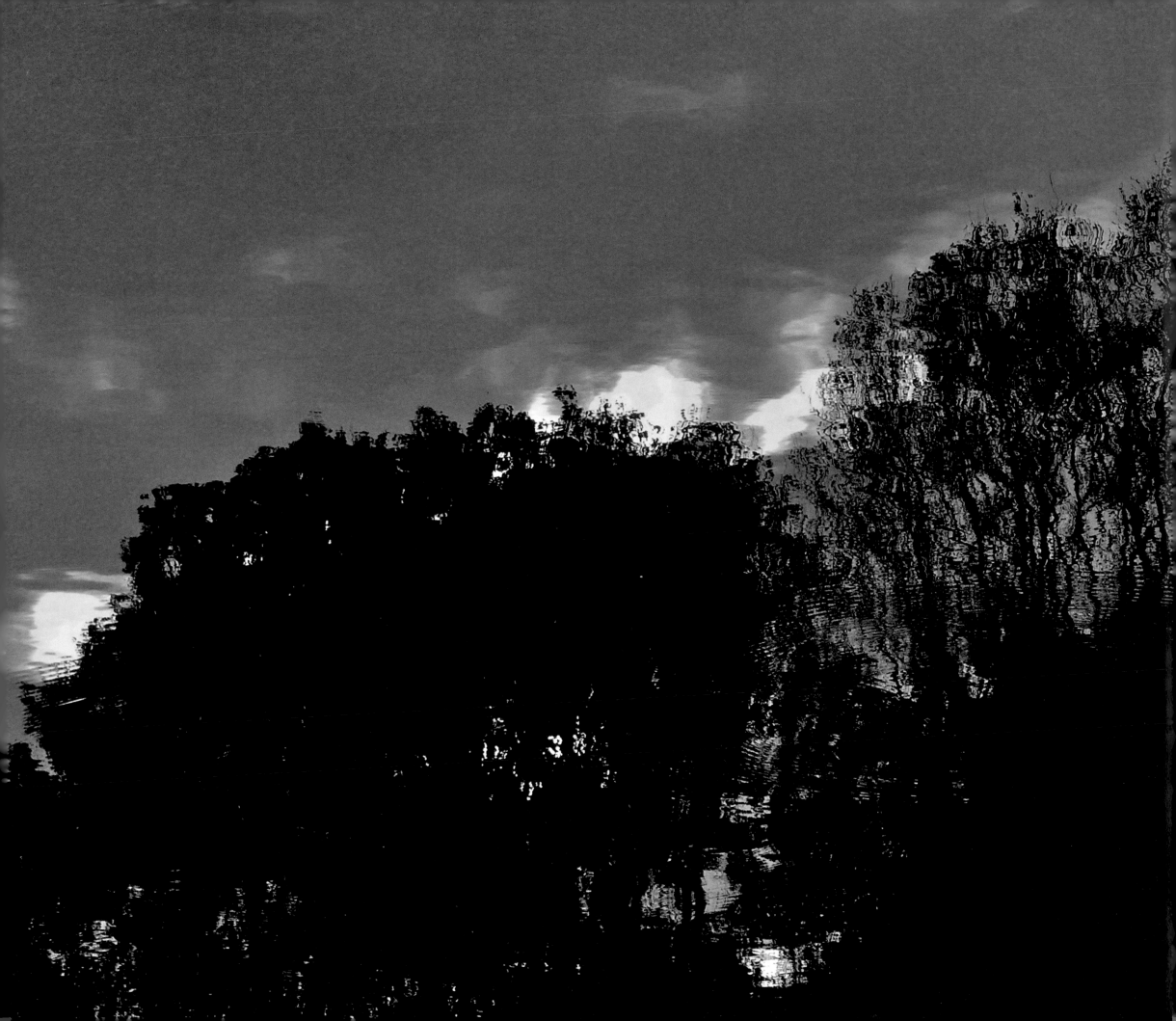

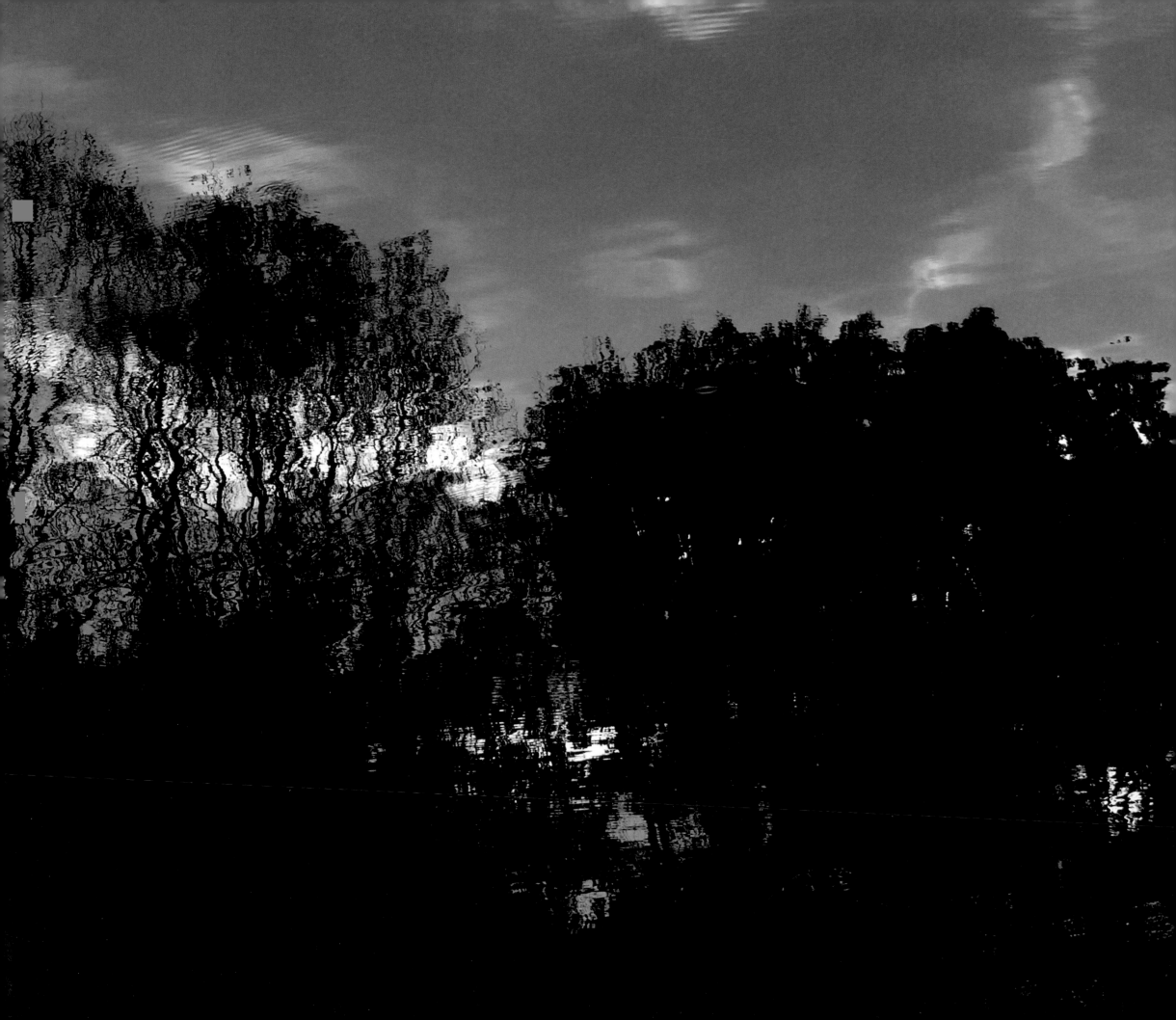

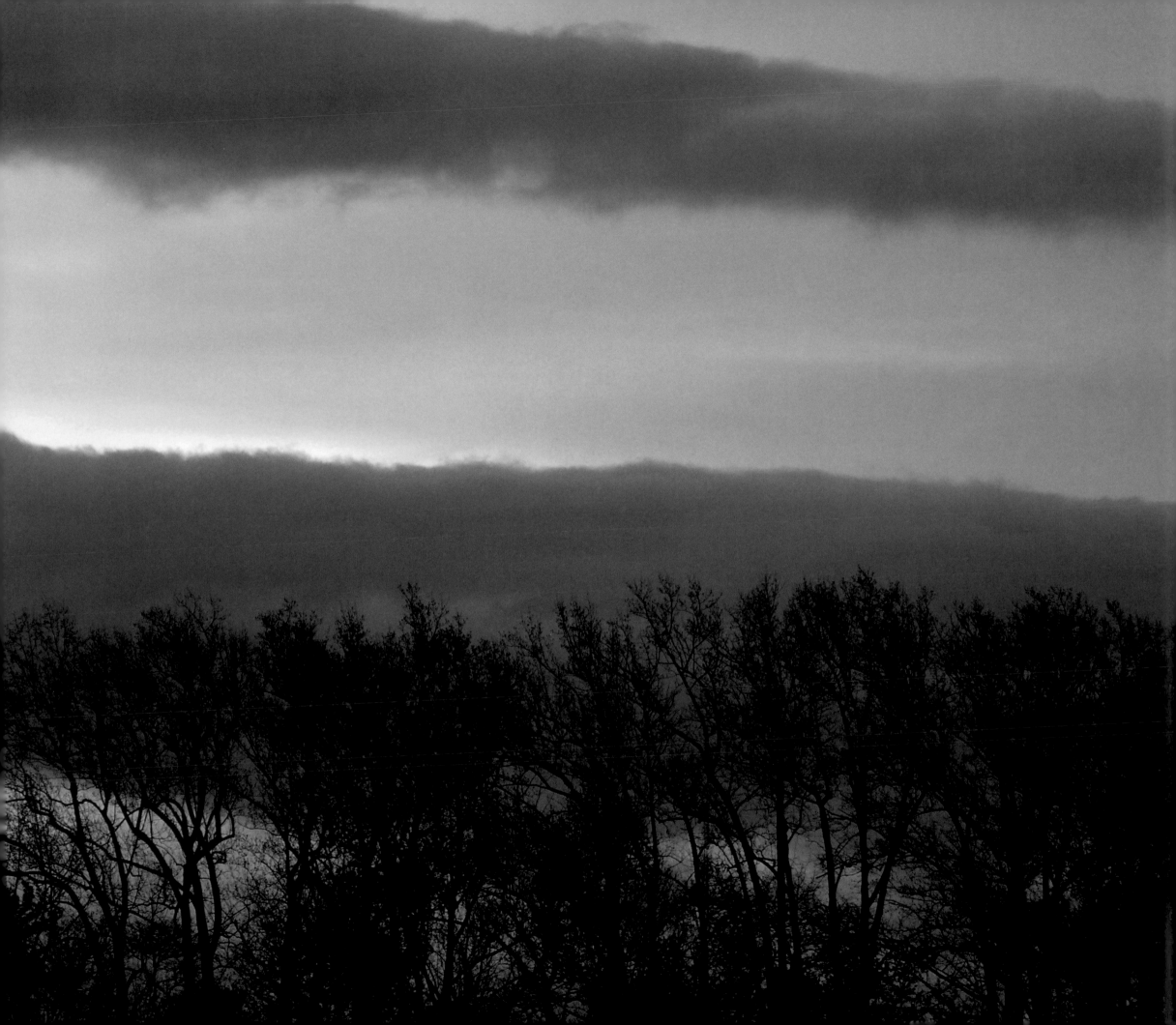

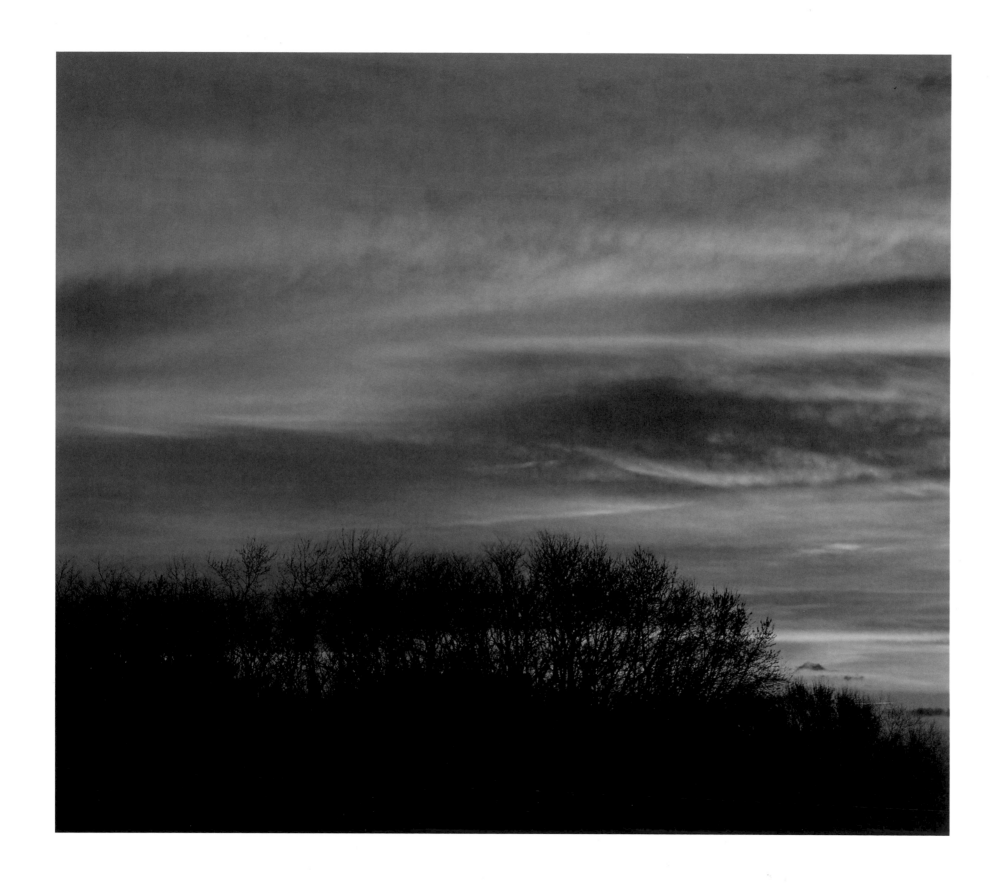

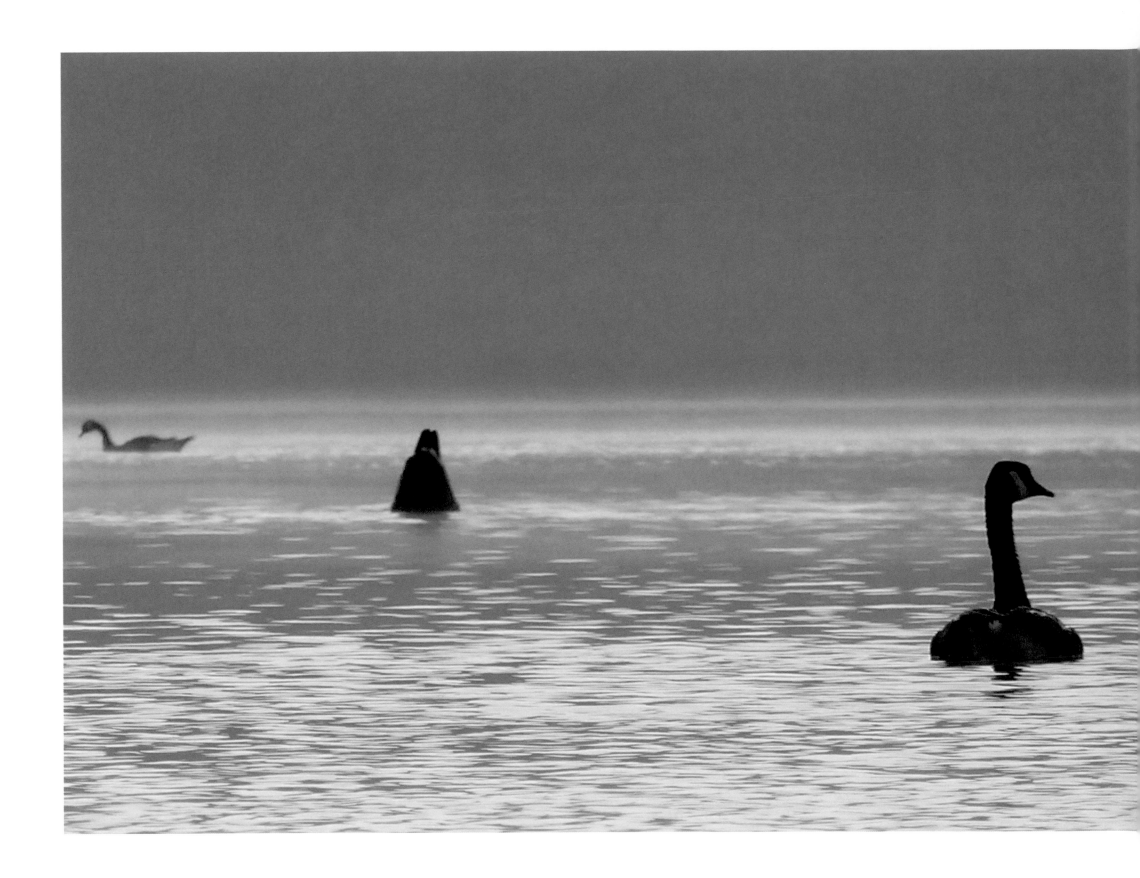

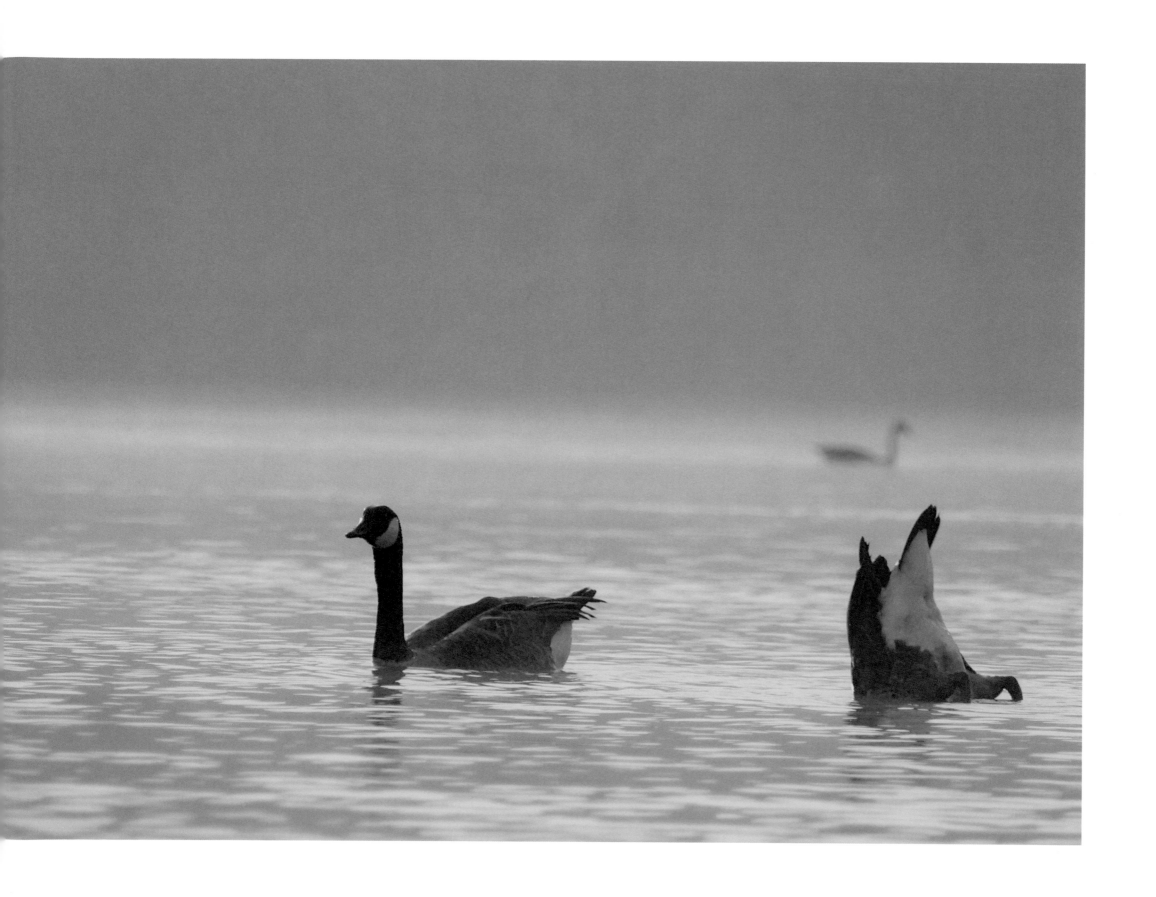

Actually, I think it is good luck to be mooned by a duck.

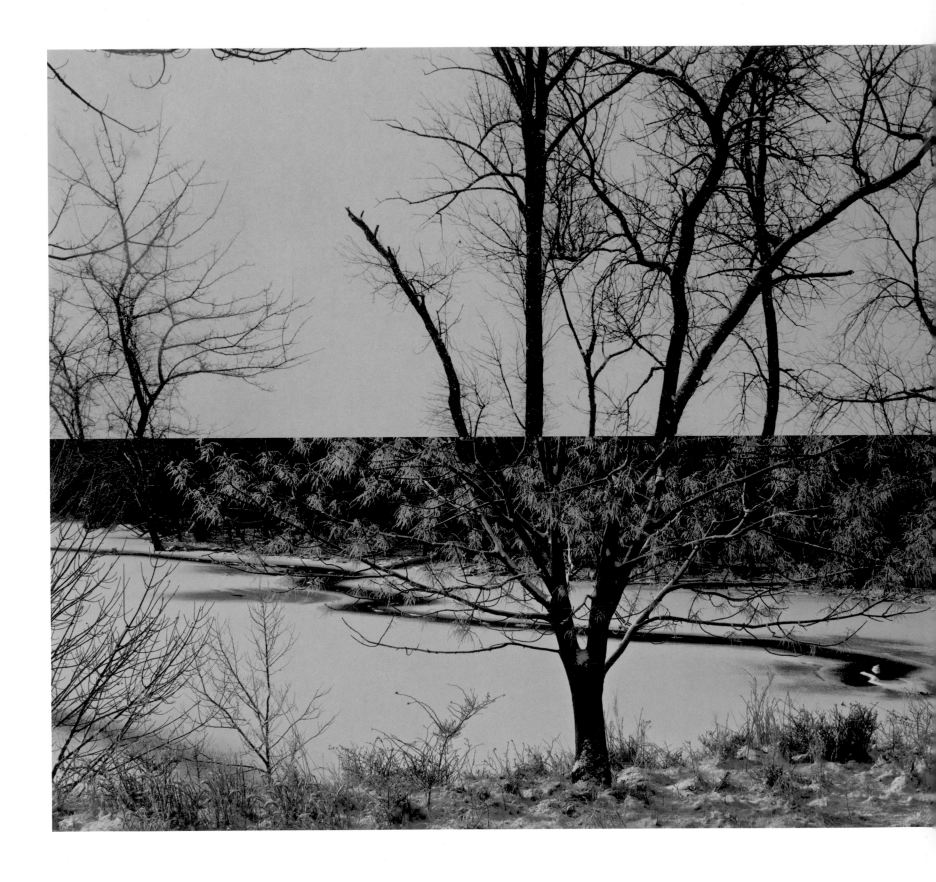

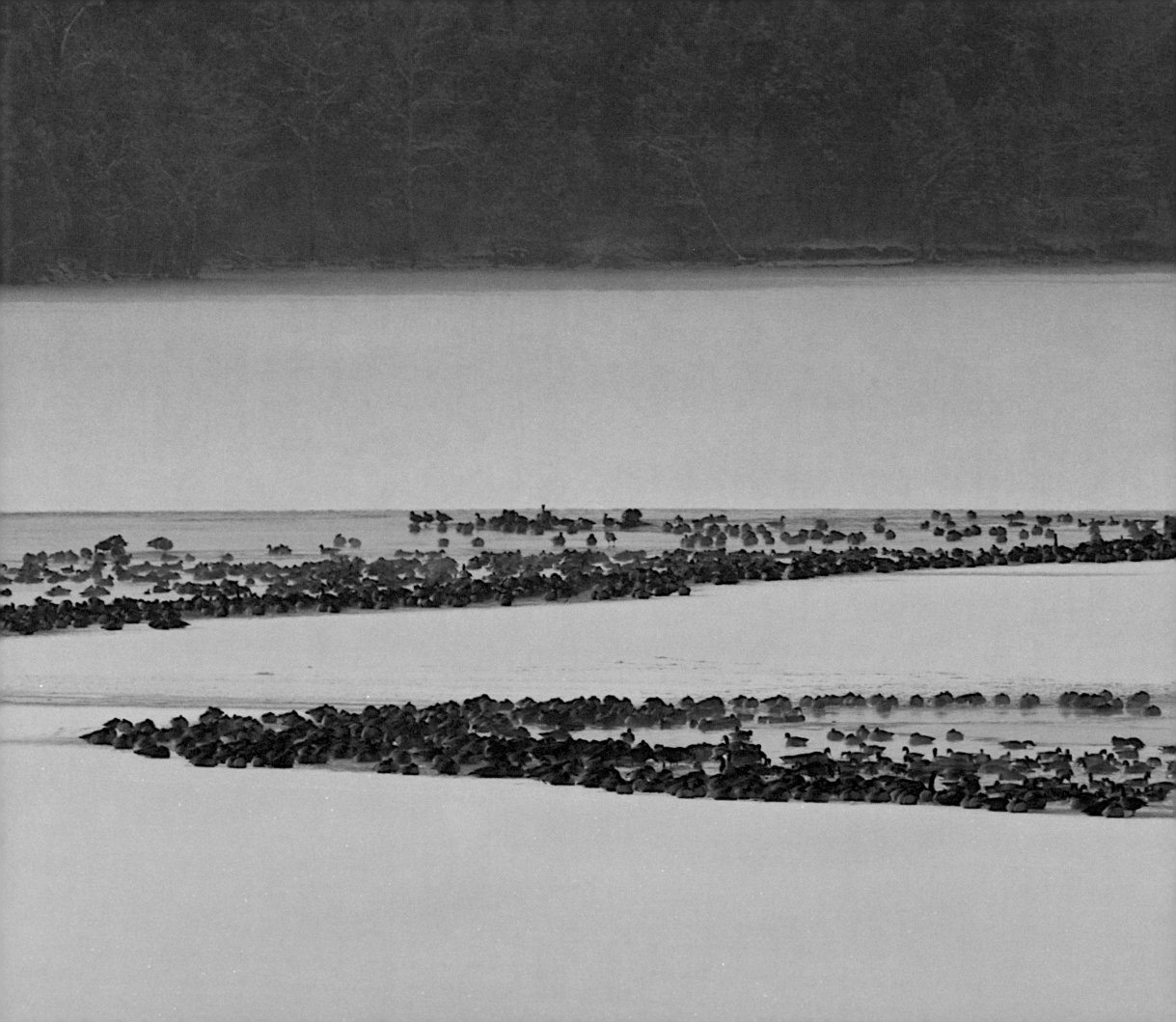

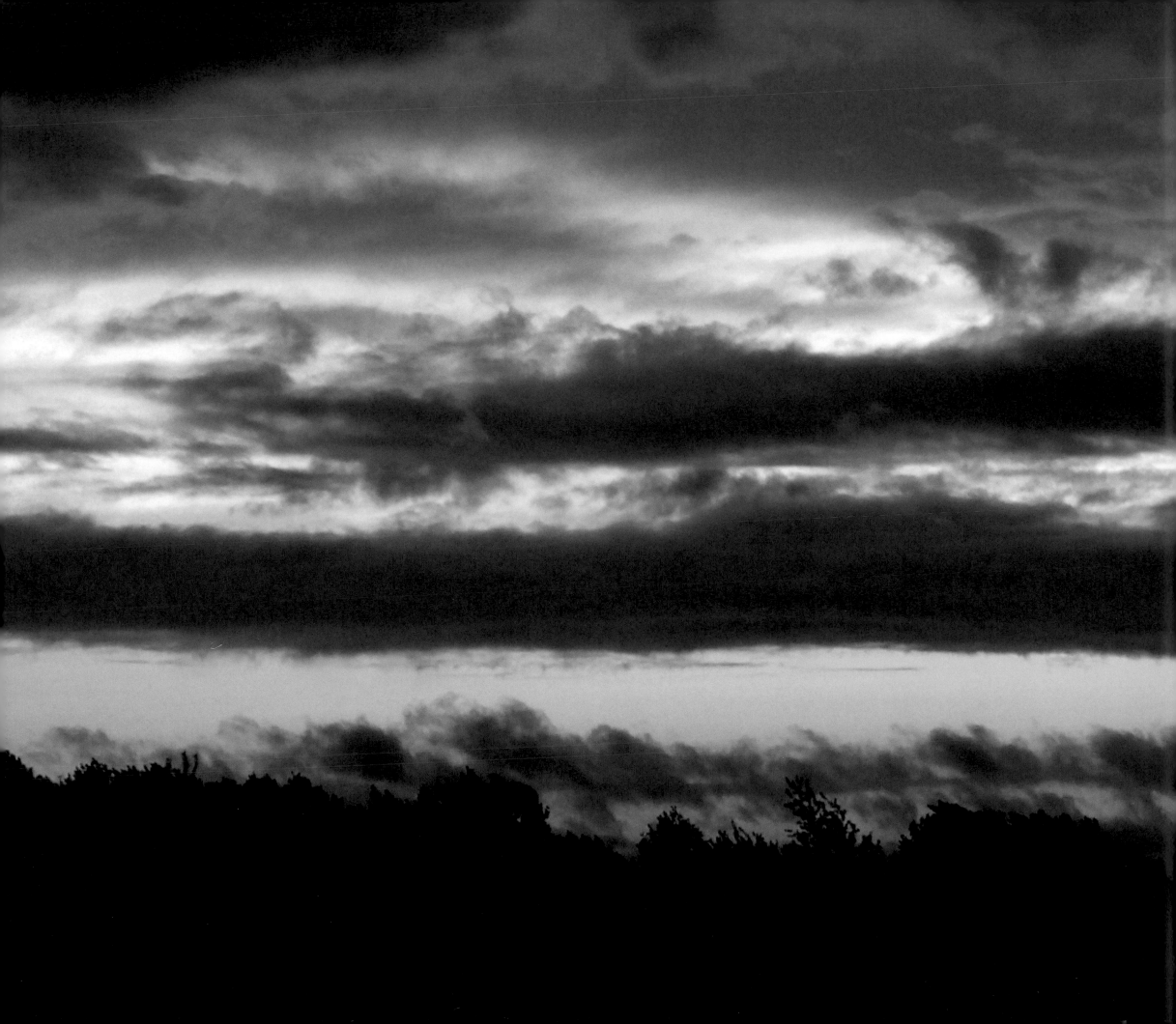

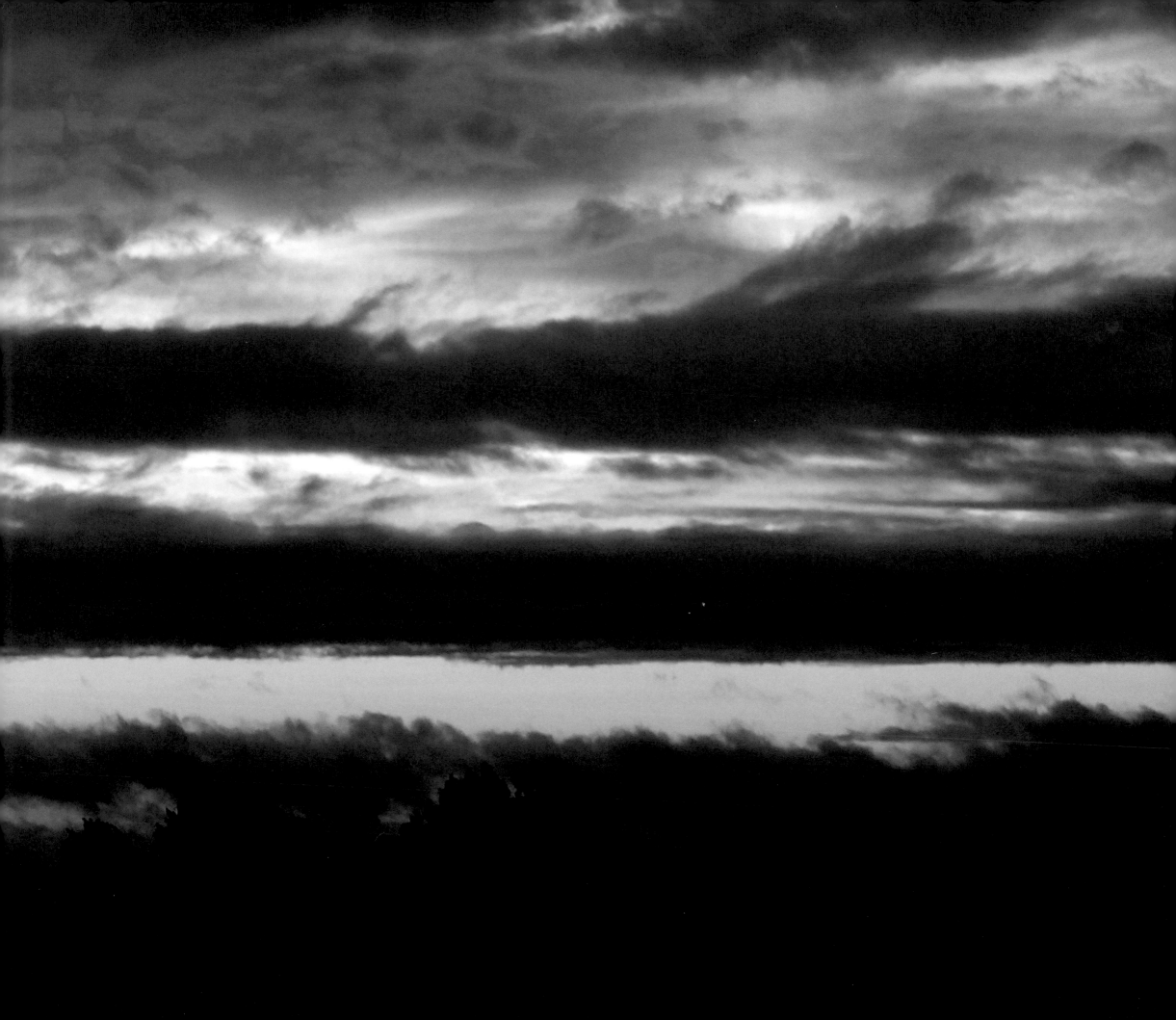

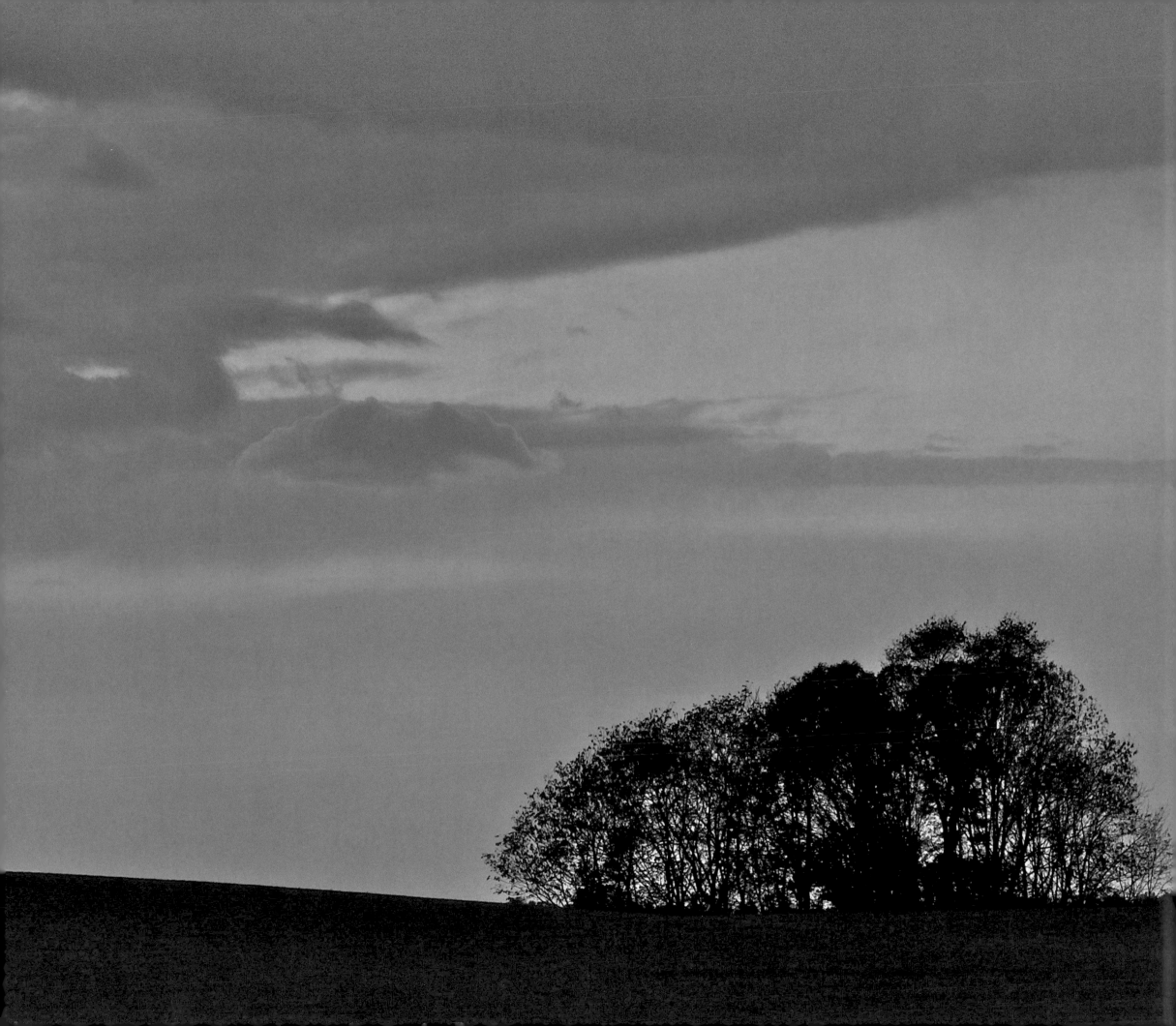

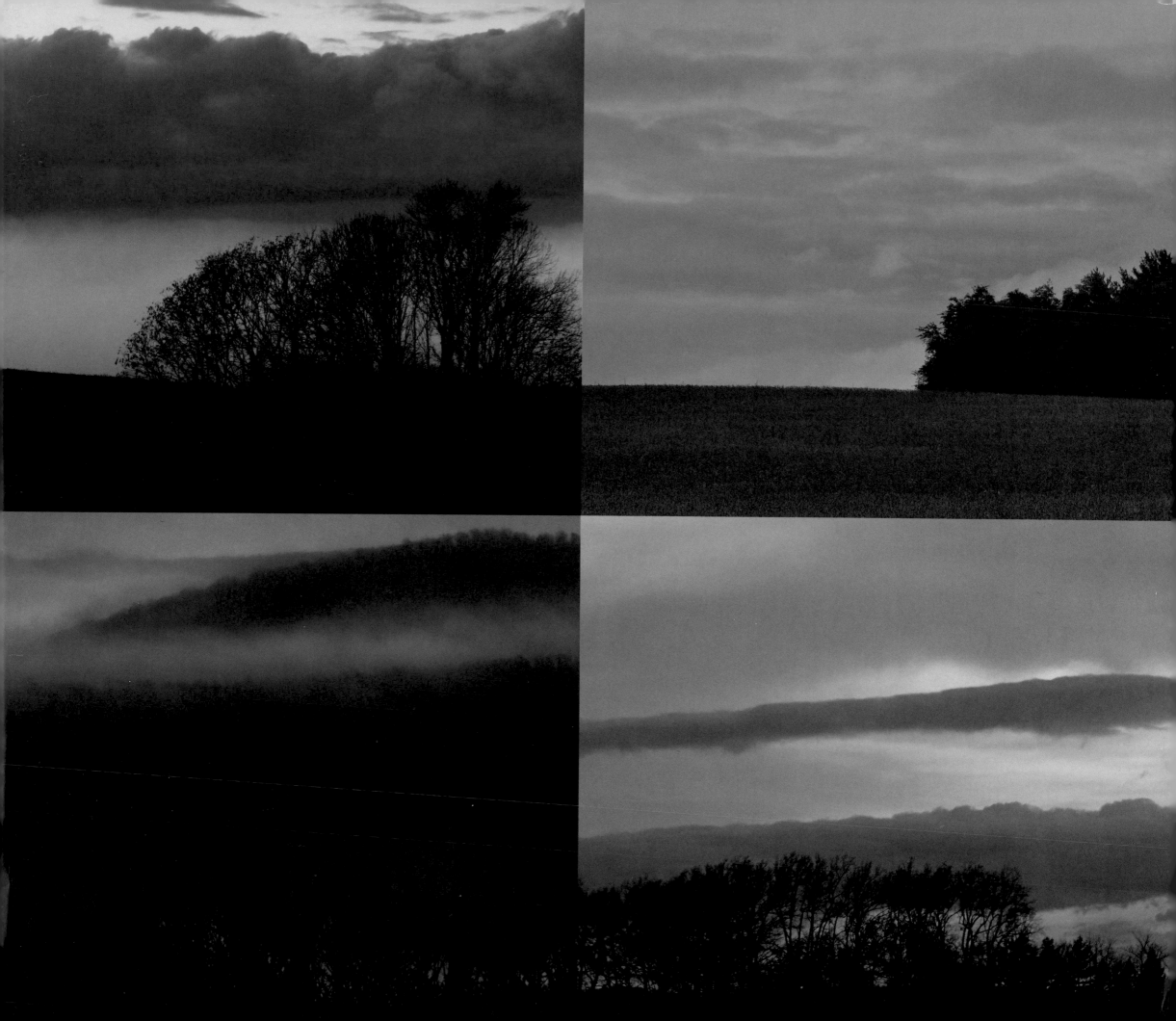

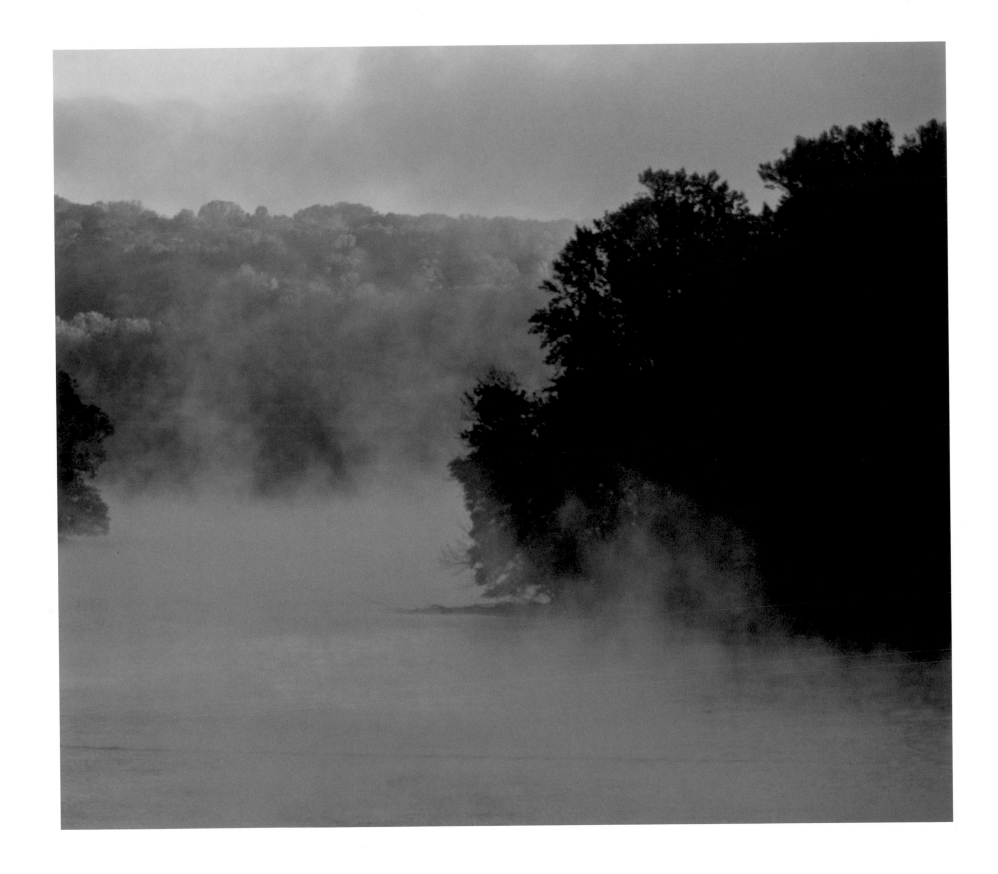

Good day.